WINSLOW HOMER'S IMAGES OF BLACKS

The Civil War and Reconstruction Years

D1240332

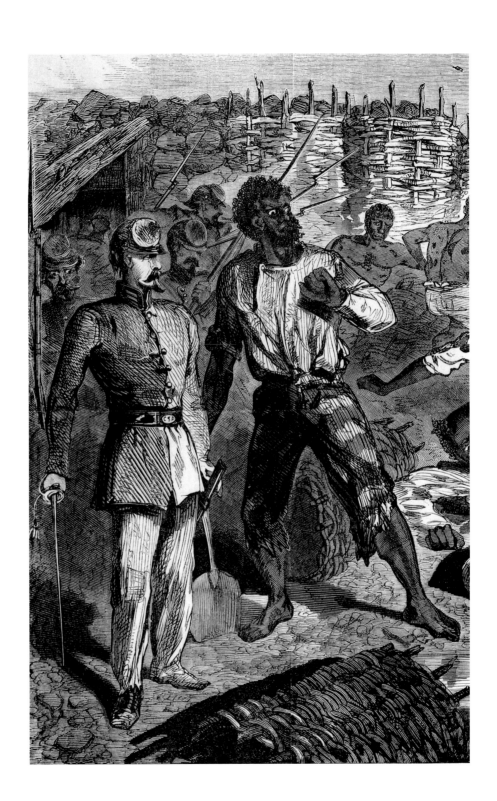

WINSLOW HOMER'S IMAGES OF BLACKS

The Civil War and Reconstruction Years

Peter H. Wood

Karen C. C. Dalton

Introduction by
Richard J. Powell

THE MENIL COLLECTION

UNIVERSITY OF TEXAS PRESS · AUSTIN

Exhibition Schedule

The Menil Collection, Houston
 21 October 1988 – 8 January 1989

Virginia Museum of Fine Arts, Richmond
 14 February – 2 April 1989

North Carolina Museum of Art, Raleigh
 6 May – 2 July 1989

This exhibition and catalogue were supported in part by a grant
from the National Endowment for the Arts, a Federal agency.

The second printing was made possible in part by the support of
The Walter Benona Sharp Memorial Foundation.

Cover illustration: Winslow Homer. *Dressing for the Carnival* (detail).
The Metropolitan Museum of Art, New York.

Frontispiece: Winslow Homer. *A Shell in the Rebel Trenches* (detail).
The Museum of Fine Arts, Houston.

All photos graciously provided by the owners unless otherwise specified.

Design: Don Quaintance – Public Address Design, Houston
Composition: Geraldine Aramanda using TEX
TEXnical Consultant: Arvin C. Conrad
Typesetting: TEXSource, Houston; composed in Bembo
Printing/separations: Gardner Lithograph, Los Angeles

Library of Congress Cataloging-in-Publication Data

Wood, Peter H., 1943–
 Winslow Homer's images of Blacks.
 1. Homer, Winslow, 1836–1910—Exhibitions. 2. Afro-
Americans in art—Exhibitions. 3. Afro-Americans—
History—1863–1877—Pictorial works—Exhibitions.
I. Dalton, Karen C. C., 1948– . II. Title.
ND237.H7A4 1988a 759.13 88–26629
ISBN 0-292-79047-3

Second printing 1990
Copyright © 1988 Menil Foundation, Inc.
All rights reserved under International and Pan-American Copyright Conventions.

Published by University of Texas Press
Post Office Box 7819, Austin, Texas 78713-7819

PRINTED IN THE UNITED STATES OF AMERICA

Contents

Lenders to the Exhibition

American Antiquarian Society, Worcester

The Brooklyn Museum, Brooklyn

Canajoharie Library and Art Gallery, Canajoharie

Cooper-Hewitt Museum, The Smithsonian Institution's
 National Museum of Design, New York

The Corcoran Gallery of Art, Washington, D. C.

Franklin and Marshall College, Shadek-Fackenthal Library, Lancaster

Georgia Museum of Art, The University of Georgia, Athens

The Metropolitan Museum of Art, New York

Mount Vernon Ladies' Association of the Union, Mount Vernon

Museum of Fine Arts, Boston

The Museum of Fine Arts, Houston

National Museum of American Art, Smithsonian Institution,
 Washington, D. C.

North Carolina Museum of Art, Raleigh

Philadelphia Museum of Art, Philadelphia

Private Collection, New York

Texas A & M University, Special Collections, College Station

University of Minnesota, Library, Duluth

Weil Brothers, Montgomery

Foreword

When Winslow Homer displayed *The Bright Side* in New York City in April 1865—only days after Lee's surrender and Lincoln's death—black persons were still not allowed to enter the galleries of the National Academy of Design. "An association that to this day has the meanness to exclude negroes from their exhibitions," *Walton's Weekly Art Journal* editorialized, "is not likely to be animated by any noble impulse, by any response to the spirit of the times." It would be generations before the spirit of the times successfully desegregated American cultural institutions, and it would be a full century before blacks appeared meaningfully on the walls of museums. Finally, in 1964, Bowdoin College Museum of Art in Brunswick, Maine—not far from Winslow Homer's studio at Prout's Neck—sponsored an exhibit called *The Portrayal of the Negro in American Art.*

At the same time John and Dominique de Menil began to explore the prospects for an exhibition tracing black images in Western works of art. They were embarking on a research project of enormous scope, which has persisted for more than a quarter century and produced a unique survey of *The Image of the Black in Western Art*, under the editorship of Ladislas Bugner.

It is fitting that this show will visit two important museums in the Southeast, beginning with the Virginia Museum of Fine Arts in Richmond, under the direction of Paul N. Perrot. Many of the pictures seen in this exhibit were conceived or executed in Virginia, and in the past several years Richmond's venerable cultural institutions have staged a number of impressive reexaminations of the region's multiracial past.

Happily, this exhibition will end up where it began, in a sense, several years ago, at the North Carolina Museum of Art in Raleigh. Director Richard S. Schneiderman, keen to accentuate one of Raleigh's special treasures, Homer's *Weaning the Calf*, spoke with Duke University professor Peter H. Wood about the possibility of an exhibition that would

situate this work in its artistic and historical contexts. The final show, based upon the collaboration of historian Wood and art scholar Karen C. C. Dalton of the Menil Foundation's Image of the Black Project, does indeed contain this beautifully restored painting and much more.

The exhibit would not have been possible, or perhaps even conceivable, ten or twenty years ago. On the one hand, the work on Homer by art historians has deepened impressively in recent years. On the other hand, social historians—influenced by expanding scholarship on the Afro-American past—have been drastically revising our understanding of the Civil War and Reconstruction eras. Moreover, the willingness to acknowledge fresh connections between painting and society, between fine arts and popular culture, has grown steadily of late. A new generation of scholars, such as Yale graduate Richard J. Powell who introduces this catalogue, find interdisciplinary work increasingly possible and rewarding. The Menil Collection is proud to offer a timely and daring reassessment of early works regarding black subjects by one of America's finest artists.

In concrete terms, *Winslow Homer's Images of Blacks* is a reality because of the generosity of several private and institutional lenders, to whom we express our profound gratitude. Special recognition and appreciation must go to Peter Wood and Karen Dalton, who have shared the responsibility of organizing the exhibition, and to Richard Powell, who joined them in writing this catalogue.

We could not have completed this project without a generous grant from the National Endowment for the Arts and the support of many outstanding institutions and committed individuals. We wish to acknowledge particularly the Winslow Homer Collection of the Bowdoin College Museum of Art and the university libraries of Rice and Duke. Abigail Booth Gerdts, curator of the Lloyd Goodrich Papers in New York, and Elaine Evans Dee, curator of Prints and Drawings at the Cooper-Hewitt Museum, have provided knowledgeable cooperation. Dean Dalton, Elizabeth Fenn, Richard Powell, and Harris Rosenstein have read parts of the text and offered useful comments. I join the authors in extending warm thanks to Geraldine Aramanda, A. C. Conrad, Fran Gebhart, Don Quaintance, and the staff of The Menil Collection for their skill and dedication in preparing this exhibition and publication.

Walter Hopps
Director

Introduction:
Winslow Homer, Afro-Americans,
and the "New Order of Things"

Richard J. Powell

Winslow Homer's paintings of black Americans have intrigued audiences for as long as the artist has been known to the greater public. Beginning with the critical acclaim that he received upon exhibiting *The Bright Side* at the Universal Exposition in Paris in 1867, the notion of him "successfully and nobly fix[ing] upon the canvas the typical historical American African"[1] is frequently repeated in references to his Civil War, "Virginia,"[2] and Caribbean subjects. The broad appeal of works like *The Cotton Pickers*, *Dressing for the Carnival*, *The Gulf Stream*, and others has abetted this perception of Homer as one of the few American artists of the nineteenth century to paint black people sympathetically, even though his early links to the popular press certainly made him vulnerable to an undiscerning and mundane notion of Afro-Americans.[3]

Homer's critics—and perhaps the artist himself—sensed that this particular body of work stood apart from "the average artist's minstrel-show conception"[4] of black people. In a lengthy review of the 1880 exhibition at the National Academy of Design, the writer extolled Homer as "one of the few artists who have the boldness and originality to make something out of the negro for artistic purposes."[5] In a review for the Twelfth Annual Exhibition of the Water Color Society a year earlier, another writer proclaimed that "a hundred years from now those pictures [of blacks] alone will have kept him famous."[6] Though Homer, in his typical fashion, hardly had more to say about these paintings beyond affectionately calling them his "darkey pictures,"[7] the fact that he entered several of them into some of his more celebrated exhibitions suggests that

he too believed that these Afro-American images were significant.[8]

Of course, there are aspects of these works which still remain a mystery. Basic facts such as the exact dates and destinations of his post-Civil War trip(s) to Virginia and the precise titles for certain paintings are either in dispute or unknown. Yet the single factor which prevents us from obtaining this information—namely, our separation in time from the circumstances and perspectives of Americans during the Civil War and Reconstruction years—is, ironically, the same factor which allows us to *see* certain relationships, cultural preoccupations, and the overall picture of Homer's artistic efforts in ways that were simply impossible for nineteenth- and early twentieth-century observers.[9]

Rising above temporal concerns and unqualified praise for these works has been the charge of scholars since the 1960s. In numerous essays, articles, and selections from lengthier works, scholars have looked at these paintings: in relation to other nineteenth-century works of art; from a strictly iconographic perspective; in terms of the chronological problems these works present in Homer's entire *oeuvre*; and with the objective of revealing the sometimes obscure narratives in some of these paintings.[10] While all of these past efforts have contributed to a clearer picture of Homer's exploration of black subject matter, questions concerning the significance of black imagery during Homer's time, the artist's motives in depicting blacks, and the cultural/social milieu in which these paintings were produced have yet to be answered.

This exhibition and the accompanying publication situate selected works by Homer within the social and historical context in which they were created. Appended to more traditional art historical methodology, this contextual approach contains the promise of examining how black Americans were perceived during the Civil War and Reconstruction years, and the implication of these perceptions on Homer's art.

In the years between 1860 and 1880, civil unrest, waves of economic inflation, political upheavals, and major social realignments captured the imaginations of most Americans. It is not far-fetched to assume that these same social currents affected Homer and his art. Like the artistic sources for fellow, mid-nineteenth century "interpreters" of American life (e.g., author Mark Twain, composer Stephen Foster, and orator Frederick Douglass), Homer's reservoir of inspiring material for art and his possible intentions for exploring aspects of a black experience surely came from this cornucopia of current events. For instance, if one thinks about Homer's *The Bright Side* in the context of the year it was painted—1865—and in terms of the ensuing debate on the prospects of blacks working for their former masters as they had under slavery, one gets an

altogether different sense of Homer's delineation of the five, recumbent, yet provocatively insolent, black teamsters.[11] American folklore about the subservient status of both mules and black men hints at an even more sarcastic and ambivalent subtext in *The Bright Side* than one might otherwise "read" from an isolated or superficial consideration of the painting.[12]

With an understanding for the controversy surrounding the education and political maturation of the freedmen, seemingly homespun works such as *A Sunflower for the Teacher*, *Weaning the Calf*, and *Sunday Morning in Virginia* take on an allegorical dimension. Homer, like many other nineteenth-century American artists, realized the symbolic potential of childhood themes in art.[13] These youthful representations, attached to an equally allusive image of the black, figured into the already conflated notion that blacks possessed "naïve" and "child-like" qualities.[14] Through placing black children in the role of pupil and/or initiate, Homer (either consciously or unwittingly) made allusions to the remedial training (in terms of both personal growth and political sophistication) that recently emancipated blacks were perceived as needing.[15]

This study has benefited from recent, scholarly advancements in the areas of American and Afro-American studies. Answers to long-standing questions, as well as new questions and answers concerning previously ignored aspects of these paintings, are now entering the art historical discourse. For example, the social contexts of a painting like *A Visit from the Old Mistress* are now given far greater importance than in earlier Homer studies. Today's scholars generally agree that what distinguishes Homer's brand of genre painting from his contemporaries is the delicate balance between things observed from life, quotations from popular sources, and an artistic license to select, interpret, and codify.[16] In a painting such as *A Visit from the Old Mistress*, nineteenth-century attitudes about slaves and masters, as well as Homer's unprecedented play of gestures, expressions, and juxtapositions, join forces to relay successfully the awkwardness, tension, and the underlying volatility between the "old" mistress and her former slaves.[17]

Thanks to specialists in Afro-American studies, the once enigmatic "harlequin" in Homer's *Dressing for the Carnival* may now be associated with a Christmas or New Year's Day celebrant of "Jonkonnu": an Afro-Caribbean derived masquerade tradition that, via commerce between the Caribbean islands and the southeastern United States, worked its way into coastal, black American communities from Florida to as far north as Tidewater Virginia.[18] Although this bit of cultural history brings into question the assumption that *Dressing for the Carnival*, with its

spring/summer setting, might have been painted completely *plein air*, Homer's inclination for perfecting his art in the studio supports the idea of a *composed*, artist-engendered work. While it is unlikely that Homer was aware of (or interested in) the cultural facts surrounding his costumed figure, the evidence seems to confirm that, rather than striving for realism and documentary-like accuracy, Homer's objective for *Dressing for the Carnival* is a scenic *reconstruction* of sorts, where memory, the artist's own agenda, and the social temper of his day all figured into his realization of the subject. Discoveries like the comparable and relatively concurrent *Frank Leslie's* illustration, *Our Colored Militia—A "Skid" Dressing for the Parade on the Fourth of July,*[19] along with closer readings of editorials and personal reminiscences of the 1870s, lead one to believe that Homer had symbolic intentions for his black masquerader and the attending women and children. Certainly, the anxiety and fear that blacks experienced under a first Reconstructed and then steadily undermined American government in the 1870s are sentiments similar to those expressed in the solemn faces of the group in *Dressing for the Carnival.*[20]

As this study shows us, placing Homer's images of blacks squarely within the historical sphere of the Civil War and Reconstruction years yields additional information about Homer's choices as an artist. However, one should exercise caution in attributing a political stance to Homer or to his paintings. Without speculating on Homer's opinion on the "new order of things," one can comfortably look at Homer's black imagery as accurate reflections of America's complex and changing attitude toward its black citizens. When these works surpass the typical "minstrel-show conception" of blacks—and fortunately, this is often the case—they do so with the same emotional depth, psychological edge, and sociological dimension that characterize Homer's other subjects. Homer's pictures of blacks from the 1860s and 1870s are not only compelling works of art but also invaluable visual documents from an era when Afro-Americans stood literally at the crossroads hoping to move from the violence of slavery and war along the uncertain path toward equality and freedom.

Winslow Homer's Images of Blacks: The Civil War and Reconstruction Years

Peter H. Wood

Karen C. C. Dalton

By the summer of 1900 the great conflict between North and South had become a distant memory. The artist Winslow Homer, now age sixty-four, was living in Prout's Neck, Maine, as he had for nearly twenty years. "My work for the past two or three years has been mostly in watercolors," Homer reported to an old Civil War friend, adding, "I have at times painted an oil picture."[1] He was referring, in his usual cryptic manner, to a work from the previous fall entitled *The Gulf Stream*, a painting of a seaman adrift in the Florida Straits, with a ship and a storm visible in the distance and large sharks circling the dismasted boat. The picture, with a black man at its center, would become one of the best known—and most confounding—paintings in American art.[2]

When the vigorous artist posed beside this famous composition for a photograph taken in his Maine studio (fig. 1), he still had another decade of active life and increasing recognition ahead of him. Already, the reclusive New Englander was a widely respected painter, and his reputation would continue to build slowly after his death in 1910. Homer's best received work included his pictures of the Civil War, his many hunting and fishing scenes, and his paintings of sailors and the sea. He was also regarded as an accomplished artist in diverse mediums—lithography, engraving, oil painting, watercolors. A superb painter of childhood subjects, Homer repeatedly turned to scenes of growing up in nineteenth-century rural America which captured feelings of early adolescence that remain universally recognizable. And as a sensitive portrayer of women, he paid close and respectful attention to the moods

and activities of teachers, fisherwomen, wives, and mothers—whether relaxing or working, watching or dreaming.

In addition, Winslow Homer depicted blacks. Not just once—dramatically—in *The Gulf Stream*, but frequently, at every stage of his career and in every medium in which he worked. Among the shy young adolescents, the strong independent women, and the hard-working men who go down to the sea in ships, black figures recur again and again, portrayed with clarity and depth of feeling. And many of the most important of these images had been executed before 1880. "Mr. Homer shows his originality in nothing so much as his manner of painting negroes," wrote the *New York Times* in that year. "This is not to say that sculptors and painters have not tried," the journal continued, "but the results for the most part have been nerveless and inane." At a time when virulent stereotypes were in the ascendant, the paper found "the magazines of the United States overrun with pitiable caricatures of negroes" and protested that oil painters, with rare exceptions, did little better than the popular press. Showing its traditional penchant for sweeping understatements, the *Times* concluded, "The political history of the last 50 years may have a good deal to do with this phenomenon. . . ."³

Indeed it did, and a major purpose of this exhibition and catalogue is to explore the historical context surrounding the first forty years of Homer's life with respect to the pivotal issue of race relations in America. A second intention is to examine, more closely than has been done in the past, possible connections between one aspect of Homer's work—his numerous early renderings of blacks—and related images in the American illustrated press, with which he was involved on a regular basis during the 1860s and early 1870s. And a third concern is to begin to expand the discussion of images of American blacks painted by Homer's contemporaries during the third quarter of the nineteenth century, for Homer was not the only artist whose works in this highly charged area rose above the pitiable and inane. To help realize these goals, we have included two chronologies at the end of the text, one showing relevant public events and related incidents in Homer's own career, the other laying out for the first time a list of more than two hundred works of art made between 1850 and 1880 (for which artist and year are known) that involve significant representations of black Americans.

While many artists had, as the *Times* article put it, "tried their 'prentice hands on the negro type," no other American, whether white or black, had returned to this subject matter so often, in such diverse settings, as Homer.⁴ The black image on Homer's easel in the snapshot from Prout's Neck, therefore, has roots which stretch far back into the

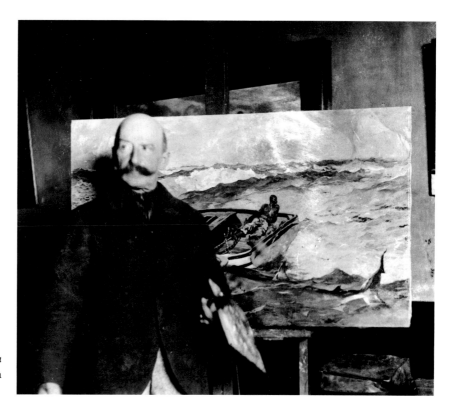

1. Winslow Homer and *The Gulf Stream* (detail), 1899. Photograph. Bowdoin College Museum of Art, Brunswick.

painter's own life[5] and into the broader history which surrounded him during his New England boyhood and his initial decades as an artist. It is those early, deepest roots which this exhibit and publication set out to examine.

Winslow Homer was born on 24 February 1836 near the center of Boston, the second of three sons for Charles and Henrietta Homer. His mother, the daughter of a successful merchant, had been raised in nearby Cambridge and educated at a private school, where her lifelong interest in watercolor painting began. According to tradition, she was at the easel "just before Winslow was born," and she encouraged his interest in drawing from an early age. Charles Savage Homer, whom she had married in 1833 at age twenty-five, was one year younger than she, a genial but strong-willed and somewhat impetuous individual who imported and sold hardware, moving restlessly from one partnership to another and traveling frequently. He too encouraged Winslow's interest in drawing—on one occasion, while on a trip to Paris, sending his son several books of lithographs to aid his sketching.[6]

Not long after the birth of their third son, Arthur, in 1841, the Homer family moved to Cambridge, where the boys would attend school. By the late 1840s they were residing in a house on Garden

Street not far from Harvard Yard. (It stood across from the Cambridge Common and the famous "Washington Elm" where George Washington had assumed command of the Continental Army.) "When we moved to Cambridge the idea was to give us boys an education, but I was the only one who wiggled through Harvard College," Homer's older brother Charles later recalled: "Win wanted to draw."[7]

And draw he did, beginning his professional career in 1854 creating sheet music covers for the Boston lithographic firm of John Bufford and Sons, where he soon undertook a tedious apprenticeship that lasted until his twenty-first birthday. "His sojourn there was a treadmill existence," reported George Sheldon after interviewing the artist in 1878. "Two years at that grindstone unfitted him for further bondage; and, since the day he left it, he has called no man master."[8] The image of escape from bondage may be Sheldon's, or it may be Homer's own, for his first twenty years had certainly exposed him to intense arguments about slavery, and the next twenty years would further deepen his sensitivity to the issue.

While the episode of Homer's brief personal servitude is well documented,[9] his early relation to the wider topic of race slavery in America has scarcely been examined. It deserves careful consideration, for Homer was born at the eye of the storm which was building around the opposition to that institution. Entering life in Boston in 1836 as the abolitionist movement intensified, he grew up with the images and issues of this passion-filled controversy swirling about him. Just when he first apprehended the matter, how he understood it, or whether it engaged his conscious interest can only be guessed at, but the topic itself was present at the time of his birth and remained in the atmosphere throughout his youth, debated in the press, examined from the pulpit, and fought over in the streets. Though we know little about his parents' specific feelings on the question, it is clear that no Boston family, including Homer's, could avoid the subject entirely.[10]

As a young man Homer's father had joined Boston's Hanover Street Congregational Church in 1827 as part of the enthusiastic throng that desired to hear Lyman Beecher's powerful preaching. The renowned evangelical minister, who had arrived in the city the year before, occasionally prayed for "poor oppressed, bleeding Africa," according to the recollections of his daughter Harriet Beecher Stowe. In 1830 Beecher moved his flock to new quarters on Bowdoin Street; soon after that he departed to preach in the West. The congregation replaced him with an appealing younger clergyman named Hubbard Winslow, and in 1836, after the birth of her second child, Henrietta Homer transferred her congregational membership to the Bowdoin Street church. It seems

likely that Mrs. Homer named the infant Winslow after her popular minister in accordance with a common practice of the time. [11]

In 1836 William Lloyd Garrison—nearly lynched by a Boston mob the year before for his outspoken opposition to slavery—attacked Lyman Beecher, Dr. Winslow's famous predecessor, in *The Liberator* for his indifference to the abolition movement. And by 1837 Garrison began working with Henry C. Wright to organize a Children's Anti-Slavery Crusade among the town's young people. The Homers' minister, like most local clergy, denounced such developments. He looked down on those agitating for immediate abolition of slavery, resented their increasingly radical tactics, and opposed requests by the movement to use his church for meetings and lectures. But the very fact of such requests illustrates that he could not shield his parishioners from the increasing controversies linked to slavery. [12]

The family's shift to Cambridge in the early 1840s removed them only slightly from the eye of the abolition hurricane that centered for so long over Boston, and it may actually have provided a sheltered vantage point from which a young boy might safely take in the storm. The abolitionist Thomas Wentworth Higginson (1823–1911) was raised in the same Cambridge neighborhood as Homer and later recalled that growing up there had been "like dwelling just outside a remarkably large glass beehive," where one could observe "the little people inside" "without the slightest peril to the beholder." [13] Despite the region's abolitionist bent, Higginson also remembered evidence of discrimination in churches, schools, and public transportation. Indeed, one famous incident had occurred literally before the house on Garden Street where the Homers would later live. "Even in Massachusetts," he wrote, "any common carrier by land or sea was expected to eject from his conveyance any negro on complaint of any white passenger; and I can myself remember when a case of this occurred in Cambridge in my childhood, within sight of the Washington Elm." [14]

By mid-century family involvement in the California Gold Rush linked Winslow's personal development to the broader issues of the day. Uncle Henry Homer died in Sacramento early in 1850. Winslow's father journeyed west as well, vainly hoping to benefit from his association with John C. Frémont, the dashing explorer, officer, and publicist who had helped wrest California from Spanish control shortly before the discovery of gold there. [15] So the son in Cambridge would not have been entirely oblivious to heated discussions of the Compromise of 1850, which admitted California to the Union as a free state in exchange for a stringent federal law covering the return of fugitive slaves. [16] And he

certainly would have known details of local skirmishes in Boston over enforcing the new statute for shipping escaped slaves back to the South. [17]

If Lyman Beecher had once been ambiguous on the slavery issue, his prominent children certainly were not, and their names became household words in the North. In 1851 Harriet Beecher Stowe began serializing *Uncle Tom's Cabin, or Life Among the Lowly* in *The National Era*, and when it appeared as a book in 1852, readers bought 10,000 copies the first week and an unprecedented 300,000 copies within a year. [18] Likewise, when the Kansas-Nebraska Bill of Senator Stephen Douglas passed Congress in 1854, overthrowing the Missouri Compromise of 1820 and prompting New Englanders to ship rifles west to help protect the free soil of the Kansas Territory from slavery, the guns became known as "Beecher's Bibles" in honor of Mrs. Stowe's younger brother, the abolitionist clergyman Henry Ward Beecher. Two years later Winslow Homer would quote the antislavery preacher in a lithograph called *Arguments of the Chivalry* (fig. 2), prepared during his own "bondage" as an apprentice at Bufford and Sons. One of the few overtly political pictures of his career, it depicted the Caning of Senator Charles Sumner, a violent public incident which attracted national attention during a tumultuous election year. [19]

On 19 and 20 May 1856 Sumner, the ardent antislavery Republican from Massachusetts, had delivered a bitter five-hour speech on "The Crime Against Kansas," vilifying his fellow senators Douglas of Illinois and Butler of South Carolina for their "championship of human wrongs." Two days later Butler's cousin, Representative Preston Brooks from the Edgefield District of South Carolina, accosted Sumner at his desk in the Senate chamber, striking him more than a dozen heavy blows on the head with a cane until the abolitionist spokesman was bloody and unconscious. According to newspaper accounts, Kentucky's venerable John J. Crittenden sought to aid Sumner, while South Carolina representative Lawrence M. Keitt held onlookers at bay with an upraised cane (some say he held a pistol in his other hand). Certain papers, perhaps hostile to his bid for the upcoming Democratic presidential nomination, claimed that Senator Douglas stood "in a free and easy position, both hands in his pockets," supposedly "making no movement toward the assailant." Douglas later denied this charge and showed that he was outside the Chamber at the time, but Senator Robert Toombs of Georgia did witness the attack and was said to have expressed his approval. [20]

Many Southern slaveholders and editors, feeling their honor and their interests were at stake, also defended the attack. In Richmond, Virginia, the *Whig* called it *"A Good Deed,"* and the *Examiner* commented,

"Far from blaming Mr. Brooks, we are disposed to regard him as a conservative gentleman, seeking to restore to the Senate that dignity and respectability of which the Abolition Senators are fast stripping it." In nearby Petersburg, the *South-Side Democrat* added its thanks for "the *classical* caning which this outrageous Abolitionist received . . . at the hands of the chivalrous Brooks."[21] The North, meanwhile, reacted to the event with widespread public outrage.[22] The press showed Henry Ward Beecher playing a prominent part in the response. "Ah, Gentlemen," he intoned before a large Sumner rally of 4,000 leading citizens at New York's Broadway Tabernacle on 30 May, "here we have it! The symbol of the North is the pen, the symbol of the South is the bludgeon."[23] As he spoke, Beecher may have been holding up John L. Magee's dramatic cartoon, *Southern Chivalry—Argument Versus Club's* [*sic*], in which a fallen Sumner, the Kansas speech still in hand, holds his quill pen above his face in a vain effort to stave off the blows from Brooks.

Perhaps Homer or his employers intended *Arguments of the Chivalry* to imitate or to upstage Magee's popular print. Regardless of whether his own concerns or those of his supervisors motivated the lithograph, it clearly contains elements of composition familiar in Homer's later work. He shows his journalist's sense for selecting and arranging the available facts in a realistic manner, even making use of the Senate floorplan which was published at the time. He demonstrates not only his ability as a political portraitist,[24] but also his instinct for the decisive moment of the drama, the brief instant when the victim senses his plight but cannot escape it. In addition, Homer suggests his penchant for narrative and shows his characteristic emphasis on the watchers. At the left an icy Toombs looks on beside Douglas, author of the Kansas-Nebraska Act, who stands aloof, "both hands in his pockets." The distraught and compassionate Crittenden is blocked from offering aid by the central figure of Representative Keitt, who appears to conceal a pistol in his left hand. The two fiery Congressmen from South Carolina divide the picture, as their action divided the troubled nation, and across the top Homer repeats Beecher's line: "THE SYMBOL OF THE NORTH IS THE PEN; THE SYMBOL OF THE SOUTH IS THE BLUDGEON."

When his lithography apprenticeship ended early in 1857, Homer began to design wood engravings for *Ballou's Pictorial Drawing-Room Companion*, located less than two blocks from Bufford's. For several years the aspiring free-lancer shared studio space beside the Ballou office with other illustrators, including Alfred and William Waud, two brothers who had recently migrated to Boston from England. Alfred Waud in particular would go on to become a leading artist for national weeklies

"THE SYMBOL OF THE NORTH IS THE PEN ; THE SYMBOL OF THE SOUTH IS THE BLUDGEON."— *Henry Ward Beecher.*

ARGUMENTS OF THE CHIVALRY.

2. Winslow Homer. *Arguments of the Chivalry*, 1856. Lithograph. 13⅞ × 20⅜ in. Library of Congress, Washington, D. C.

in the 1860s, and his early association with Homer deserves special note. Both men sent occasional designs to *Harper's Weekly* in New York, and in 1859 (with *Ballou's* about to close down) they each moved to New York City to take full advantage of the opportunities provided by this expanding publication. [25]

Week after week, the pages of *Harper's* reflected evidence of the impending national crisis. In the fall of 1859, just as Homer moved to New York, the abolitionist John Brown undertook his dramatic raid on Harper's Ferry; his execution on 2 December elevated him to the status of martyr for many Northerners. [26] On 24 December (the same day *Harper's* published Homer's first scene of New York) the crew of the well-known schooner *Wanderer* made headlines by sailing into Boston harbor unexpectedly, after refusing to take part in an illegal African slaving venture. [27] Similarly, in the spring of 1860 a naval vessel captured the bark *Wildfire*, with 510 enslaved Africans aboard. When the boat was brought into Key West for violation of the 1807 law prohibiting importation of slaves, *Harper's* ran a story with a grim picture of the captives. [28] It provided a visual reminder of the issues dividing American society, as did their illustration published a year earlier entitled *Yᵉ Abolitionists in Council—Yᵉ Orator of the Yᵉ Day Denouncing Yᵉ Union, May, 1859*. [29]

After his first year in New York, Homer himself illustrated a much stormier gathering in *Expulsion of Negroes and Abolitionists from Tremont Temple, Boston, Massachusetts, on December 3, 1860* (fig. 3). With South

Carolina slaveholders threatening to secede in the wake of Lincoln's victory in the presidential election, Frederick Douglass joined others at a meeting called to commemorate the death of John Brown and to debate the question: "How can American Slavery be Abolished?" A faction of well-to-do Bostonians with pro-Southern leanings took over the gathering, passed resolutions condemning John Brown, and then called upon the police to expel their antislavery rivals, challenging the right of Frederick Douglass to speak. When the black abolitionist attempted to address the bitterly divided crowd, the police took hold of him "and said he must instantly leave."[30] *Harper's* stated that its picture came "from a sketch by a person who was present" and reported that "the meeting ended in the expulsion from the hall of the abolitionists and negroes by sheer force."[31] As in *Arguments of the Chivalry*, Homer portrayed—not unsympathetically—a major abolitionist at the instant of being denied his right to free speech while others look on.

As a talented young draftsman, therefore, Homer was not simply conscious of the momentous events and public figures around him, he was responsible in part for the way thousands of Americans would visualize them. *Harper's* made continuous use of the speed and skill with which he could translate photographs of leaders into convincing wood engravings and distill realistic scenes from quick sketches or written reports. Following Lincoln's election Homer prepared a cover portrait,

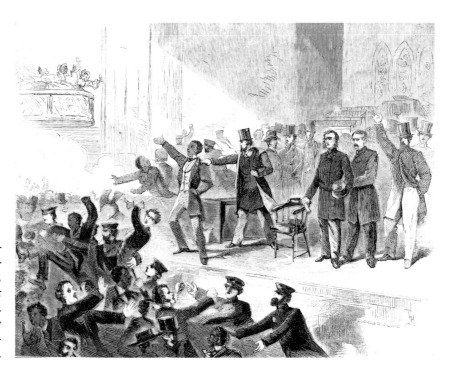

3. Winslow Homer. *Expulsion of Negroes and Abolitionists from Tremont Temple, Boston Massachusetts, on December 3, 1860* in *Harper's Weekly* (15 December 1860). Wood engraving. 6¹⁵/₁₆ × 9⅛ in. The Mavis P. and Mary Wilson Kelsey Collection of Winslow Homer Graphics, The Museum of Fine Arts, Houston.

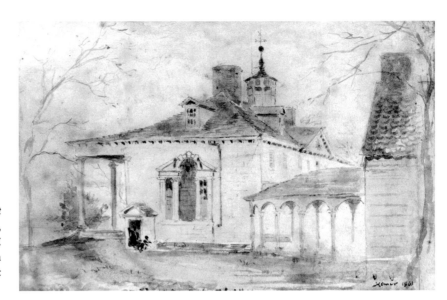

4. Winslow Homer. *View of Mount Vernon and North Colonnade*, 1861. Ink, watercolor, and pencil on paper. 5⁷/₁₆ × 8⁹/₁₆ in. Collection of the Mount Vernon Ladies' Association of the Union, Mount Vernon.

using the famous Mathew Brady photograph made at the time of the candidate's address at New York City's Cooper Institute the preceding February.[32] For the *Harper's* of 22 December, two days after South Carolina's secession vote, he had ready a composite of the seven members of that state's congressional delegation, including Lawrence Keitt, who had appeared in *Arguments*.[33]

In March 1861 *Harper's* sent Homer to Washington briefly to sketch Lincoln's inauguration, but by this time the young artist was "determined to paint." He had been studying painting through night classes and Saturday lessons in New York, and over the summer he took time off from commercial illustration to experiment, "buying himself a tin box containing brushes, colours, oils, and various equipments."[34] Running short on funds by fall, he obtained another assignment as a "special artist attached to *Harper's Weekly*," this time "detailed for duty with the Army of the Potomac," and he set out for Washington again in early October.[35] "We hear often from Win," Mrs. Homer wrote to her son Arthur in the Navy; "he is very happy & collecting material for future greatness."[36]

One location where he collected material during his fall tour can be seen from a small sketch in pen and watercolor, *View of Mount Vernon and North Colonnade* (fig. 4). We know from an undated drawing that Homer visited Fort Lyon, south of the Potomac near Alexandria,[37] and it may have been on that circuit that he paid his respects at George Washington's home and burial site. For Americans of the mid-nineteenth century, the memory of the country's first president was fraught with intense

significance, and they felt troubled that his Virginia estate had fallen into disrepair and been put up for sale. When the federal government refused to buy it, a drive was organized to purchase and preserve the plantation with private funds. Between 1855 and 1860 this national campaign became emblematic of the larger and less successful struggle to preserve the Union itself.[38] Eastman Johnson visited the site in the late 1850s, creating pictures of Washington's tomb and of the once busy kitchen. In the latter, a single slave woman sits by the gaping hearth with several black children and stares wistfully at the light which enters the dark sunken room through a slightly open door, as if contemplating the slim possibility of freedom.[39]

Homer may have had this scene in mind when he composed his exterior view, for it also, on the surface, is no more than a delicate rendering of a dilapidated historic structure, but it too can be read at another level. Viewed from the north as winter weather sets in (even the conspicuous weathervane is emblematic), the deteriorating mansion is not unlike Lincoln's "house divided." The observation tower stands empty; the tall windows appear untended, dark, and broken. From amid the faded grays and browns, several small black figures, dressed in red, emerge through a low covered door at the corner of the house.[40] It is as though the enslaved Virginians, whom Johnson portrayed as confined to a decaying kitchen interior several years before, have suddenly stood up and are now beginning to exit from the somber interior via the opened door. At the end of the war Homer would return in a dramatic way to the theme of a black woman emerging into the light from a covered doorway. But for now the figures seem small and remote, barely glimpsed from the distance as they spill out of the dark cellar onto the wide lawn, facing toward the north.

So while Homer represented Mount Vernon accurately, he also used Washington's famous home to suggest the most startling aspect of his fall visit to the Army of the Potomac: the fact that a small trickle of enslaved persons was beginning to emerge from beneath the large and darkened structure of plantation society. During 1861 these persons arriving at the Union stronghold of Fortress Monroe, across from Norfolk at the mouth of the James River, became known as "contrabands." They figured significantly in two pictures the artist prepared for *Harper's* upon his return to New York: *The Songs of War* (fig. 6) and *A Bivouac Fire on the Potomac* (fig. 9).

Homer, who had worked on pictures for numerous sheet music covers during his years in Boston, chose the popular war tunes of the time as the subject for his first engraving from the field.[41] Across the

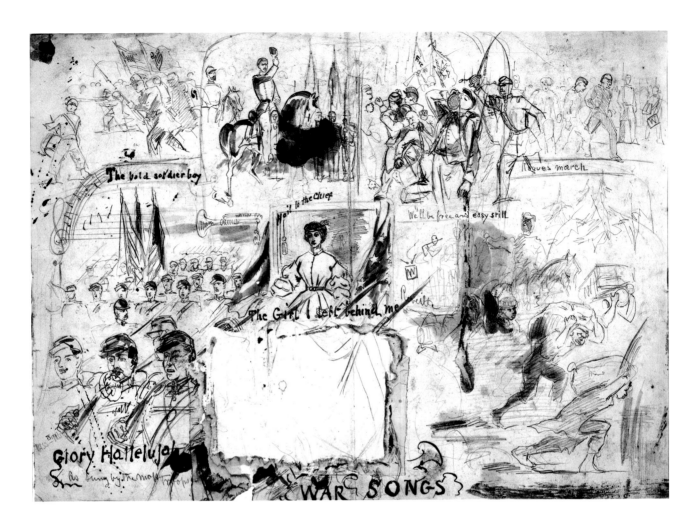

5. Winslow Homer. *War Songs*: sketch for *The Songs of War*, 1861. Pencil and gray wash, with iron gall ink on paper. 14¹/₁₆ × 20 in. Library of Congress, Washington, D. C.

top he illustrated four songs balancing the prospects and problems of the day.[42] On the positive left side he showed both low and high: "The Bold Soldier Boy" and General George B. McClellan reviewing his well-drilled troops to the strains of "Hail to the Chief." On the problematic right side he depicted a group of Zouaves, not yet disciplined for war, carousing to the song, "We'll be Free and Easy Still," while three ruffians are drummed out of camp to the beat of the "Rogues March." In true Homer fashion he put a waiting woman at the center of the composition, representing "The Girl I Left Behind Me."

At the bottom of *The Songs of War*, as at the top, optimism and idealized martial spirit are juxtaposed to troubling realities through a contrast of two popular songs, both undergoing significant transitions. On the left, soldiers step to the tune of "John Brown's Body." The first half of the chorus is spelled out—"Glory Hallelujah"—while the second half is personified by the advancing ranks—"His truth is marching on." In his sketch for the wood engraving, entitled *War Songs* (fig. 5), Homer

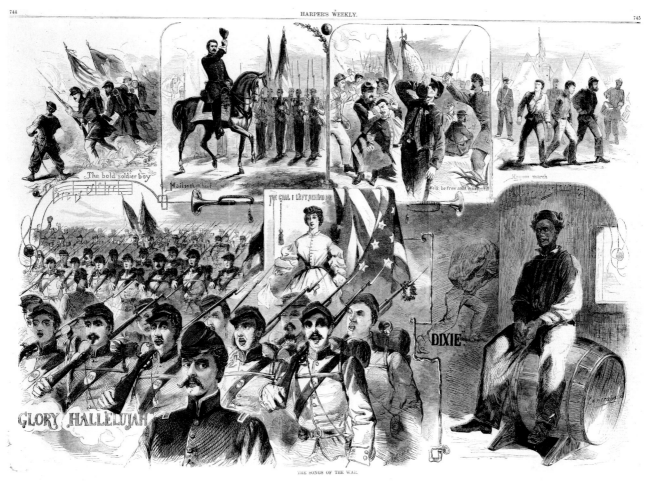

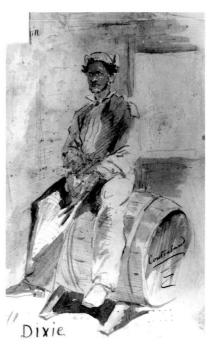

6. Winslow Homer. *The Songs of War* in *Harper's Weekly* (23 November 1861). Wood engraving. 14 × 20 in. The Mavis P. and Mary Wilson Kelsey Collection of Winslow Homer Graphics, The Museum of Fine Arts, Houston.

7. Winslow Homer. *Dixie*: sketch for *The Songs of War*, 1861. Pencil and gray watercolor on paper. 10 × 7 in. Cooper-Hewitt Museum, New York.

notes that these are Massachusetts troops singing the song, for they did much to spread its popularity through the Army of the Potomac.[43] (Interestingly, the woman behind them is suggestive of the well-known Bostonian, Julia Ward Howe, who also visited Union forces in northern Virginia in the fall of 1861. Upon hearing the men sing "John Brown's Body," she promptly composed fresh words to the same tune, and her "Battle Hymn of the Republic" became immensely popular the following spring.[44])

In *War Songs* Homer first thought of combining "Reveille" (a familiar if despised tune) with an ambiguous scene involving black workers carrying heavy burdens. They move steadily, almost stealthily, to the right, while a white woman in a bonnet and a frowning man on horseback, perhaps a black overseer, face to the left. They may be Negro laborers shouldering the arduous and unwanted weight of the new Confederacy.[45] But more probably they are contrabands slipping toward Fortress Monroe, while those in charge "look away" (to quote the song, "Dixie," which is invoked in the final engraving). In a separate sketch called *Dixie* (fig. 7), made with pencil and watercolor washes, these same toilers appear outside the open window, beneath the very faint word *Fortress*, while in the final picture the distant, sunlit fortress, guarded by a tiny sentry, is barely visible on the right, and a single stooped figure moves off toward it from the shadows on the left.

But who is the person seated on a barrel in the foreground? During the 1850s the name "Dixie" had appeared in theatrical numbers applied to black characters, and among Northern showmen "Dixie's land" became an occasional synonym for the South. The leading blackface minstrel, Daniel D. Emmett, composed a tune that popularized these terms, writing lyrics in which a black Southerner made fun of his master and mistress. Bryant's Minstrel Troupe first performed the song in New York in 1859, and with different verses it became a musical staple of both sides, not just the South, during the war.[46] Superficially, Homer's image suggests Dan Emmett in blackface, seated before a theater audience and preparing to sing a song or tell a story in dialect. But at a deeper level this figure invokes a real black man, born free, who had managed to return north from the land of cotton. For his posture and general attitude bear a striking resemblance to the free black depicted in the frontispiece to *Twelve Years a Slave: The Narrative of Solomon Northup* (1853). The author of this dramatic book had been kidnaped and sold into slavery, only to escape and write a moving autobiography. This would not be the last time that Homer infused a humorous popular figure with added dignity.

But unlike Northup in his frontispiece, Homer's black man is seated

on a cask. This may be mere coincidence, but cartoonists of the day often illustrated the danger of sectional strife by showing kegs labeled "gunpowder." Verbal and visual references to slavery as an explosive issue had been common for a long time—and would continue into the war years. In the wake of Nat Turner's rebellion in 1831, for example, an anonymous opponent of slavery had written threateningly to the governor of Virginia: "We know that there is a heavy charge that lies securely buried beneath you and though it may hereafter, as it has, frequently flash, yet be assured that the vindictive match of vengeance, will one day reach it, and tremendous will be the explosion."[47] In 1857 Thomas Wentworth Higginson had commented, "there is a mine beneath us, and the South will cram in powder quite as fast as we can touch it off."[48] A contemporary cartoon called *Like Meets Like* showed two intransigent foes, abolitionist William Lloyd Garrison and secessionist Lawrence M. Keitt, conversing with one another beside a barrel marked "gunpowder."[49]

The barrel in Homer's picture may indeed be explosive, literally or figuratively, for the word *Contraband* has been written across the end of the cask. The term covers military goods of the enemy that can be seized and retained in wartime under international law, so it could well be that this man is sitting on a very real keg of contraband gunpowder—a simple metaphor for the precarious situation in which everyone, and Southern blacks in particular, now existed. But earlier in 1861 the noun *contraband* had suddenly acquired an additional and novel meaning. During May, when Major General Benjamin F. Butler had occupied Hampton Roads controlling the mouth of the Chesapeake, three Virginia slaves being used to build Southern defenses had presented themselves to Northern pickets at Fortress Monroe, seeking refuge and freedom. The Confederate colonel who owned them immediately sought their return under the Fugitive Slave Act. But Butler, a Boston lawyer with a political appointment to command troops, replied that the claim had no standing once the Constitution had been rejected, and he ruled that the Union could retain the men as legal contraband of war.[50]

The administration in Washington backed up this impromptu field decision, and soon black Virginians were building defenses for Butler and boarding ships at Hampton Roads for service in the August expedition that seized the Hatteras forts on the North Carolina coast. On 6 August Congress passed an act ruling that blacks employed by the Confederate military could be acquired along with any other "property" being used "in aid of the rebellion." But the first Confiscation Act did not explicitly emancipate these slaves, and the topic of how to deal with contrabands

remained a controversial one throughout the fall.[51] Some Union generals aided masters loyal to the Union in their search for runaways, and government troops, Frederick Douglass claimed, occasionally "made themselves more active in kicking colored men out of their camps than in shooting rebels."[52] After Union gunboats reached South Carolina's Sea Islands in early November, releasing thousands of black Carolinians from bondage, a Northern paper reported that one officer had been detected preparing to ship Negroes to Cuba, selling them back into slavery at a profit.[53]

But if Yankee soldiers hardly made blacks feel universally welcome, the refugee communities springing up near Union camps still constituted a welcome alternative to bondage. So when the Northern Army shifted position, as when it pulled back from Hampton, Virginia in early August, fear of reenslavement "lent wings to the contrabands." A *Harper's* sketch entitled *Stampede of Slaves from Hampton to Fortress Monroe* (fig. 8) depicted their hasty nighttime withdrawal alongside federal troops, and

8. Unidentified artist. *Stampede of Slaves from Hampton to Fortress Monroe* in *Harper's Weekly* (17 August 1861). Wood engraving. 9³⁄₁₆ × 13⁷⁄₈ in. Mary & Mavis Kelsey Collection, Special Collections, Texas A & M University, College Station.

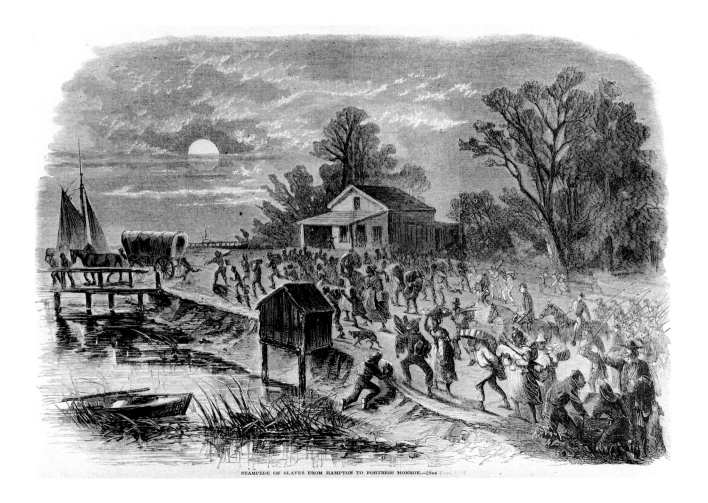

STAMPEDE OF SLAVES FROM HAMPTON TO FORTRESS MONROE.—[See

the accompanying description of this exodus may well have inspired Homer's contraband image in *War Songs*:

> All awakened from their sleep, they seized such articles as they valued most, and set out in the midnight hours, over a long and lonely road leading to the fort, . . . toting household furniture upon their heads, hurrying along lest their masters should finally snatch them from their newly-found freedom, and again send them to the fields under the overseer's whip. . . . The day broke, and still the road was traversed by contrabands, each one bearing a load on his or her head, or wheeling a creaking barrow, . . . and what was too heavy to carry was placed in the canoes, flatboats, and wherries that dotted the bay, pulled by swarthy sons of Africa. Never was such an exodus seen before in this country.[54]

The Northern public, for the most part, greeted word of this initial flow of black refugees with interest and fascination.[55] Soon newspaper accounts and letters from the front contrasted the desolate material situation of the contrabands with their rich tradition of music and dance. A *New York Times* correspondent who had accompanied the Union forces to Port Royal told of Sea Island contrabands "dancing and singing around fires" to celebrate their deliverance. And a young minister sent to aid refugees at Fortress Monroe wrote back to the American Missionary Association in New York about a hymn for those still in bondage that he had heard one evening among the contraband tents. The Reverend Lewis Lockwood's description of this song, with the refrain "Let my people go," became the first published record of "Go Down, Moses." In early December Horace Greeley's *New York Tribune* printed twenty verses of this spiritual, and on 14 December a New York firm published sheet music for this "Song of the Contrabands," in cooperation with the Boston music company of Oliver Ditson, for which Homer had previously done work.[56]

This intense public interest in the contraband experience provides the context for *A Bivouac Fire on the Potomac* (fig. 9). The double-page engraving appeared in *Harper's Weekly* on 21 December 1861, shortly after Homer's return to New York, and shows a black man, clearly not a soldier, dancing before Union troops gathered around an evening bivouac fire.[57] A preliminary sketch of the main character has been called *Soldier Dancing* (fig. 10), and it may well show an army man, for his skin appears light, his step seems European—perhaps Irish—and he wears boots on his feet and what may be the tassled cap of a Zouave on his head (such

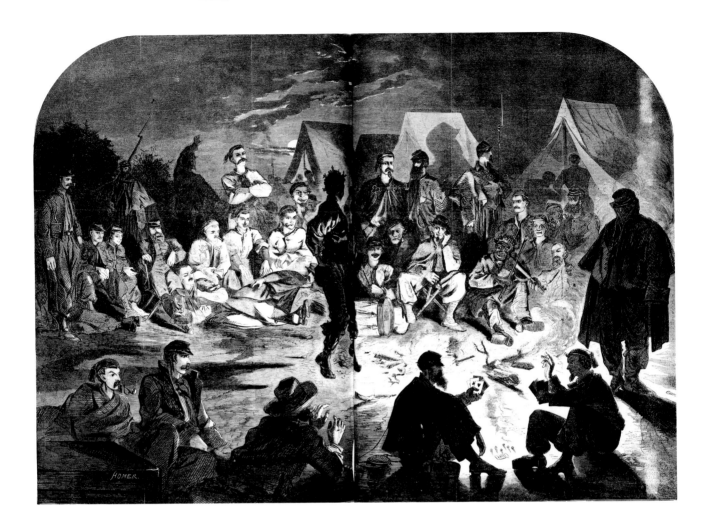

9. Winslow Homer. *A Bivouac Fire on the Potomac* in *Harper's Weekly* (21 December 1861). Wood engraving. 13¹³⁄₁₆ × 20³⁄₁₆ in. The Mavis P. and Mary Wilson Kelsey Collection of Winslow Homer Graphics, The Museum of Fine Arts, Houston.

as those worn by some of the onlookers in the final engraving).[58] His left hand and also his left foot have been tested in several positions to achieve a sense of uplift and movement. Homer retains this same jaunty movement in the finished picture, merely darkening the skin and removing the cap and shoes to create an unmistakably black figure.[59] This shift determines the entire thrust of the picture and may represent a last-minute idea by the artist or his editor in response to New York's sudden infatuation with contraband stories.[60]

Campfire scenes would remain common throughout the war, as would images of blacks dancing before white viewers,[61] for both subjects touched upon a larger theme. One undeniably positive aspect of all the mayhem and destruction associated with the war was the extended interaction between men from different regional and ethnic backgrounds. On both sides the army became an enormous melting pot where new words, games, songs, and dances could be endlessly observed and

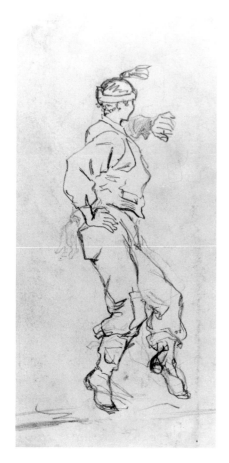

10. Winslow Homer. *Soldier Dancing* (detail): sketch for *A Bivouac Fire on the Potomac*, 1861. Pencil on paper. 9½ × 6¼ in. Cooper-Hewitt Museum, New York.

exchanged. The process was most intense and novel at the beginning of the war, and the space around the campfire embers, more than any other single location, provided the cultural hearth where such interchange took place. An elaborate summation of this theme appeared in an 1862 *Leslie's* illustration called *Camp Life in the West*. In the center Indian dancers perform for whites at the bivouac fire, while in the upper left a black man dances for Indian onlookers and in the upper right a white enlisted man kicks up in front of fellow soldiers and an interested black observer. [62]

Homer's picture shows a black dancer, back turned, who jumps to the lively tune of a toothless old black musician, whose wrinkled face is lit up by the fire. Like "Dixie," this print invokes the old tradition of blacks performing for whites and the new phenomenon of contrabands in the Union camps, and it can be studied at different levels. In part, it is a first-hand report from the front of the varied responses among Northerners to their initial exposure to the music and movements of Southern blacks. While much has been written about this encounter over the years in terms of music, the confrontation between dramatically different dance traditions and body movements had a cultural impact on all parties that is only beginning to be explored. [63] One figure beyond the firelight in the upper left appears to wave for friends to come and watch the dance. A few men turn their backs on the scene and ignore it while most eye the dance with skepticism or amusement. Meanwhile, others smile with a sense of discovery and become drawn into the encounter, like the white drummer seated closest to the dancer.

At another level Homer uses the compositional contrasts of black and white, so familiar to any engraver, to ruminate on the situation of the Negro. Suddenly the center of attention, Homer makes him the dominant figure in a picture containing dozens of whites—an unusual arrangement for the time. But the contraband is still regarded as property by those around him, an object of curiosity to be viewed at a distance. Only half free, his visage remains partially obscured, like the face of the full moon rising in the distance. And yet his head, silhouetted against a tent, bears a clear visual relationship to the head of a white soldier staring watchfully into the night and to the soldier's tent shadow, which makes a dark figure on white canvas. Near the bottom on the right side, a small note is visible in the foreground that says simply "I O U." It seems to figure in the stakes of a card game between two contending white soldiers, for it rests between them, along with half a dozen gaming dice. But it also rests between the audience and the fire, at just the place where the viewer would enter the circle, an apparent reminder of all the complex human debts between regions and races built up during

generations of slavery.

Whether viewed in moral or economic terms, the black man was at the center of this circle of debt. A *Leslie's* cartoon portrayed a shipboard scene in which an ominous black bursar/devil tolls the bell for white Southerners and tells them to pay up, implying they have prospered by a pact with Satan and there is now "Hell to pay."[64] Planters, for their part, wanted to protect a long-term investment in labor, and many had come to argue that their workers, more than they themselves, were the true beneficiaries of slavery. But enslaved blacks questioned an equation implying that they were indebted to their masters, and they looked forward to the prospect of a final reckoning for generations of incalculable sacrifice. Nor did the debt cycle end with escape to the North. For who could settle the claim that contrabands, obviously indebted to the Union army for freedom, had not more than paid for this protection in advance by growing the cotton that had helped Northern industry to prosper? If history could ever balance this enormous ledger, it would take many generations, but in the short run the ranks of the contrabands continued to expand, and most proved willing, even impatient, to work for the Union cause.[65]

Exactly what that work would be changed gradually over time, as summarized by an 1864 illustration in *Leslie's* entitled *The Negro in the War* (fig. 11). By then blacks had been actively employed as soldiers for more than a year, as emphasized in the dramatic central image of U. S. Colored Troops (USCTs) from Louisiana and Mississippi engaged in fierce combat with a Texas regiment at the Battle of Milliken's Bend, 7 June 1863.[66] But well before blacks gained acceptance as pickets, scouts and front-line soldiers, they were pressed into service in less controversial, noncombat roles. "The women are employed in washing, and both sexes in cooking," *Leslie's* explained, while the men "make roads, load steamers, act as teamsters and do much of the blacksmith work."[67] Winslow Homer witnessed all these activities when he returned to Virginia early in 1862. The young artist, now age twenty-six, had hoped to travel to Europe in the spring "for improvement," but straitened finances and the affairs of war sent him south again, instead of east.[68] By 1 April he had obtained a pass to join McClellan's forces, now on the move in preparation for the Peninsular Campaign, and he was sketching "Soldiers leaving Alexandria for Fortress Monroe" with their teams of mules and horses very much in evidence.[69]

Much of the responsibility for handling these teams had been turned over to blacks, and by the following spring Homer's friend, Alfred Waud could report:

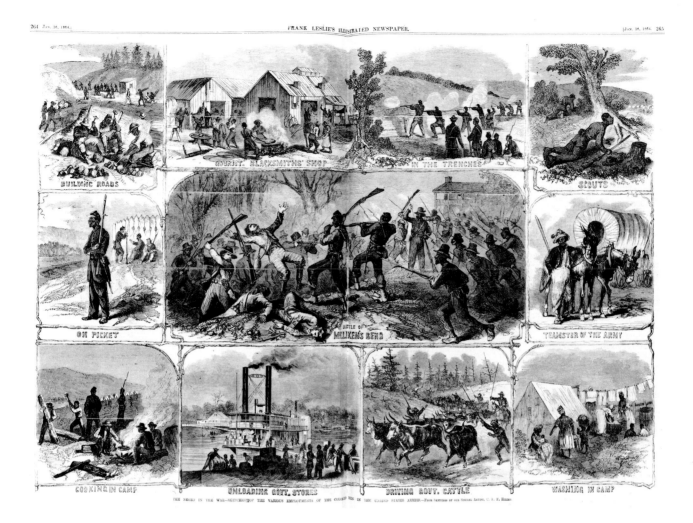

11. C. E. F. Hillen. *The Negro in the War—Sketches of the Various Employments of the Colored Men in the United States Armies* in *Frank Leslie's* (16 January 1864). Wood engraving. 14³/₁₆ × 19½ in. Archives and Special Collections Dept., Shadek-Fackenthal Library, Franklin and Marshall College, Lancaster.

In the Army of the Potomac there are probably from 8,000 to 10,000 Negroes employed as teamsters. This is a business they are well fitted for, and of course it relieves an equal number of white men for other duties. A teamster's life is a very hard one, particularly at this season of the year. It does not matter how much it storms, or how deep the mud, subsistence must be hauled to the camps, and day and night, toiling along with tired horses and mules, the creaking wagons are kept busy carrying to and fro commissary, quarter-master, and ordnance stores, in addition to keeping the camps supplied with fire-wood.

The Englishman Waud went on in a patronizing manner about the black teamsters' "comic heads of wool," ragged clothes, "and great variety of expression. Many of them are very wild, and need strict management to keep them in order," he concluded disdainfully. "They appear, however,

in most cases to realize the advantages of their new position, and do as well as can be expected."[70]

To what extent Homer himself shared in this condescending outlook, so pervasive among Northern whites especially during the early phases of the war, is difficult to assess. Like other artists in the camps, he sketched the ever-present mules and muleteers in various situations,[71] and one of his most engaging drawings, a *Study of a Negro Teamster* (fig. 12) made with graphite and gray watercolor, probably dates from the 1862 trip. It shows a mounted teamster as he pulls a covered baggage wagon. He sits easily and solidly in the saddle with his long whip, known as a "black-snake," resting comfortably on his arm. His face stands out handsomely, for the artist has managed to capture the alertness of the rider's piercing gaze beneath the dark shadow of his hat brim. (This same intense look will reappear later in the confident stare of another black teamster in *The Bright Side*.) Clearly, Homer already has the requisite skill and insight to transcend stereotyped forms and present a vivid black personage, free of caricature, when he desires to do so.

A similar sketch, called *Army Wagon* (fig. 16), also uses pencil and watercolor washes, and seems to have been done at the same time. Throughout his career Homer liked to picture the same scene from different angles, so these two men could easily be perched on the back of the very wagon shown in *Study of a Negro Teamster*. Whether or not the wagon is the same one, the specific devices explored by Homer are similar, for here again he shows a black man with a broad hat who cocks his left eye, and whose head is juxtaposed to the dark hole in the wagon's canvas cover.[72] But the artist changes the picture somewhat when he transforms it into a lithograph the following year, as part of a series entitled *Campaign Sketches*. The meaningful glance of the figure on the left is replaced by rolling eyeballs (almost minstrel style), and the closed mouths of both men drop open slightly to reveal white teeth. Moreover, mud engulfs the wheels and a raised whip appears in the background, suggesting that the wagons are having a tough time and that the two men constitute added weight, hooking a ride to keep their army-issue boots dry and to steal a smoke. The very title, *The Baggage Train* (fig. 15), suggests we may be looking at excess baggage—men who refuse to pull their own weight—a theme that was raised repeatedly regarding contrabands in the Northern press.[73]

As with so many of his pictures, the intended audience appears to be important, for in 1863 Homer undertook a venture in commercial lithographs with Boston publisher Louis Prang. The first phase, *Campaign Sketches*, involved six scenes plus a cover and sold for $1.50;

this set was followed in 1864 by *Life in Camp*, a two-part series of twenty-four smaller chromolithographs the size of playing cards.[74] The pictures tended toward humorous or sentimental stereotypes, avoiding images of combat or death. In one, called *Our Special*, Homer caricatured himself, seated on the barrel of a cannon, moustache flowing and sketchpad in hand. In *Foraging* (fig. 13), several soldiers have "a bull by the horns," and everyone—including the viewer—is suddenly on the horns of a dilemma. An officer in the background looks the other way, since this confiscation of meat on the hoof raises delicate issues, while a black man waves his arms helplessly in consternation. Depending upon one's perspective, he could be a loyal slave protesting the intrusion, or a willing accomplice cheering the army on, or even a struggling freedman who had raised the cow and knew it to be central to his livelihood.

Homer seems to have prepared the lithographs quickly, drawing heavily upon pictures he had already produced. In one of the *Campaign Sketches* (*A Pass Time: The Cavalry Rest*) he borrowed the card players

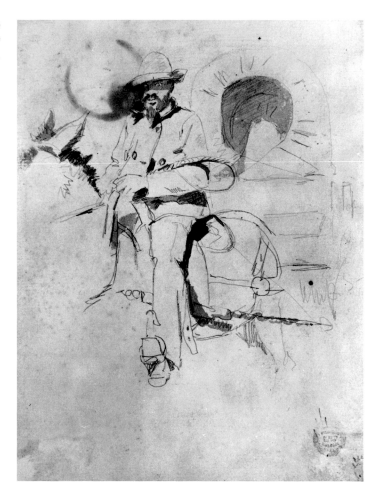

12. Winslow Homer. *Study of a Negro Teamster*, 1862(?). Graphite and gray watercolor on paper. 8⅞ × 6¹³/₁₆ in. Cooper-Hewitt Museum, New York.

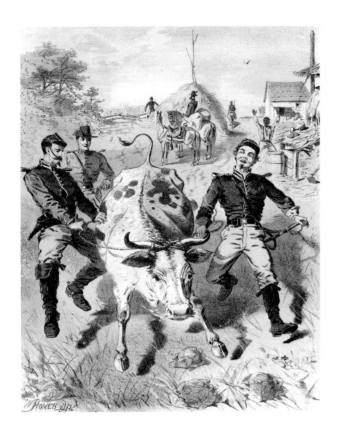

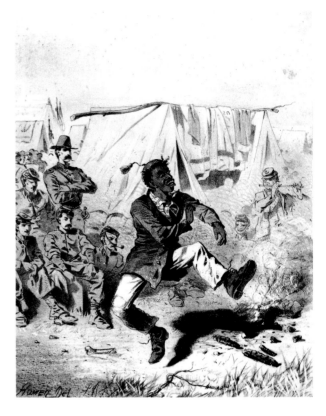

13. Winslow Homer. *Foraging* from *Campaign Sketches*, 1863. Lithograph. 14 × 10⅞ in. Museum of Fine Arts, Boston.

14. Winslow Homer. *Our Jolly Cook* from *Campaign Sketches*, 1863. Lithograph. 14 × 10⅞ in. American Antiquarian Society, Worcester.

from *Bivouac Fire*, and in another called *Our Jolly Cook* (fig. 14) he reused four onlookers from that same engraving, simply dressing them in different uniforms. They are still located to the left of the central black dancer, but the entire picture has been "turned around." It is day instead of night, and the dancer, now facing the opposite direction, has become grotesque instead of graceful. At one stereotypic level he certainly appears footloose and carefree, cutting up in his cast-off army boots and Zouave cap, but beneath the surface something feels forced about the way he kicks up his heels. Could he be grimacing as he dances over hot coals, obligated to perform while a white piper calls the tune? Though ostensibly the cook, this black man seems obliged to sing for his supper.

For several years the black cook had proven among the most common of wartime images, appearing frequently in the pages of the Northern illustrated press.[75] In 1862 sculptor John Rogers created a popular group entitled *The Camp Fire—Making Friends with the Cook*.[76] Early that same year *Harper's Weekly* published a collection of scenes called *In and About Port Royal, South Carolina*; it showed blacks bartering fresh food at the "Brigade Market" and featured a picture of "Mary Curtis" preparing a

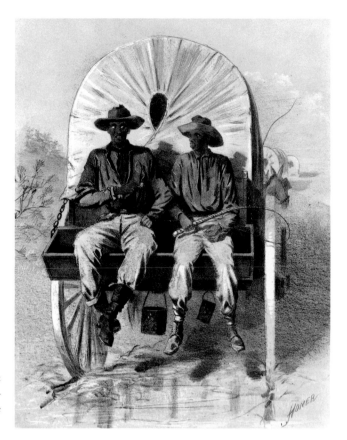

15. Winslow Homer. *The Baggage Train* from *Campaign Sketches*, 1863. Lithograph. 14 × 10⅞ in. Museum of Fine Arts, Boston.

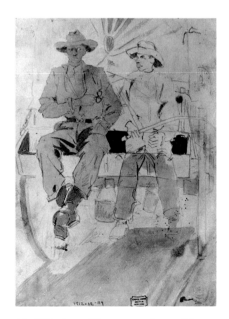

16. Winslow Homer. *Army Wagon*: sketch for *Campaign Sketches: The Baggage Train*, 1862. Pencil and watercolor washes on paper. 9½ × 6¹³⁄₁₆ in. Cooper-Hewitt Museum, New York.

meal at her large army cookstove.[77] Northern readers, long familiar with Negro cooks and servants, no doubt found reassurance in such portraits, which reinforced stereotypic associations of blacks with bountiful food, good-humored nurture, and nonthreatening service. But the image was a transitional one that would all but disappear as the war progressed. For while Homer was drawing *Our Jolly Cook* in 1863, stories were circulating of a young black cook who had begged for a gun at Milliken's Bend and then fought bravely until badly wounded.[78] In the words of Union scout Jim Williams, an ex-slave who had joined the army as a cook: "I am willing to work, but would rather fight."[79]

By the time Homer left the Army of the Potomac and returned to New York in the early summer of 1862, the pressures of extended war were beginning to alter the very nature of the conflict, particularly with respect to blacks. On 17 July an impatient Congress passed a Confiscation Act declaring free any slaves who escaped from masters who were in rebellion. On the same day, anxious to free white soldiers for combat by expanding the role of blacks in the war effort, Congress passed a Militia Act mandating the enrollment of Negroes in "any military or naval service for which they may be found competent." Despite sensitivity to

the objections of soldiers from the border states, Lincoln's administration could no longer resist the military need for more manpower and the political pressure from members of the Republican party, especially black leaders who demanded the right of full participation in the war effort. Soon free Negro regiments were being organized in Kansas, Louisiana, and South Carolina. Moreover, the president, long an advocate of gradual, compensated, peacetime emancipation, was considering the prospect of using his war powers as commander-in-chief to proclaim emancipation for slaves held in the secession states.[80]

In the fall of 1862 Winslow Homer was back in his studio in the old University Building in Washington Square at work on *Sharpshooter*, an image that would become "one of the icons of the Civil War." The now famous picture of a Union rifleman taking aim from the fork of a tree appeared first in *Harper's* as a wood engraving (15 November 1862), although Homer was already well advanced on an oil version, reputedly his "very first picture in oils." He was determined to become successful enough as a painter so that he would not be obliged to give up his free-lance status and accept a permanent post with Harper's Brothers.[81] This early watershed in the artist's career coincided with a major transition not only in the process of the war, but in the whole history of the United States, Lincoln's Emancipation Proclamation. Artist Thomas Nast would later summarize this momentous national turning point for *Harper's* (24 January 1863) in a work entitled *The Emancipation of the Negroes, January 1863—The Past and the Future* (fig. 17).

On 22 September, shortly after the battle of Antietam and not long before he removed General McClellan from command of the Army of the Potomac, Lincoln signed a preliminary emancipation proclamation which supported Congress's earlier Confiscation Act and declared freedom for slaves in any region that had not returned to the Union within one hundred days—by 1 January 1863. Predictably, Confederates took the fourteen-week grace period as an insult and condemned Lincoln's statement as a desperate effort to foment servile insurrection. Just as predictably, black Americans and their white supporters saw this edict as a dramatic step toward making abolition of slavery the central mission of the Northern war effort, and they treated the last one hundred days of the old year as an advent period of breathless anticipation. "Do not let the dying die," Ralph Waldo Emerson beseeched his transcendental God; "hold them back to this world until you have charged their ear and heart with this message...."[82]

On the night of 31 December, thousands who had prayed or

struggled for an end to slavery put aside all else to count down the final hours of an era that had endured for generations. At the large Contraband Camp in Washington six hundred refugees, most with relatives still in bondage, came together for an evening of prayer and song. The former slaves offered personal testimonies and joined repeatedly in singing "Go Down, Moses," the spiritual that had first moved Northern listeners in 1861. At two minutes before midnight the rows of temporary wooden barracks fell silent, as the entire camp knelt in prayer. Then joyful pandemonium erupted—singing, dancing, and an impromptu parade around the campground with a visit to the superintendent that was in marked contrast to year-end visits to the white master in former years. [83]

William Tolman Carlton captured this drama in a picture entitled *Watch Meeting Dec. 31st 1862. Waiting for the Hour*, in which contrabands of all ages crowd together expectantly to watch the hands of a large pocket watch advance toward midnight. Lincoln's preliminary proclamation of 22 September has been tacked to the open door with a kitchen

17. Thomas Nast. *The Emancipation of the Negroes, January, 1863—The Past and the Future* in *Harper's Weekly* (24 January 1863). Wood engraving. 13⅜ × 20½ in. Mary & Mavis Kelsey Collection, Special Collections, Texas A & M University, College Station.

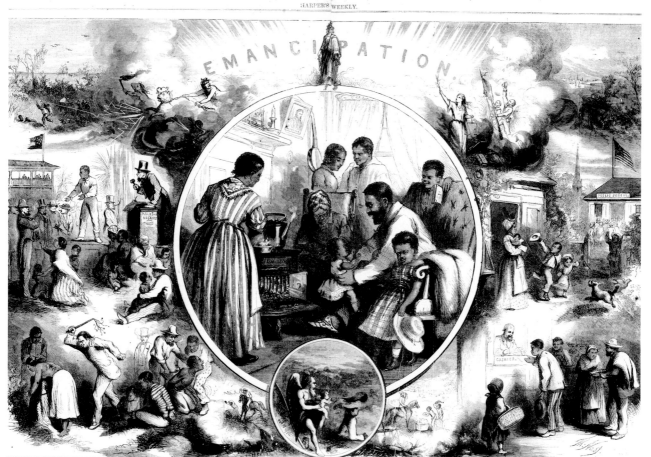

THE EMANCIPATION OF THE NEGROES, JANUARY, 1863—THE PAST AND THE FUTURE.—Drawn by Mr. Thomas Nast.—[See preceding Page.]

fork, and a Bible (resting on an upturned crate of the Army Sanitary Commission) lies open to the Book of Exodus and the Lord's words repeated by Moses to Pharaoh: "Let my people go." On the right a newcomer still in shackles lifts a pine torch aloft for light. At the left a man holding an American flag looks out through a cross-shaped opening toward the bright North Star (long a beacon for freedom among the slaves), and a banjo has been hung upon the back wall. Its silence may invoke the line, "Hang up de fiddle and de bow," from Stephen Foster's popular song about the slave, "Uncle Ned." But more probably, as Hugh Honour suggests,[84] it calls up the beginning of Psalm 137:

> By the rivers of Babylon, we sat down, yea, we wept, when we remembered Zion.
> We hanged our harps upon the willows in the midst thereof.
> For there they that carried us away captive required of us a song; and they that wasted us required of us mirth, saying, Sing us one of the songs of Zion.
> How shall we sing the Lord's song in a strange land?

Thankful celebrations continued the following day as regular watch meetings, held annually to observe the arrival of the New Year, assumed momentous significance. Near Beaufort on the coast of South Carolina, where the Union army and a vanguard of Northern missionaries had been ensconced for some time, the soldiers roasted a dozen oxen on spits, and several thousand freed blacks came by land and water to join the celebration, though some stayed away, apparently suspecting "a trap" or believing the news too good to be true. A converted local planter who had long since emancipated his own slaves read Lincoln's proclamation aloud, and an elderly Negro led the local residents in singing "My Country, 'Tis of Thee." The regiment known as the First South Carolina Volunteers, newly trained black troops resplendent in their scarlet trousers, received the colors, heard moving words from their exceptional leader Sergeant Prince Rivers, and closed by singing the "John Brown" song.[85] According to Charlotte Forten, a black schoolteacher recently arrived from Philadelphia, it was "the most glorious day this nation has yet seen."[86]

In Boston that same day "an immense assembly" gathered at Tremont Temple, where Homer's sketch only two years before had shown Frederick Douglass and other abolitionists being ejected from the stage. William C. Nell told a morning session that New Year's Day, long known to blacks in the South as "Heart-Break Day" because new

contracts and sales of that day could split a family apart, would forever have a "new significance and imperishable glory in the calendar of time." (The secretary recording his words was the black artist Edward M. Bannister, whose reputation would grow with time.) Though Lincoln signed the proclamation in Washington in the late afternoon, word of the event did not reach the Boston meeting until late evening, where Douglass and other speakers had been trying to dispel the doubts of the impatient audience with their "confident utterances." At last a messenger shouted the news: "It is coming! It is coming on the wires," and Douglass led the jubilant throng in singing "Blow ye the trumpet, blow." Before the giant celebration ended, all joined in singing:

> Sound the loud timbrel o'er Egypt's dark sea,
> Jehovah hath triumphed, his people are free.[87]

At *Harper's* illustrator Thomas Nast summarized the deep-felt sentiments of the moment in his elaborate two-page wood engraving, *Emancipation*. In a small circle at the bottom center we are shown "old Father Time, holding a little child (the New Year), who is striking off the chains of the bondsman and setting him at liberty forever," while in the central scene a black family, gathers beneath a portrait of Lincoln, free at last from fears of exploitation and separation. "Here domestic peace and comfort reign supreme," explains the accompanying text, "the reward of faithful labor, undertaken with the blissful knowledge that at last its benefit belongs to the laborer only, and that all his honest earnings are to be appropriated as he may see fit to the object he has most at heart—his children's advancement and education."[88]

On the left Nast brings together all the most familiar images from generations of antislavery propaganda—the slave ship, the brand, the lash, the bloodhound, the auction block—soon to be things of the past. On a new page, at the right, he projects an idyllic future of wage labor and integrated public education. The rap of the auctioneer's gavel, Nast tells subscribers, will soon be replaced by the ring of the school bell, as indicated by the idealized vignette at center right. Innumerable white mothers in popular art and literature had stood at the cottage door and watched proudly as their children went off through the open gate to worship, study, and improve the world. Now black women too would stand at the cabin door with pride.

It is in this context that we can look closely at *Pay-Day in the Army of the Potomac* (fig. 18), Homer's double-page wood engraving that appeared in *Harper's* on 28 February 1863. It contains the caricatured face of a

Negro man at the front and center in a prominent, if lowly, position, and it has always been viewed as nothing more than another vignette of camp life, designed to link the readership at home to the boys away in the war. As with Nast's *Emancipation* and many of Homer's own earlier drawings for the illustrated press, this one expounds on various aspects of a central narrative theme and can be read from left to right along several horizontal levels. Since the topical starting point is "money," Homer logically turns the conventional round scenes into coins. Through the overall composition he implies the intricate flow of currency and the complex exchanges surrounding it—involving things as intangible as love and loyalty, as substantial as tobacco and condensed milk.

Above, earnest young men accept their pay and promptly mail much of it home, along with a sincere letter that will be eagerly received. The man's sphere, risking death in war, is contrasted to separate woman's sphere, rocking the cradle at home. But their lives remain joined—opposite sides of the same coin. His dedication to duty earns money for the family; her steadfast service raises sons for the army. Below these idealized bubbles, made more ethereal by the stars on the coins, appears a scene that is much more chaotic and down-to-earth. Some of the same soldiers (perhaps after a quick drink from the circular and circulating canteen) jostle to buy eggs, cheese, and pickled oysters from the camp provisioner, or "sutler."

Dividing his time between painting oils for a livelihood and selling illustrations to *Harper's Weekly*, Homer's pattern for thinking and working was now becoming set. When using two different mediums and addressing two different audiences, he could simply repeat a scene from the front in the same manner as he had with *Sharpshooter*, saving time but limiting his breadth of interpretation, or he could develop the same scene in several ways, appealing to alternative types of viewers. Though slower, this approach allowed him to explore more sides of a single subject, perhaps to satisfy different sides of his own artistic character, and no doubt to continue to weigh the complicated economic variable—never far from Homer's mind—in his chosen line of work. In 1863 he had several promising oil paintings in the works which ruminated on the fighting man's ties to the home front (*Home, Sweet Home*) and on the hungry soldier's common desire for extra rations (*The Sutler's Tent*). He had used ideas from the latter (as well as his earlier sketch, *Soldier Dancing*) in creating *Thanksgiving in Camp* for *Harper's Weekly* (29 November 1862), and he combined these themes in *Pay-Day*, putting special emphasis on the sutler himself.

In the dominant scene, called "A Descent on the Sutler," money and

PAY-DAY

SENDING MONEY HOME

THE LETTER

A DESCENT ON THE SUTLER

PAY-DAY IN THE ARMY OF THE POTOMAC.—[Drawn by Mr. Homer.]

18. Winslow Homer. *Pay-Day in the Army of the Potomac* in *Harper's Weekly* (28 February 1863). Wood engraving. 13⁹/₁₆ × 20½ in. The Mavis P. and Mary Wilson Kelsey Collection of Winslow Homer Graphics, The Museum of Fine Arts, Houston.

provisions are in rapid circulation, all passing through the outstretched hand of the gentleman minding the store. He holds a powerful position, for the usual peacetime rules of free-market competition do not apply. Still one might sympathize with his spot, for he must satisfy many people with diverse tastes, all demanding prompt recognition. After all, there are limits to the material resources and staff of even the most well-stocked sutler. Moreover, the personal time and emotional reserves of even the most dedicated proprietor are not boundless. The viewer, though removed, is positioned on the same side of the wide plank counter as the beleaguered man, looking over his shoulder at the unruly scene in such a way as to see it somewhat from the sutler's own point of view.

And this is not just any sutler, as most careful readers of *Harper's* would have realized, and as no subsequent art historians seem to have noticed. Though he is too busy for us to get a good look at him, this angular civilian with whom soldiers of all ranks must deal in their individual ways, bears an uncanny resemblance to Abraham Lincoln.[89]

43

The store itself, with its all-male clientele, is reminiscent of a recruiting station or a polling place. So far, the man in charge seems honest enough, for his large palm is still empty, and he extends it openly and from his heart, as though he would just as soon shake his patrons' hands as take their money. Clearly, in the military-commercial-political arena below, as in the more intimate personal scenes above, strong emotions are circulating as well as cash.

Part of the picture's text and context undoubtedly involves McClellan. Photographs from Lincoln's visit to the Army of the Potomac on 3 October show a somber and dissatisfied president, recent beard and stove pipe hat much in evidence, confronting the popular but headstrong McClellan, who would become Lincoln's Democratic rival in the election of 1864. In various camp photographs, whether surrounded by other military men (Lincoln referred bitterly to the army as "McClellan's bodyguard") or sitting alone in a tent, the two confront each other silently in an obvious battle of wills. "I incline to think that the real purpose of his visit is to push me into a premature advance into Virginia," the determined "Little Mac" wrote to his wife. Lincoln, for his part, felt McClellan had a severe case of the "slows," and made clear that if the hesitant general failed to pursue Lee across the Potomac by the end of the month, he would be replaced. October disappeared without movement, and the president stuck to his word. "I said I would remove him if he let Lee's army get away from him, and I must do so."[90]

By 7 November McClellan's military career was over, but the clean-cut commander did not disappear from the political stage, and a reminder of his image may appear in the right foreground as the tight-fisted officer with a handsome moustache who glowers at Homer's sutler the way "Little Mac" had stared at Lincoln in the photos from Antietam. More important than Lincoln's relation to his general, however, may be the commander-in-chief's relation to his troops as a whole. When we recognize the gaunt figure in the tall hat as the man who once kept a store in Springfield, Illinois, then we can concentrate upon his complex interactions with the men in uniform. They are indebted to him in a variety of ways, but he now holds their lives in his hand. If some of his constituents seem pleased with their bargain for the time being, others at best remain skeptical and stoic. The oblong box at the bottom of the picture, empty for the moment, suggests a waiting coffin between the artist and viewers on one side and the soldiers and storekeeper on the other, like a death's-head in the foreground of a medieval painting.

Framed between the frowning officer and the beleaguered sutler is the Negro, occupying the same key place in the composition which

Nast gave over to a slave being unshackled by the arriving New Year. Somehow, the peripheral contraband figure has wormed his way from the edge of camp to a place at the counter, and he is protecting and consuming a large stock of biscuits. The portrayal is clearly stereotyped, as with *Our Jolly Cook* or the banjo player Homer later painted in *Inviting a Shot before Petersburg, Virginia*, but the image used to portray the black was in rapid transition, just as was the status of the people it represented. (If, for instance, one surveys the overt cartoons featuring Negroes—as distinct from general illustrations including black figures—appearing in *Harper's Weekly* during the war, an average of sixteen per year occur in 1861 and 1862, but they occur at a rate of only four per year—one quarter as many—in the next three years.)

While the portrayal may seem dubious and simplified, the placement of the image is important and its meaning is complex. Visually, the black man is joined to Lincoln by a circle of gestures that echoes the circular coins above. Across that circle, they are linked directly by the Negro's gaze, Lincoln's pointing hand, and the white counter with dark shadows. They seem to be connected by action as well. Lincoln has just given something to the Negro and holds something else in his left hand below the table. The glance of the black seems both grateful and greedy; he has obviously received quite a bit of a good thing and would not mind receiving more. Has he been given too much? How will it be paid for? Will more be provided to him at the expense of others now waiting? In other words, how do accounts now stand between him and those around him; has that mysterious IOU in the corner of *Bivouac Fire* been settled to the satisfaction of all?

As if to drive these questions home, a large grocer's scale, with its balance bar exactly level, completes the circle between the president and the black.[91] For here amid the dried fish and brandied fruit of extra rations is the most controversial and weighty problem of all—emancipation. Many felt that Lincoln, in bestowing freedom on the slaves, had literally given away the store. That included not only Jefferson Davis, who told the Confederate Congress in January that the Emancipation Proclamation was "the most execrable measure in the history of guilty man," but most Northern Democrats as well. McClellan had reacted to Lincoln's September edict as "infamous," and an influential colleague labeled it the "absurd proclamation of a political coward."[92] Black leaders and radical Republicans, on the other hand, were concerned not that the measure was premature and excessive, but that it was belated and incomplete. The outcome of the war and the entire nature of subsequent society seemed to hang in the balance: only the scales of

history would judge.

While the weighty issue of emancipation seemed abstract, many of its most important themes, as Nast had stressed, revolved around the payment of wages. The transition from servitude to wage labor was watched with pride, fascination, and more than a little light-hearted condescension by whites in the North. The previous year *Frank Leslie's Illustrated Newspaper* had published a picture from Port Royal, South Carolina, of *"Pay-Day" Among the Negro "Contrabands" Employed in Gathering Cotton on the Sea Islands.*[93] It emphasized the sheer novelty and wide-eyed excitement of the situation, as did a picture of black wage earners rendered by Homer's English-born colleague, Alfred Waud, entitled *Paying Off the Teamsters in the Army of the Potomac.* Waud's illustration appeared in *Harper's* the week after Homer's *Pay-Day.* Amid patronizing commentary, the artist explained:

> White teamsters have $25 a month. Colored men are paid $20, an increase of $10 a month on "Contrabands pay" previous to the proclamation of emancipation. To a negro slave the ideal of social existence is to have their labor paid for as the white men do; consequently "pay-day" has unusual charms for them. It is amusing to watch the effect of a handful of bills on the countenances of the colored ones as they receive their dues. . . . Some . . . hardly knew how to approach their funds, especially as they had been immensely overawed by the solemn ceremony of holding the end of the pen, while the clerk, Mr. Fury, wrote their names at the foot of the pay-roll.[94]

The quizzical ex-slave in Homer's *Pay-Day*, therefore, is justifiably uncertain about the system of currency and exchange in the new world of wage labor he has suddenly entered, just as he is doubtful, at a deeper level, about the possible meaning and long-range implications of emancipation itself. But for the immediate future he is also concerned about his standing within the military, as the composition of Homer's engraving suggests. Except for Lincoln, he is the only civilian in the "sutler" scene, and there is no hint that he may be issued a uniform and a rifle. But as liberation of the slaves became a central theme of the Union war effort, the active participation of armed Negroes in that military crusade became an issue of huge psychological and strategic importance, debated by blacks and whites, North and South.

Harper's quickly offered unmitigated support to the idea of Negro troops, especially given the use of blacks at the front by Confederate

forces. "It has long been known to military men," the Republican weekly announced in January, "that the insurgents affect no scruples about the employment of their slaves in any capacity in which they may be found useful." The accompanying front-page picture by Theodore Davis, of two blacks outfitted as soldiers and "fully armed," illustrated a Union officer's report of *Rebel Negro Pickets as Seen Through a Field-Glass* near Fredericksburg.[95] The previous spring, when the Northern army was before Yorktown, the same weekly had presented a more startling scene, also said to have been seen through an officer's glass. It depicted *A Rebel Captain Forcing Negroes to Load Cannon under the Fire of Berdan's Sharp-Shooters*, and it illustrated, according to the editors, "the way in which the cowardly rebels force their negro slaves to do dangerous work."[96]

Homer, who had been present at Yorktown, prepared a related picture, which appeared in *Harper's* a week after the *Rebel Negro Pickets*, in the issue carrying the text of the Emancipation Proclamation. *A Shell in the Rebel Trenches* (fig. 19), "drawn by Mr. Homer, is an event of not uncommon occurrence," observed the paper, in a rare comment on the artist's work. (Unlike other special artists, Homer did not submit text explaining his images but preferred to let them speak for themselves.) "The secesh chivalry generally place their negroes in the post of danger; and when our gunners get the range of their works and drop a well-aimed shell into them, the skedaddle which ensues is such as Mr. Homer has depicted."[97]

The deep ironies are self-evident. Black workers, under the eye of a Southern officer with his sword drawn, dig trenches to protect the regime by which they are enslaved. Having woven hundreds of hollow fascines from twigs and sticks, they now fill them with dirt and push them onto the growing earthworks. (Hoisting these gabions onto the parapets was a back-breaking task assigned to blacks by both armies, as shown in Homer's 1864 chromolithograph, *Life in Camp. Part 2: In the Trenches* [fig. 20].) Meanwhile, their would-be liberators fire shells from the other side of the river (two distant puffs of smoke at right), apparently content to destroy them in the process of saving them.

Caught in the thick of the conflict, many are blown backward by the sheer force of the explosion. A man who has been loading dirt into an empty gabion to strengthen the rampart waves his shovel like a flag to steady his comrades or silence the Yankee guns. Another figure remains upright and defiant, his gaze as sharp as the bayonets behind him, as if determined to take control of his own destiny, despite the odds. Whatever shells may be lobbed inside enemy lines, he seems to know that none will prove more explosive than the bombshell of emancipation

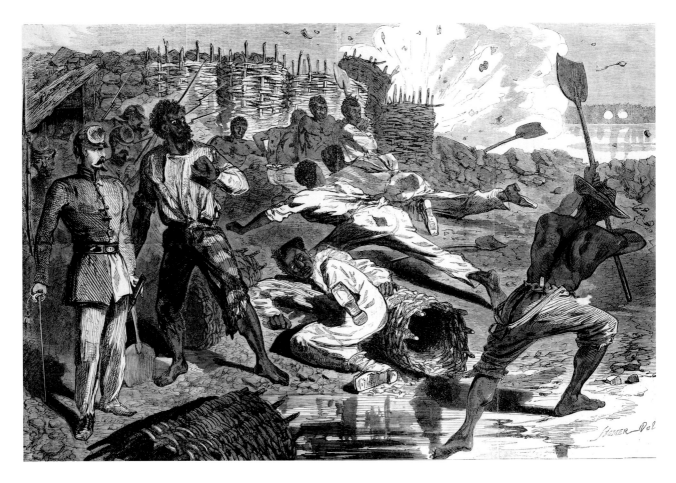

19. Winslow Homer. *A Shell in the Rebel Trenches* in *Harper's Weekly* (17 January 1863). Wood engraving. 9⅛ × 13¹³/₁₆ in. The Mavis P. and Mary Wilson Kelsey Collection of Winslow Homer Graphics, The Museum of Fine Arts, Houston.

which Lincoln has just dropped upon the Confederacy.[98]

Homer did not return to the front in 1863, perhaps in part because his main contact, General Francis Channing Barlow, was severely wounded at Gettysburg. But Barlow rejoined Hancock's Second Corps the following year, and Homer was soon back in Virginia, no doubt again under his friend's auspices, for some of the heaviest fighting of the war. In early May he witnessed part of the Battle of the Wilderness, and by mid-June he was present as the tired armies dug in to face each other at the siege of Petersburg.[99] For weeks the opposing forces gazed and sniped and swore at one another from ever deeper trenches in an ever dustier and more desolate landscape. Before Homer returned north he had sketched this stump-filled wasteland, and he would use these drawings to create the haunting oil, *Inviting a Shot before Petersburg, Virginia* (fig. 21). In terms of the fabled conflict between Blue and Gray, the painting provides a counterpoint to *Sharpshooter*, and a companion piece of sorts to *Prisoners from the Front* (1866).[100] But a black man sits near the center of this composition (fig. 22). He has generally been ignored, or dismissed as a mere banjo-strumming stereotype, and as a result much of the meaning

behind this powerful painting has been overlooked.

A lone Confederate, silhouetted against the cloud-swept sky, shouts with clenched fists at the distant Union lines, as comrades look on from the safety of the trench behind him. No wonder the picture was later given the added title of *Defiance*, and that his heroic and dangerous gesture has absorbed the attention of art historians as readily as it attracted the notice of Yankee marksmen. Two tiny puffs of smoke suggest that snipers' bullets are already on the way. These shots have recently prompted Marc Simpson to point out the striking connections between the 1864 work and one of Homer's last great oils, *Right and Left* (1909).[101] Less obvious, but also important, is the conceptual and compositional link to *A Shell in the Rebel Trenches*. There Homer had already explored the vantage point of the Southern lines under fire, employed the attention-getting device of distant smoke and incoming fire, and acknowledged the deep symbolic meaning of the black presence at the Confederate front.

The meaning of the Negro figure here, and of the entire picture as well, hinges on an association that was once readily apparent but that has become obscure with time. The key lies buried deep in Homer's brown Virginia earth, and it concerns the climactic event associated with Petersburg. On the morning of 30 July Union forces detonated an enormous explosive charge that had been placed far beneath a section of the Confederate defenses, blowing a huge hole in the rebel line so that waves of troops could pour through the breach. "This was the famous battle of the Crater," writes James McPherson. "In conception it bid fair to become the most brilliant stroke of the war; in execution it became a tragic fiasco."[102] A regiment of Pennsylvania coal miners had dug for weeks to plant the charge, and as early as mid-July Southern forces had become suspicious, sinking listening shafts of their own to detect the slightest sound of underground tunneling. Idle shouts and banjo music provided a respite from agonized stretches of attentive stillness.

Therefore, while personal gestures of defiance took place throughout the war, at Petersburg individual acts of risk above the long rampart, dramatic in themselves, provided a meaningful prelude to the far greater drama that would soon erupt. For a crucial battle had been waged silently, far below the surface, and a whole generation knew this.[103] One look at the picture's title would remind viewers that the soldier is standing on a powder keg—320 kegs, in fact—and the long stick on the left and the bayonets and banjo on the right all seem to point to the location far below his feet. When detonated, the four tons of powder would blast out a hole ten yards deep and over fifty yards long, instantly obliterating

IN THE TRENCHES.

20. Winslow Homer. *Life in Camp. Part 2: In the Trenches*, 1864. Chromolithograph. 4⅛ × 2½ in. Museum of Fine Arts, Boston.

21. Winslow Homer. *Inviting a Shot before Petersburg, Virginia,* 1864. Oil on canvas. 12 ×18 in. The Detroit Institute of Arts, Gift of Dexter M. Ferry, Jr.

more than a whole Southern regiment. In the iconography of the time, as we have seen, the only more explosive charge beneath the Confederacy was the institution of slavery itself, and Homer evoked that proposition by placing a slave with a banjo below the ground upon which the rebel has taken his stand. [104]

But this stereotyped Negro figure performs several additional symbolic functions. If, as we suggest, he is quite literally located in what will become the Crater, then for Northern viewers he evokes immediate thoughts of the black soldiers who fought and died there. Homer's friend Alfred Waud, who witnessed the battle, had sketched the U. S. Colored Troops that were sent into the fray late and took particularly heavy losses within the Crater itself. [105] Not only did they acquit themselves well, but in fact they had originally been chosen to lead the initial charge, being well seasoned, highly committed, and specially trained for the mission. But skepticism among the Union high command about public reactions to the move, and about the fighting capacities of black soldiers, caused an eleventh-hour change of plans. The switch proved disastrous, and the

entire foray became a costly debacle. Neither side gained an advantage, yet more than 6,000 men—North and South, black and white—lost their lives. Grant called it "the saddest affair I have witnessed in the war."[106] Ironically, much of the fault for the Union failure belonged to a Northern officer corps which still regarded blacks as banjo-playing minstrels and failed to utilize their proven strength as determined soldiers.[107]

As Northern public opinion accepted a combat role for blacks in uniform and the government edged toward a policy of equal pay, reporters and artists commented admiringly on the evolution of ragged contrabands into dedicated recruits and battle-scarred veterans. The weeklies ran pictures of Negro recruits in training and combat, and they published occasional profiles of ex-slaves turned soldiers.[108] After the war Thomas Waterman Wood developed this convention into a well-known triptych, *A Bit of War History: The Contraband, The Recruit, The Veteran* (1866), and Thomas Nast showed "Columbia" herself asking trust and the franchise for a crippled black veteran.[109] But Homer, never drawn to battle scenes or the obvious celebration of heroes, took a different approach to Negro involvement in the final phase of the war.

The artist appears to have returned to the front near Petersburg in late March 1865, during the last weeks before Appomattox,[110] and that same year he completed several engaging oils of blacks in camp. *Army Boots* (fig. 23) and *The Bright Side* (fig. 24) may be seen as representing their own progression of sorts,[111] and they clearly have much in common. Each focuses on a relaxed scene of everyday camp life and gives a reminder of the ongoing chores for which blacks now received regular pay.[112] In both pictures Homer employs the interplay of black heads against white tents that he first introduced in *A Bivouac Fire*, a useful device that acknowledged a simple reality of camp life, north and south.[113]

Whether these pictures are intentionally "humorous" is debatable,[114] but both contain a certain lightness of spirit, as well as atmosphere, reinforced through the multiple puns in their titles. The two boys in their sunlit tent, though playing cards at present, have been shining black army boots; the polish is open in the foreground. One is wearing a black army boot; it is juxtaposed purposefully with the other youth's bare foot. In fact, they themselves are black army boots in several senses, for a boot is a bootblack who shines shoes, and a boot is also a fresh military recruit or new arrival, as in "boot camp." *The Bright Side*, developed from several earlier studies, has obvious associations with bright sunshine and welcome repose after hard work for teamsters whose mules stand tethered nearby.[115] But as Hugh Honour has recently pointed out, "The

22. Winslow Homer. *Inviting a Shot before Petersburg, Virginia* (detail).

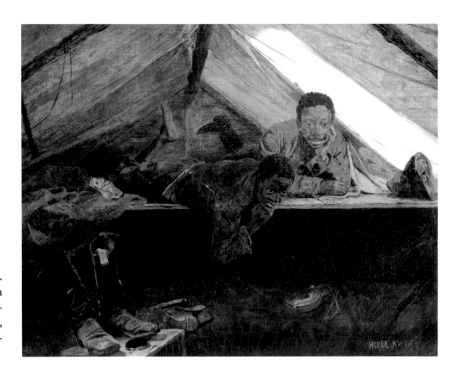

23. Winslow Homer. *Army Boots*, 1865. Oil on canvas. 14 × 18 in. Hirshhorn Museum and Sculpture Garden, Washington, D. C, Smithsonian Institution, Gift of the Joseph H. Hirshhorn Foundation, 1966.

title seems to refer not only to the sunny side of the tent and the spirit of comradeship that lightened the burden of military service but also, more seriously, to the one happy outcome of the war that was ending when Homer painted the picture."[116]

What makes the two scenes most distinctive is the fact that Homer has brought the black figures to the foreground. Gone is the furtive entry into a foreign world, represented by the inquisitive white woman at the edge of Eastman Johnson's 1859 painting, *Negro Life at the South*. Gone too is the sense of strangeness and confrontation that surrounded the anonymous contraband dancer in *A Bivouac Fire*. These self-confident persons are living humble but safe lives under federal protection—a decided step up from their previous existence, as suggested by the place of the "army boots" in a dry location one step up from the muddy ground. They seem "at home" in their government-issue tents, no longer isolated refugees, and when a white artist looks inside the flap or a pipe-smoking teamster pokes out his head, the encounter is amicable and unhurried, as between equals.[117] Homer seems to have entered their space without disrupting it, transmitting to the viewer several disarming gazes that imply questions for the future. Are these direct glances more dignified versions of the quizzical stare fixed upon Lincoln in *Pay-Day*? Now Lincoln is gone, and the look is focused upon us.

If any one image epitomizes Homer's Civil War evolution and his

increasing willingness to place substantial black figures at the center of his work, it is a little-known painting of a slave woman that was discovered in a New Jersey attic in the early 1960s, nearly a century after its completion. An antiques dealer called in to appraise the picture in 1962 entitled it *Captured Liberators*, for in the left background two Union soldiers in blue are being marched back from the front by armed Confederate soldiers whose flag is prominently displayed. In 1966, before donating the piece to the Newark Museum, the owners had it authenticated by Homer expert Lloyd Goodrich, who suggested a more generalized name, *At the Cabin Door*. But recently, scholars have discovered the painting's original title, *Near Andersonville* (fig. 27), enabling them to explore more fully the complexities of this seemingly simple composition.

As Marc Simpson has pointed out, the serious young woman, "with individualized rather than stereotyped features, . . . is among the earliest

24. Winslow Homer. *The Bright Side*, 1865. Oil on canvas. 13¼ × 17½ in. By permission of The Fine Arts Museums of San Francisco, Gift of Mr. and Mrs. John D. Rockefeller 3rd.

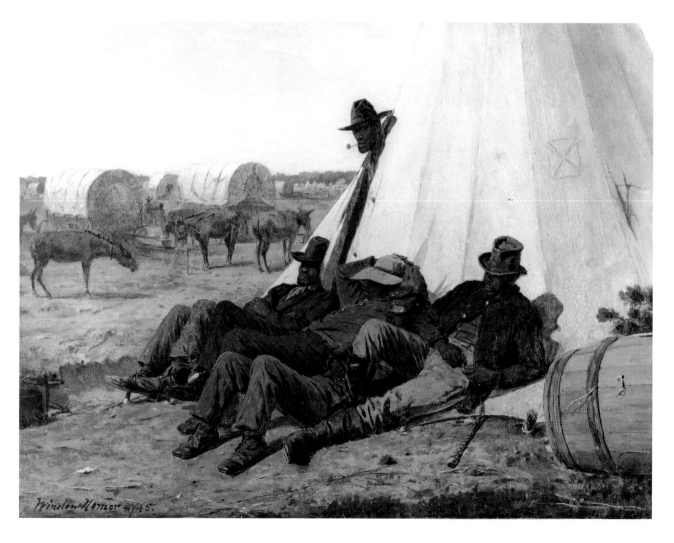

of Homer's quiet and stoic women, a subject that over the next several decades he would find equally among the blacks of Virginia and the fishing folk of the North Atlantic." Like the innumerable fisherwomen and sailors' wives of later years, she gazes out beyond the bounds of the picture toward a stormy masculine world which is at once sharply delimited from, and intimately bound up with, her own separate sphere. This strong, thoughtful figure represents an important departure in Homer's work. But she is not without antecedents, and, as with so many of his figures, she has much more than a tangential tie to images of the popular press.[118]

While thousands of slaves came to the Union army as contrabands during the course of the war, the army itself came to thousands of others. The reactions of countless women and children to the appearance of federal troops became a subject of recurrent attention—both light-hearted and serious—in Northern publications.[119] As early as June 1862, for example, *Harper's Weekly* juxtaposed a picture of advancing Union soldiers with a caricatured black mammy (fig. 25) who rushes to the rail fence and exclaims, "Oh! I'se so glad you is come."[120] According to the accompanying note on "Our Black Friends Down South," the picture "illustrates a scene which we are told is very common in the States through which our armies have penetrated. The negro woman, hearing the army's approach, runs out to meet it."[121] *Harper's* published an even more patronizing rendition in January 1865: a black woman in a bandanna looks out from a porch in wide-eyed disbelief toward Sherman's invading column and asks, "Is All Dem Yankees Dat's Passing?"[122]

But this derisive stereotype was more than offset by a contrasting positive female image that emerged in *Harper's* during the last year of the war. Black men were being portrayed as determined soldiers fighting for Negro freedom, and also as scouts and spies risking their lives to aid whites.[123] Similarly, black women began appearing as informed and sensitive Union sympathizers behind Confederate lines. Often they were linked to the white Unionists who appeared at federal camps in growing numbers as the war moved south.[124] In a November 1864 picture entitled *Union Refugees Coming into the Federal Lines*, a strong black woman with a kerchief surveys the scene, framed in a covered doorway (fig. 26).[125] She stands apart from the others, casting a determined eye at the viewer while watching over the poor whites who were once her overseers. The accompanying text seems to include her in the observation that many Southerners "have borne obloquy on account of their devotion to the old flag, and we should receive them as heroes who have served our

glorious cause. There are in the South many such, of whom we must remember that 'They also serve who only stand and wait.' "[126]

Later *Harper's* made clear that such patient heroines, like their male counterparts, were quite capable of making the ultimate sacrifice. In September 1865, readers learned the saga of Amy Spain, "One of the martyrs of the cause which gave freedom to her race." After Sherman's cavalry had passed through Darlington, South Carolina, early in the year, this black woman was hanged from a sycamore tree in front of the court house by local whites, at the same spot where slaves had traditionally been auctioned off. Her only crime, according to the story, had been to show her emotions by exclaiming, "Bless the Lord the Yankees have come!" Her "simple expression of satisfaction at the event sealed her doom."[127] Hence Homer's woman stands at a crucial fork, as symbolized by the diverging boards in front of her. On one hand, the Union army has never been closer—a fact which may explain her good dress, since slaves often put on their best go-to-meeting clothes when facing the prospect of liberation. On the other hand, a mistake now could worsen her situation or endanger her life.[128]

When Homer sold half a dozen of his Civil War paintings at an auction on 19 April 1866, *The Evening Post* commented that "his picture entitled 'Near Andersonville,' depicting a negro woman standing at the door of her cabin, gazing at Union prisoners as they pass, is full of significance." Much of this significance can be discerned without knowing the original title. Her position on the threshold, emerging from the shadows into the light through an open doorway, recalls the tiny figures in *Mount Vernon* and is of obvious importance, as are the dipper gourds which grow beside her home. If the passing flag epitomizes her enslavement, these gourds (widely grown and used by Africans and Afro-Americans alike) signify her hope of freedom.[129] "At virtually the beginning of his artistic career," writes Nicolai Cikovsky, Jr., "Homer possessed both the intention and the intelligence to create symbolic meaning." And in this painting, as with *Inviting a Shot*, the full meaning hinges upon understanding the wartime significance of the place name in the title.

Andersonville, after all, was the desolate stockade built in southwest Georgia in 1864, where 45,000 Union soldiers faced confinement and possible death through sickness, exposure, and malnourishment. A total of 13,000 captives lost their lives in this largest of all Civil War prisons, and Northerners did not take kindly to such quips as that of a bitter Georgia newspaper editor in August 1864: "During one of the intensely hot days of last week more than 300 sick and wounded Yankees died at

Oh! Ise so glad you is come. Massa says he wish you was in de bottom ob de sea—but you aint in de bottom ob de sea, you is he'yar & Oh! Ise so glad to see yer.

25. Unidentified artist. *"Oh! I'se so glad you is come . . ."* in *Harper's Weekly* (14 June 1862). Wood engraving. 5¹¹⁄₁₆ × 4⅝ in. Fondren Library, Rice University, Houston.

27. Winslow Homer. *Near Anderson-ville*, 1865 and 1866. Oil on canvas. 23 × 18 in. Collection of The Newark Museum, New Jersey. Gift of Mrs. Hannah Corbin Carter; Horace K. Corbin, Jr.; Robert S. Corbin; William D. Corbin; and Mrs. Clementine Corbin Day in memory of their parents, Hannah Stockton Corbin and Horace Kellogg Corbin 1966.

26. Unidentified artist. *Union Refugees Coming into the Federal Lines* (detail) in *Harper's Weekly* (5 November 1864). Wood engraving. 9⅛ × 13¹³⁄₁₆ in. Fondren Library, Rice University, Houston.

Andersonville. We thank Heaven for such blessings." General Sherman, stalled by Hood before Atlanta, sent a cavalry division south to break open the internment camp, but instead Southern forces intercepted the Andersonville raiders and led away six hundred to be imprisoned there. [130] Several of these men may be the bluecoats in Homer's imagined scene. If so, Sherman's soldiers are moving south to face possible death past a black woman who will soon be free, much as the ranks of McClellan's army appear dimly in the left background of Eastman Johnson's *Ride to Liberty*, marching into the sacrifice of battle on behalf of the blacks in the foreground. [131]

During the months after Appomattox, when Homer apparently began work on this picture, conditions at Andersonville became common knowledge through the postwar military trial of Henry Wirz, the camp's commander. Following a controversial decision, Wirz was executed for war crimes. But most people realized all too well that he was a scapegoat, and that the underlying reason for the protracted suffering at Andersonville had been the inability of the warring governments to agree upon the exchange of prisoners. That impasse, in turn, had causes of its own, including a Northern reluctance to refurbish the dwindling Southern army, and Confederate violations of parole agreements. But the largest impediment involved the central matter of slavery, for the South refused to regard freedmen in uniform as prisoners of war, defending its "right to send slaves back to slavery as property recaptured." Despite public pressure, Lincoln's government refused to yield on this point, fortified by grim Confederate directives stating that black prisoners were an inconvenience and "summary execution must therefore be inflicted on those taken." [132]

At one level, therefore, *Near Andersonville* is a cogent comment on the prison of slavery and the enslavement of Union prisoners. [133] As such, the picture bears comparison to *The Initials* (a white woman contemplating the tree-trunk inscription carved by her lover before he left for battle), *Trooper Meditating beside a Grave*, and *The Veteran in a New Field*, other Homer paintings from the close of the war that concentrate broad and deep dimensions of the gigantic conflict into the thoughts and movements of a solitary figure. At another level, the picture may even represent the artist's private brief on the Thirteenth Amendment to the Constitution, abolishing slavery forever, which Congress approved before Appomattox and the states ratified by December 1865. It would take three more years before the Fourteenth Amendment became law, assuring citizenship irrespective of race, but within his own artistic world Winslow Homer had already acknowledged blacks as full citizens.

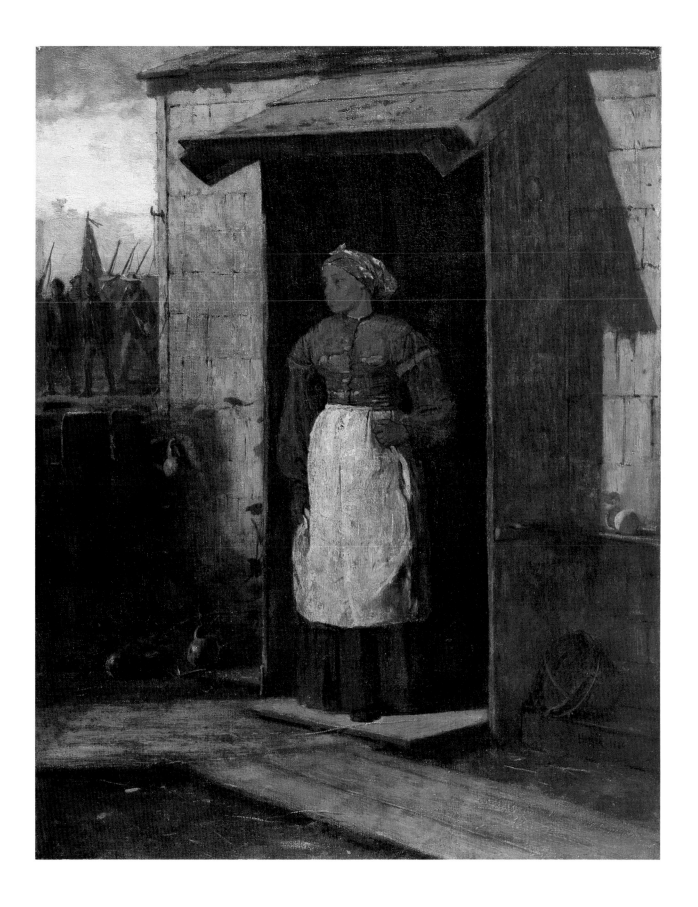

RING OUT A SLOWLY DYING CAUSE,
AND ANCIENT FORMS OF PARTY STRIFE;
RING IN THE NOBLER MODES OF LIFE,
WITH SWEETER MANNERS, PURER LAWS.

WHEEL OF TIME

1864
1865
1866
1867
1868

GRANT & COLFAX

ABCDEFGHIJKLMN

HOMER DEL

RING OUT FALSE PRIDE IN PLACE AND BLOOD,
THE CIVIC SLANDER AND THE SPITE;
RING IN THE LOVE OF TRUTH AND RIGHT,
RING IN THE COMMON LOVE OF GOOD.

For Afro-Americans the Emancipation Proclamation and subsequently the passage of the Thirteenth Amendment marked the beginning of a new era, a threshold opening onto full citizenship. Triumphant joy and hope for the future accompanied this moment as blacks set about defining their new freedom. Unwilling to settle for a partial emancipation in which, apart from an interdiction on the sale of human flesh, the status quo would remain unchanged, freedmen sought the right to control their own lives. Essential were the rights to be paid for their labor and to determine for whom and under what conditions they would work; to obtain an education; to worship as they pleased; to own property; and to participate fully in the government both as voters and office holders. Most freedmen understood, and Frederick Douglass declared in May 1865, that "slavery is not abolished until the black man has the ballot."[134]

Southern planters, however, saw the quest for suffrage as cause for alarm, and they tried desperately to deny ex-slaves the franchise. But white fears were not limited to the prospect of black participation in the public world of politics. Black literacy was also perceived as a threat to the economic and social control of the gentry. So much so that laws had long proscribed any formal schooling for blacks, thus forcing Afro-Americans to obtain what education they could through surreptitious means.[135] The very notion of an educated black had always challenged the myth of white cultural and intellectual superiority.[136] So when blacks appeared ready and able to acquire literacy in vast numbers after the war, it represented a social upheaval fully as great as that suggested by black access to wages and property. Immediately, the swelling demand for black education was met by white efforts to retain a monopoly over schools, books, and newspapers. According to *Harper's Weekly* in 1867, the traditional Southern leadership realized all too well "that knowledge is power, and it trembled."[137]

Even before the Emancipation Proclamation, black Southerners were clamoring for formal education. At Fortress Monroe black schools were established by contrabands, with the assistance of the American Missionary Association, before the end of 1861.[138] Later, black men serving in the Union army, first as noncombatants and then as soldiers, learned to read and write from chaplains and off-duty enlisted men.[139] Responding to the needs of the ever growing numbers of former slaves who freed themselves by entering Union lines, freedmen's relief associations in the North sent, along with material aid, missionaries and teachers to establish schools. The goals of these educators (known as "Gideon's band") were both lofty and patronizing. As a Boston lawyer put it in a speech to teachers en route to the Sea Islands, "You go to

◄ **28.** Winslow Homer. *1860–1870* in *Harper's Weekly* (8 January 1870). Wood engraving. 13⁷/₁₆ × 20½ in. The Mavis P. and Mary Wilson Kelsey Collection of Winslow Homer Graphics, The Museum of Fine Arts, Houston.

elevate, to purify, and fit them for the duties of American citizens."[140]

While benevolent societies, religious groups, and government agencies proffered education as the appropriate tool in preparing ex-slaves for citizenship, the former bondsmen hardly proved passive recipients, for they recognized literacy as one of the principal means of improving their lot. Despite their poverty and dislocation black people throughout the South took the initiative to insure their own education, both contributing to the Northern-supported schools and establishing their own institutions. By late 1865 the Freedmen's Bureau reported the quantitative effect of such efforts: 90,850 former slaves were attending schools under its auspices, with 1,314 teachers using 740 buildings. But sheer numbers did not capture the intense motivation shown by students of all ages. J. W. Alvord, Inspector of Schools and Finances of the Freedmen's Bureau, in a report dated 1 January 1866, found four reasons to explain the obvious Negro enthusiasm for learning:

1. They have the natural thirst for knowledge common to all men.
2. They have seen power and influence among white people always coupled with *learning*—it is the sign of elevation to which they now aspire.
3. Its mysteries, hitherto hidden from them in written literature, excite them to the special study of books.
4. Their freedom has given wonderful stimulus to all *efforts*, indicating a vitality which augurs well for their whole future condition and character.[141]

In opposition to the pursuit of black suffrage and education were Southern rebels, Northern Democrats, and some Southern Unionists who, along with President Andrew Johnson, favored "a white man's government." They felt that no inferences about civil equality or suffrage should be drawn from emancipation. (One of the precepts of Presidential Reconstruction was that only the states could grant the right to vote.) In the opinion of one of Johnson's gubernatorial appointees, blacks should simply "return to the plantation, labor diligently, and 'call your old Master—Master'." Even the Freedmen's Bureau, established by Congress in March 1865 to assure the transition from slave to free labor, worked under the assumption that "the interests of the South, the nation, and the freedmen themselves would be best served by blacks' return to plantation labor."[142] Moves were even taken to reinstate conditions resembling slavery during the winter of 1865–66 when provisional Southern legislatures, set up under Johnson's plan, adopted laws known

as the Black Codes designed to invest the state with the powers of former slave owners, in controlling the labor and personal freedom of blacks. Reacting to these developments, in December 1865 Republicans in the Congress blocked the seating of the senators and representatives from the South and set about devising their own plan of Reconstruction.

This plan came in the form of the Fourteenth Amendment to the Constitution declaring Negroes citizens and making the Confederate debt invalid, with compromise provisions that prevented high-ranking Confederates from holding office, protected freedmen, and attempted to persuade the Southern states to enfranchise blacks voluntarily. Faced with the time required for the ratification process and Johnson's public opposition to the plan, Congress passed two stopgap bills intended to protect freedmen, one extending the life and broadening the functions of the Freedmen's Bureau, the other guaranteeing minimal civil rights to all citizens. The president vetoed both, but the Civil Rights Act was passed over his dissent. When all the Southern states except Tennessee refused to ratify the Fourteenth Amendment, Congress reconvened in December 1866 to draw up a second blueprint for Reconstruction. Convinced by the May and September race riots in Memphis and New Orleans of white Southern hostility toward freedmen, the Republican majority passed the Military Reconstruction Act of 2 March 1867. The act divided the ten Confederate states that had not ratified the Fourteenth Amendment into five military districts. Under this plan each state was required to hold a new constitutional convention, draft a constitution that included Negro suffrage, and ratify the Fourteenth Amendment, after which the state could apply for readmission to the Union. Thus, under army supervision, freedmen participated in the drafting of new state constitutions between November 1867 and May 1868. Many of these documents promised equality of all citizens before the law and provided for state-supported public education. All but four former Confederate states returned to the Union by June 1868; the others were readmitted in 1870 and 1871.

The participation of Afro-Americans in the body politic during the postwar years so galled many white Southerners that they redoubled their efforts to regain the upper hand. Attacks upon freedmen by racist vigilante groups like the Ku Klux Klan grew in frequency as Southern Democrats set about restoring "home rule." This reactionary backlash in the South coincided with changing national concerns. Freedmen no longer commanded the limelight, as reformers' attentions shifted to honest government and civil service reform. Predictably, as black Southerners were pushed from the center of the political stage, their presence declined in the popular press. W. L. Sheppard and Sol Eytinge,

Jr., published an occasional caricature, and Thomas Nast continued to lash out against racial violence. But with these exceptions, black images virtually disappear from the pages of *Harper's Weekly* and *Frank Leslie's Illustrated Newspaper*.

The Republican abandonment of freedmen was completed by the compromise negotiated to settle the disputed Hayes-Tilden election of 1876. Intent on keeping Democratic nominee Samuel J. Tilden out of the White House, Republicans agreed to withdraw all federal troops from the South and to allow the two remaining Republican administrations to be replaced in Louisiana and South Carolina, this in exchange for the electoral votes necessary to elect Rutherford B. Hayes. That deal officially ended Reconstruction, for it left the white South free to instate the measures necessary to keep blacks deprived, both economically and politically. It also closed the door that had been flung open so dramatically on an era of hope when Lincoln proclaimed emancipation.

In November 1866, just before Congress began work on its second Reconstruction plan, Winslow Homer was preparing for a long desired trip to France. Knowing that *The Bright Side* and *Prisoners from the Front* would be shown in the Universal Exposition in Paris the following April, he and his colleague Eugene Benson held a joint sale of their works in New York, probably to raise money for the journey. Once in

29. "John." *The Great Labor Question from a Southern Point of View* in *Harper's Weekly* (29 July 1865). Wood engraving. 9¹/₁₆ × 9¹/₁₆ in. Fondren Library, Rice University, Houston.

France Homer shared a studio in Montmartre with another American painter, Albert Kelsey, and traveled outside of Paris to Picardy and the area around Cernay-la-Ville where he painted several haymaking scenes, some with solitary young women working in the fields.[143] Of the four wood engravings derived from Homer's trip abroad, one included a black gentleman in a top hat at the edge of a crowd watching a couple in a Parisian dance hall.[144]

No other blacks figure in Homer's work until early 1870 when *Harper's* published his reflections on the past decade, *1860–1870* (fig. 28). A circular montage organized around the "Wheel of Time," Homer's recapitulation passes from an image of "party strife" reminiscent of the *Arguments of the Chivalry* through the firing on Fort Sumter and early conflicts in the Civil War to the event situated at the top of the circuit as the high point of the decade, Lincoln's Emancipation Proclamation in 1863. On the right a subsequent battle scene and the final laying down of arms leads to veterans harvesting a new field, alongside Father Time. *Harper's* described their work as "the progress of material and civil reconstruction, the rebuilding of the Southern cities, the construction of work-shops and factories, the education of the freedmen and the multiplication of common schools, and the general obliteration of the

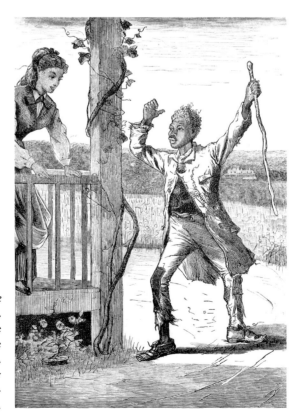

30. Winslow Homer. *"Hi! H-o-o-o! He Done Come. Jumboloro Tell You Fust"*. Illustration for J. W. De Forest, "The Duchesne Estate," *The Galaxy* (June 1869). Wood engraving. 6⅞ × 4⅞ in. The Mavis P. and Mary Wilson Kelsey Collection of Winslow Homer Graphics, The Museum of Fine Arts, Houston.

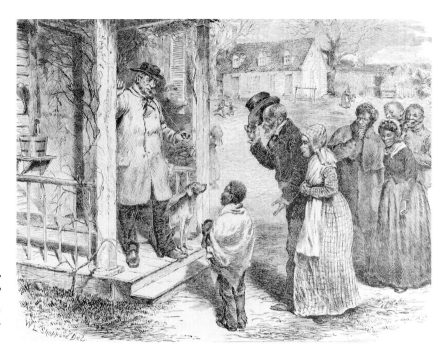

31. William Ludwell Sheppard. *"Merry Christmas and Christmas Gift, Ole Massa"* in *Every Saturday* (31 December 1870). Wood engraving. 8¹³/₁₆ × 11¹³/₁₆ in. Fondren Library, Rice University, Houston.

traces of the civil war all over the land." [145] The most current image, in the lower right-hand corner, introduces the positive theme of integrated education. In showing a school teacher, he repeats the seated woman reading a book whom he had drawn that same month as a frontispiece for *Galaxy*. Behind her sit three children, two white, one black, learning their ABCs from a chart on which the artist's name is signed. In the background the names of President Ulysses S. Grant and Vice President Schuyler Colfax are written on a blackboard, referring to Republican support for public schools, one of the issues most staunchly opposed by Southern Democrats. Bridging the space between the classroom and year's end, the pointed lines from Alfred, Lord Tennyson's poem, *In Memoriam*, call for reconciliation on all levels:

> Ring out false pride in place and blood,
> The Civic Slander and the spite;
> Ring in the love of truth and right,
> Ring in the common love of good.

This forward-looking attitude contrasts with the subject and tone of a wood engraving by Homer created six months earlier to illustrate John W. DeForest's short story, "The Duchesne Estate," a romance set on an antebellum plantation in Louisiana. [146] One of its principal characters is Jumboloro, an aged slave who in the opening scene rushes to inform his

young mistress of the arrival of her lover. The old servant is introduced by DeForest as

> one of the antiques and curiosities of the African race, a negro who had not yet ceased to be fractionally monkey, a little less than primitive man, a tamed monster. Hat off, tufts of white wool jigging about his black scalp, legs and arms of different lengths flying in all directions, a huge cane or stick joining erratically in the movement, a whirlwind of tattered clothing circling and shaking around him, his appearance and locomotion were alike amazing. He was lame. . . . His cane was incessantly busy; he seemed to walk on it and to fly with it; it was a crutch, and it was a wing; moreover it made gestures.[147]

Homer's illustration (fig. 30) seizes the moment Jumboloro arrives at the big house and blurts out his news to Miss Ninette who stands on the piazza. Faithful to DeForest's description, the resulting figure is caricatural, despite a sensitivity in the rendering of the facial expression that belies the exaggerated gestures and clothing. The composition of the engraving is similar to that used in some contemporary illustrations of postemancipation meetings of freedmen and their former masters. In *The Great Labor Question from a Southern Point of View* (fig. 29), published in the 29 July 1865 issue of *Harper's*, a black field laborer stands on the ground in front of the plantation house while the planter rocks back in a chair on the veranda. A row of columns and an extensive vine separate the men and their spheres: house is set off from field, owner from worker, white from black. A similar division occurs in William Ludwell Sheppard's *"Merry Christmas and Christmas Gift, Ole Massa"* (fig. 31), a wood engraving that appeared in *Every Saturday* on 31 December 1870. Here former slaves approach the main house and bow deferentially to the old planter who stands on his porch to receive their holiday greetings. In these images the relationship between a white person on a slightly elevated porch looking down on an approaching black is a metaphor expressing the difference of status between the two races and classes. Homer's *Jumboloro* marks that division most emphatically with the vertical porch post that separates the collected plantation mistress from the agitated old African. Later in his career, after his trips to Reconstruction Virginia, Homer will reverse this convention by having the old mistress go to her former slaves' dwelling and stand on the same level with them (see fig. 50).

Exactly when and how many times Winslow Homer returned to

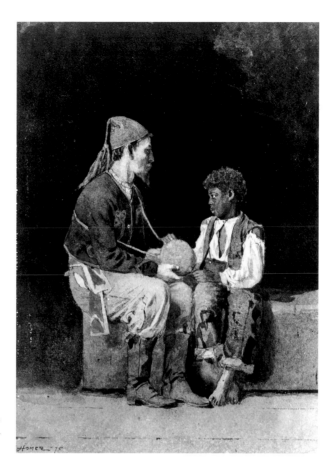

32. Winslow Homer. *Contraband*, 1875. Watercolor on paper. 7 × 5⅞ in. Cana-joharie Library and Art Gallery.

the area around Petersburg, Virginia, are questions that remain open to debate. Downes speaks of one journey in 1876, while Goodrich speaks of visits in 1875 and "the next year or so."[148] Hendricks suggests that the artist may have traveled back to the South in 1873 and offers evidence that he spent the Centennial Fourth of July in Virginia.[149] What we do know is that, after a brief hiatus during which Afro-Americans do not appear in his works, Homer creates between 1875 and 1879 one drawing and a number of important watercolors and oils that examine blacks' concerns and struggles at the end of Reconstruction. Several of these works demonstrate Homer's ability to choose a scene or isolate a moment that can provide the distillation of an era. With his typical economy of means, complex social issues and the broad human drama can be expressed by a solitary figure or by the encounter of a few individuals.

Such is the case with *Contraband* (fig. 32), an 1875 watercolor that was exhibited, along with fourteen others, at the American Society of Painters in Water Color in February 1876.[150] Seated side by side are a thin-faced Union Zouave and an appealing black youth who recurs in a number of Homer's works from this period.[151] This otherwise static

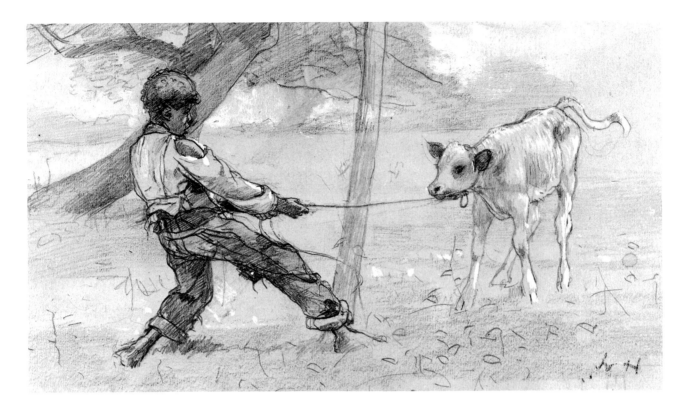

33. Winslow Homer. *Study for "The Unruly Calf"*, ca. 1875. Pencil with chinese white on paper. 4¾ × 8½ in. The Brooklyn Museum.

composition is relieved by an exchange of glances as the veteran offers the youngster a drink from his canteen. A simple meeting between a Northern white adult and a Southern black child recapitulates the relationship between Union soldiers and contrabands during the Civil War and recalls the attitude of liberals in the North toward the freed slaves, who were viewed as immature children. Enlightened Northerners felt it was their responsibility to provide guidance and protection to the newly emancipated, especially during the period of transition following the war, and they worried openly about blacks' abilities to function as full citizens.[152]

This paternalist attitude is communicated on a number of levels: the former soldier is clad in the exotic uniform peculiar to Zouave troops and shod in sturdy boots while the young black's clothing is ragged and his feet are bare. While for nineteenth-century sensibilities both costumes would have been considered "picturesque," the hierarchy would have been equally obvious. Also, it is the reticent youth who accepts the canteen proffered by the confident and composed adult. During a war a sip from a comrade's canteen could mean the difference between life and death—the ultimate act of friendship when water was in short supply— and now soldier and contraband will drink from the same canteen.[153] (To judge how acutely Homer's watercolor reflects the nation's perceptions

34. Winslow Homer. *Haystacks and Children*, 1874. Oil on canvas. 15½ × 22½ in. Courtesy of the Cooper-Hewitt Museum, Smithsonian Institution / Art Resource, New York.

35. Winslow Homer. *The Unruly Calf*, 1875. Oil on canvas. 24¼ × 38½ in. Collection of Mrs. Norman Woolworth. Photo courtesy of Coe Kerr Gallery.

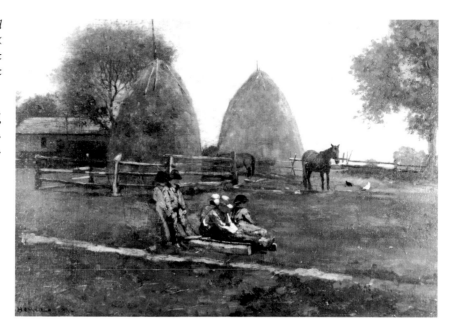

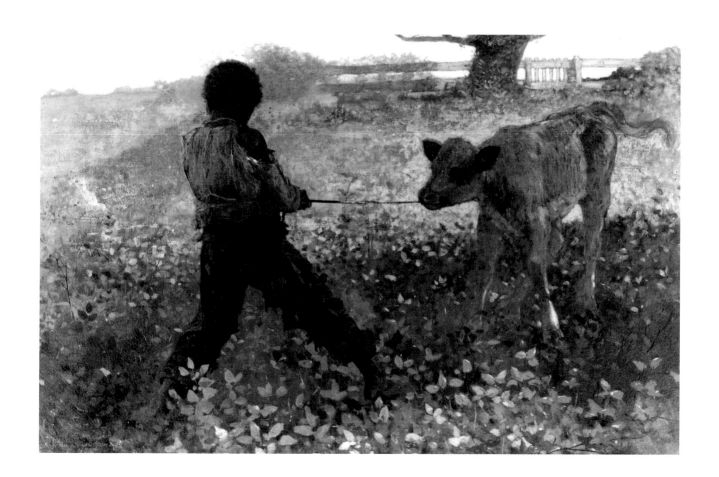

and concerns, one needs only to note the absence from American art of any images, for example, of a Southern white child receiving aid from the black soldiers who entered Charleston and Richmond in victory.)

The theme of maturation in the postemancipation period is further explored in an oil painting, *Weaning the Calf*, and a surrounding complex of pictures that reveal the artist's working methods. In 1874 Homer painted *Haystacks and Children* (fig. 34), a rural scene of two boys pulling other children on a sledge in the foreground, with farm animals, a rail pen, and two monumental mounds of hay in the background. Next year he made a study in pencil and chinese white (fig. 33) of a black adolescent (the same model who appeared in *Contraband*) struggling to subdue a stubborn calf. His feet braced wide apart and his hands gripping a rope attached to the resistant animal, the youth leans backward trying to secure the creature by wrapping the cord around a small tree that divides the sketch in half and visually separates the two figures. From this drawing came a work first exhibited at the National Academy of Design in 1876 as *Cattle Piece*, but now known as *The Unruly Calf* (fig. 35).[154] The boy and the calf are once again balanced against each other, joined by the umbilical rope. In addition to other modifications, they now struggle in the shade, the tree trunk in the center has been removed, and a fence with a closed gate has been added in the distance. The leverage the young black could have hoped to gain from working around the upright has now disappeared: he is on his own, feet firmly planted.

Out of these works evolves *Weaning the Calf* (fig. 36), a rural vignette with clear links to the wider world of Reconstruction America. Building on the composition of *Haystacks and Children*, the painter replaces the drawn sledge with the contending pair which he has moved from an enclosed meadow to an open pasture. The massive haystacks and rail pen of *Haystacks* are situated left of center in the middle distance of *Weaning* while, at the far right, a farmer contends with the calf's irate mother who casts an anxious eye toward her young. No longer does this struggle go unobserved, for two white boys now stand at a slight remove and contemplate the contest, making no move to help, or hinder, the young black.

The independence of the black in his effort is emphasized by Homer's treatment of the figure and by its relation both to the other children and to the haystacks. The artist achieved the youth's exceptional definition and three-dimensionality by first painting the figure's outline with a very fine brush and then bringing the ground up to the form, leaving a hairline crevice between the two areas. Secondly, he established an arc that falls down the right side of the left haystack through

36. Winslow Homer. *Weaning the Calf*, 1875. Oil on canvas. 24 × 38 in. North Carolina Museum of Art, Raleigh.

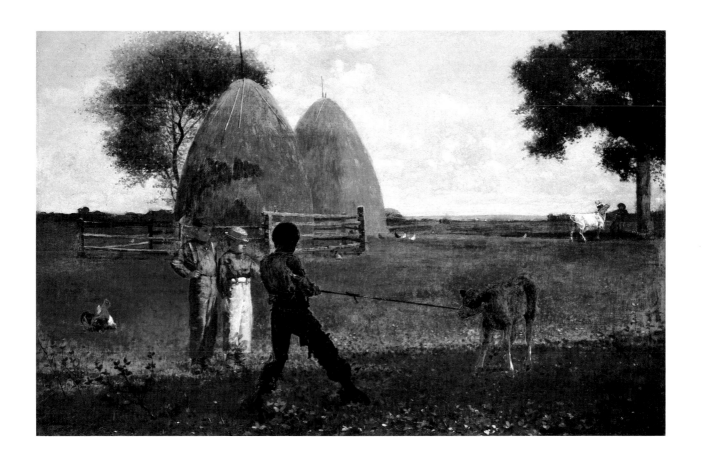

the fence rails, the grass, and the boy's forearm to terminate in the piece of torn cloth hanging from his thigh. This precipitous line creates a sense of nervous motion in sharp contrast to the rather stiff posture of the observers at left. To highlight further the drama of the struggle, the artist modified the original composition by increasing the scale of the onlookers, thus drawing them closer to the tug-of-war in the foreground.[155] The isolation of the young black, coupled with the tensions and contrasts that abound in the painting (taut rope; idle, white spectators vs. active, working black; sunlight vs. shadow) force the inevitable question: Can he make it on his own? From a Northern, liberal perspective, black Americans were also being weaned, severing the umbilical cord that linked them to the plantation past of forced dependency and perpetual childhood.[156] It would seem that from Homer's viewpoint blacks were not simply being weaned, they were participating in the liberating process of growing up.

The profound changes wrought upon American society by four years of civil war and by the industrialization and urbanization that followed in its wake fostered a nostalgia for the simplicity of antebellum rural life.[157] One expression of this idealization of bygone days was the popular image of the rustic barefoot boy, the incarnation of lost innocence, youth, and contentment. Carefree and in harmony with nature, the country boy, though not idle, passes his time running, playing, fishing, hunting; work is the domain of adults.[158] Several works by Homer from 1875, including *Weaning the Calf* and the watercolors *The Busy Bee*, *Blossom Time in Virginia*, and *Two Boys in a Cart*, provide variations on the theme. This is not surprising since he was closely associated with other artists who worked in this genre, such as Eastman Johnson, and with the youth periodical *Our Young Folks*.[159] However, such works must also be viewed in light of the current and intense debate over the Negro's ability to provide for himself in the aftermath of emancipation. Overlooking the generations of Afro-Americans who supported the Southern economy by their labor, the argument maintained that in slavery blacks had lived as children under the protective roof of their benevolent, often indulgent, white masters. According to this line of reasoning, freedmen were unprepared for, perhaps incapable of, assuming responsibility for their lives outside the fold of slavery. Homer's pictures put the lie to this attitude when time and again they depict young blacks, unlike their white contemporaries, hard at work.

The national nostalgia for rustic youth and the tendency to view new black citizens as children come together in *The Busy Bee* (fig. 37). Cropped at the knees and drawn close to the picture plane of this

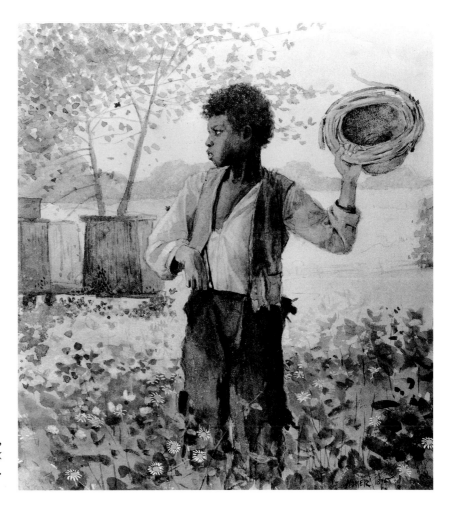

37. Winslow Homer. *The Busy Bee,* 1875. Watercolor on paper. 9¾ × 8⅞ in. Private Collection, New York. Photo courtesy of Berry-Hill Galleries.

watercolor, the now familiar model stands in a field of wild flowers. His attention is drawn to the left by one pesky bee, which he prepares to swat with a straw hat, while a second lands on his sleeve. The substantial hives in the background explain the presence of the aggressive insects and remind the viewer that bees are the traditional symbol of industry. Thus the association of youthfulness, blackness, and busy-ness, coupled with the punning title, raise the widely discussed question of whether liberated slaves, safe from the overseer's whip, will fall into indolence.

Any ambivalence about blacks' industriousness that may exist in *The Busy Bee* is absent from *Blossom Time in Virginia* (fig. 38) and *Two Boys in a Cart* (fig. 39). In the former—perhaps a sequel to *Weaning the Calf*—a boy and a young ox plow a field in preparation for planting. A fruit tree in glorious bloom announces the return of spring as the confident young farmer strides down the furrows. Ten years earlier Homer had painted *The Veteran in a New Field,* a powerful symbol of rebirth in which another solitary figure harvests the first postbellum crop, reminding all that

Union and Confederate swords alike have been beaten into plowshares, that daily life has passed from the battlefield to the wheat field.[160] Like the former soldier, the black youth in *Blossom Time in Virginia* is in a new field and a new era, and this springtime scene embodies the hope born in Afro-Americans after the passage of the Thirteenth Amendment. Unlike the white farmboy in the drawing *Boy Seated on a Plow* and in the watercolor *Harrowing*, he is hard at work and quite independent.[161]

In the myth of the barefoot boy as expressed visually and verbally during the 1870s, the barn is a world apart, a private place where children can romp and play.[162] Not so for the *Two Boys in a Cart* who have just completed the labor of pitching loose hay from the wagon into the barn. His task completed, one youth lies back on the haywagon while the second, pitchfork suspended just behind him, stands gazing into the distance. Presumably he is looking past the barn's open door, perhaps at an arriving wagonload of hay, or perhaps he is daydreaming momentarily. First present on the moving face of the young woman in *Near Andersonville* and hinted at in *Contraband* and *The Busy Bee*, this significant, distant gaze recurs in several of Homer's depictions of blacks from this period, always requiring the viewer to ponder what has claimed their thoughts.

A questioning look plays an important role in a painting Homer

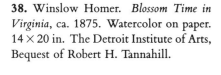

38. Winslow Homer. *Blossom Time in Virginia*, ca. 1875. Watercolor on paper. 14 × 20 in. The Detroit Institute of Arts, Bequest of Robert H. Tannahill.

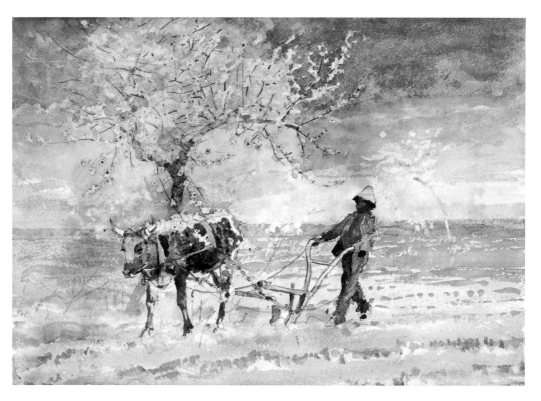

39. Winslow Homer. *Two Boys in a Cart*, ca. 1875. Watercolor and graphite on paper. 8¾ × 6¼ in. Philadelphia Museum of Art.

exhibited in 1875, *Uncle Ned at Home* (fig. 41).[163] When shown at the National Academy of Design, this painting's title and its central figure must have brought to mind Stephen Foster's popular song "Old Uncle Ned." Copyrighted in 1848, four years before the white composer traveled into the South, the lyrics to this melody drew the image of "an old darky" with "no wool on de top ob of his head" who lived and died faithful to Massa and Missus. As the dialect verses proceed, the miseries of Uncle Ned's life as a slave dissolve in the mellow refrain:

> Den lay down de shubble and de hoe,
> Hang up de fiddle and de bow;
> No more hard work for poor Old Ned—
> He's gone whar de good darkies go.

The final reward to the old man with "fingers like de cane in de brake" is release and the grieving of his former masters.[164]

Firmly engrained in the popular consciousness by minstrel performances of Foster's time, this grandfather figure was represented by at least two of Homer's contemporaries, John Rogers and Thomas Water-

man Wood. Rogers had a particularly acute sense of what would appeal to a broad American public, for early in his career he had opted for marketing his genre groups in plaster and bronze by mail order catalogue.[165] Judging the national mood was crucial to Rogers's business, as the rejection of his second commercial venture, *The Slave Auction* of 1859, proved. The defiant black man in his prime standing on the auction block, the distressed mulatto wife and children he may never see again, and the evil auctioneer formed a statuette that could not fail to please northern abolitionists . . . and to offend Southern slave holders and their sympathizers. The sculptor quickly learned that the forthright expression of such a political stance was unwise business practice, for, as he noted: "By taking a subject on which there is a divided opinion I lose half my customers."[166] Rogers ran no such risk with *Uncle Ned's School* of 1866 (fig. 40),[167] which was a perfectly calculated balance of humor and seriousness, youth and age, ignorance and knowledge, past and future. Responding to the postwar concern over the employment and education of former slaves, he captures a balding Uncle Ned with shoe brush in one hand and a boot slipped over the other, as he pauses from his job as a bootblack to work at reading the book an adolescent girl, probably his granddaughter, holds out to him.[168] The unquestionable seriousness of the old man's effort is undercut both by his "picturesque" rags and bare feet and by the young boy's attempt to distract him by tickling his dangling foot.

His bare pate notwithstanding, the Uncle Ned of Rogers's group seems vigorous and hopeful as he tries to adapt to the societal changes brought on by emancipation. This forward-looking attitude is not evident in Thomas Waterman Wood's small canvas *Admiring the Kitty* (1870).[169] A nostalgic mood hangs over this moment when a white girl and boy visit a kindly old black man in a barn. A kitten nestled in the palm of his hand, the consenting mother cat at his side, and the expectant children are confirmation of his gentle, unthreatening nature. Corresponding exactly to the "Old Darky" type of minstrelsy, Wood's frail Uncle Ned is more in touch with matters of the heart and nature than those of politics and the intellect.[170]

In *Uncle Ned at Home* Homer combines many of the elements used by Rogers and Wood—an aged black man, a black youth, visiting white children, cuddly kittens, a barnyard setting—to create one of several works that speculate on the outcome of emancipation and Reconstruction. A critic who saw the painting at the National Academy described it as "a dove-cote scene with an old negro and a group of children looking at the fluttering birds, a quaint conceit by Winslow

Homer."[171] The "home" of the title is a barnyard dominated by a dilapidated plank structure that appears to be part dovecote, part pigsty.[172] Stretching almost from one edge of the canvas to the other, this complicated construction is topped with geometric wooden boxes pierced with rectangular openings and fitted with perches for the nesting birds. Its roofline rises gently from either end toward the center, while the boxes are balanced in pairs on each side of an opening just above this midpoint. All these elements appear to exist in a precarious balance that could be destroyed by the slightest shift of weight in any direction.

This ungainly shed forms the backdrop against which is played out what appears to be a common rustic scene. In the right foreground a black youth in a red jacket leans forward to pour liquid from a bucket into a barrel as he exchanges glances with Uncle Ned. The white-haired man in a tattered dark suit and brown coat pauses before emptying a bucket. Peering into that space behind him are three primly dressed children, apparently white, their backs turned to their hosts.[173] Lined up along planks balanced on two saw horses of unequal height, the trio appears to be standing on one end of a teeter-totter, adding one more note of instability to this complex composition.

This sun-drenched barnyard teems with images of birth and plentitude: in the left foreground a black kitten scrambling over a barrier to reach its white brother under the watchful eye of a black and white mother cat; the doves at their nesting place, not to mention all the barrels and buckets, symbols of fullness. The entire picture revolves around the axis of the old black man. Situated precisely in the center of the painting, in line with the heave in the roofline and the unfettered space above it, Uncle Ned is the hinge upon which the composition and its meaning hang. Like the young woman in *Near Andersonville*, his centrality is emphasized by the dark opening against which he is silhouetted. His feet facing in one direction, his head and torso in another, in an ambivalent directionality that will recur in *Dressing for the Carnival*, he moves between the certainty of the past, embodied in the assured white children, and the ambiguity of the future, expressed in the expectant glance of the young black. Uncle Ned was born in the past of slavery. The dove hovering above his head, precisely where the roofline peaks, signals the old man's role as mediator, intercessor between the past and future. But can he provide the answers sought in the boy's questioning gaze? Or, weary, will he finally call

> Oh, good Lor' gib me dem wings
> Gib me dem wings to fly away.[174]

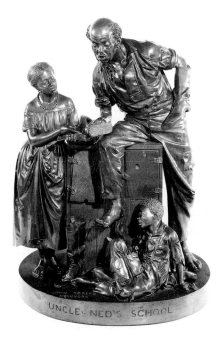

40. John Rogers. *Uncle Ned's School*, 1866. Bronze. H: 20 in. The New-York Historical Society, New York.

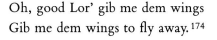

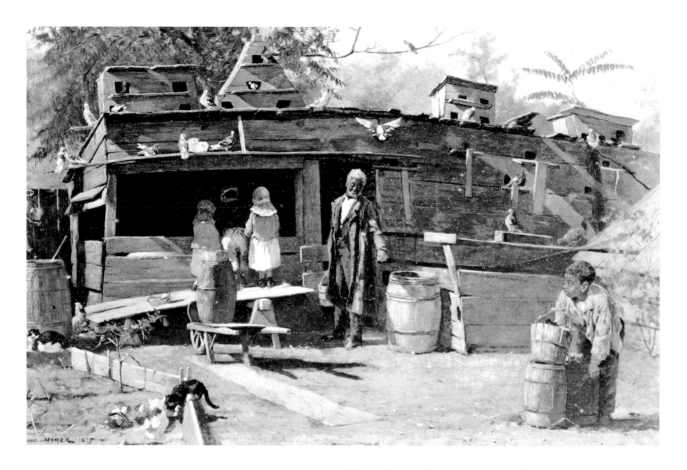

41. Winslow Homer. *Uncle Ned at Home* (also known as *A Happy Family in Virginia, Uncle Ned's Happy Family, The Dove Cote*), 1875. Oil on canvas. 14¼ × 22 in. Present whereabouts unknown.

In Foster's "Old Uncle Ned" repose awaits the "good darky" at the end of a life of servitude. That was before 1 January 1863. Subsequently the task of reconstructing life after slavery created new challenges for young and old alike and brought into question the stereotype of the docile old servant. In *Uncle Ned at Home,* as in the slightly later *Sunday Morning in Virginia* (see fig. 47), Homer explores the ties and tensions between elders raised in slavery times and a new generation, filled with hope and trepidation. The elaborate balancing act of *Uncle Ned* becomes a metaphor for the tense transition from the dependency of plantation life to the responsibility of freedom.

The home of another black family is the setting for *Sketch of a Cottage Yard* (fig. 42), a small oil on academy board which may date to 1875 or to the summer of 1876.[175] A clapboard cabin rises to form a background punctuated by yellow orange sunflowers stretching skyward. In the foreground a wood saw leans against a sawhorse while in the middle of the picture, on a line with the gray black cabin door, is an odd shape that might be a musical instrument, perhaps a gourd-bodied fiddle and bow.[176] Instead of an old man, the principal figure is a woman, elbows propped on her knees and chin resting on her folded hands, who holds

the attention of three children. This scene would seem to be both the forerunner and the counterpoint of *Sunday Morning in Virginia.* In both works knowledge is shared—in the latter by the written and read word while in *Sketch of a Cottage Yard* ideas and traditions are passed on orally.

The issue of educating freedmen figured prominently in the Northern press after the war, with *Harper's* editorializing: "The alphabet is an abolitionist. If you would keep a people enslaved refuse to teach them to read. . . . Near Corinth, in Mississippi, an old gentleman says: "My little contrabands have been picking up bullets on the battlefield, and have sent them to me to buy spelling books."[177] In 1866, the same illustrated newspaper assigned Theodore R. Davis and Homer's old associate Alfred R. Waud to report on the Southern states under Reconstruction.[178] With his commentary and his sketches Waud gave glowing reports of freedmen's schools in the former slave states, devoting a full-page illustration to the *"Zion" School for Colored Children, Charleston, South Carolina.* "It is the peculiarity of this school that it is entirely under the superintendence of colored teachers," he noted. "Although the Southern people seem generally opposed to the education of the negroes, still, if they must have it, they prefer to see colored people in charge of their own race to having Northern whites as teachers."[179] But Waud could not ignore the attacks being directed against the emblems of freedmen's independence, their schools and churches. The front page of *Harper's Weekly* on 26 May

42. Winslow Homer. *Sketch of a Cottage Yard,* ca. 1876. Oil on canvas. 10¼ × 14½ in. The Corcoran Gallery of Art, Washington, D. C.

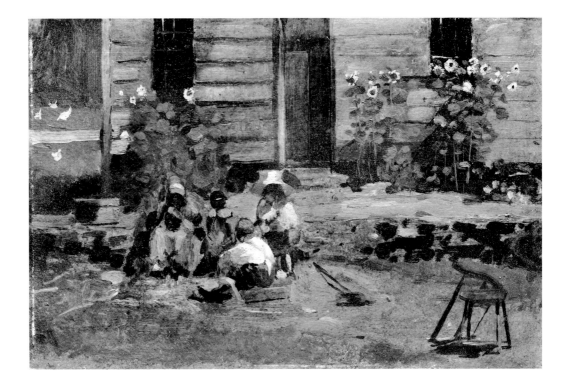

1866 featured his drawings and account of the riots in Memphis, Tennessee, in which almost fifty blacks were murdered. In addition, "some thirty houses, occupied by negroes, every school-house for colored children, and every place of worship for the freedmen were given to the devouring element."[180] Such assaults aimed at halting the education of Southern blacks proved increasingly common as the newly founded Ku Klux Klan directed much of its white supremacist violence at the new black schools and those who studied and taught in them.[181] At this time the black school in flames appears in Thomas Nast's political cartoons as the symbol of barbarism and racial hatred, and will recur throughout the 1870s.[182]

Winslow Homer had alluded optimistically to the education of Southern blacks in *1860–1870* (see fig. 28), and the theme of freedmen and formal education is taken up again in several of his works dating from the mid-1870s, beginning with his poignant watercolor, *Taking a Sunflower to the Teacher* (fig. 43).[183] A solitary black youth, the same model we encountered in *Contraband* and *The Busy Bee*, wearing the same torn and patched clothing, sits on a log at the edge of a wood. The upper left-hand corner of a slate is visible on the ground beside him, propped against the log. In one hand the young student holds a brilliant sunflower while a monarch butterfly lights momentarily on his shoulder.

The idea of a young black scholar was not original to Homer. In 1868 *Harper's* published a Thomas Nast wood engraving of a barefoot pupil arriving at school, his slate and books under one arm.[184] Nast transformed this usually happy scene into a nightmarish allegory of the resistance many white Southerners were raising to the education of blacks. Contrary to the popular image of the country child dawdling his way to class, this student has broken into a run, hounded by a gaggle of geese. The caption beneath the image leaves no doubt about the significance of this bizarre scene: "Prejudice. 'What! won't these stupid White Geese even let me go to School without hissing and biting at me?'"

Two years later the same periodical devoted a full page to the reproduction of a visual pun entitled *A Brown Study* by William Henry Hunt (1790–1864), a British artist known especially for his watercolor paintings of rustic scenes, hearty boys, and still lifes with fruit.[185] Sitting on a stool with his legs crossed at the knee, the youth holds his slate in one hand while chewing on his pencil. He looks up from his ciphers, obviously in a "brown study." The presence of a large jug in the background would seem to call into question the scholar's seriousness. *Harper's* saw the engraving as

43. Winslow Homer. *Taking a Sunflower to the Teacher*, 1875. Watercolor on paper. 7 × 5⅞ in. Georgia Museum of Art, University of Georgia, Athens.

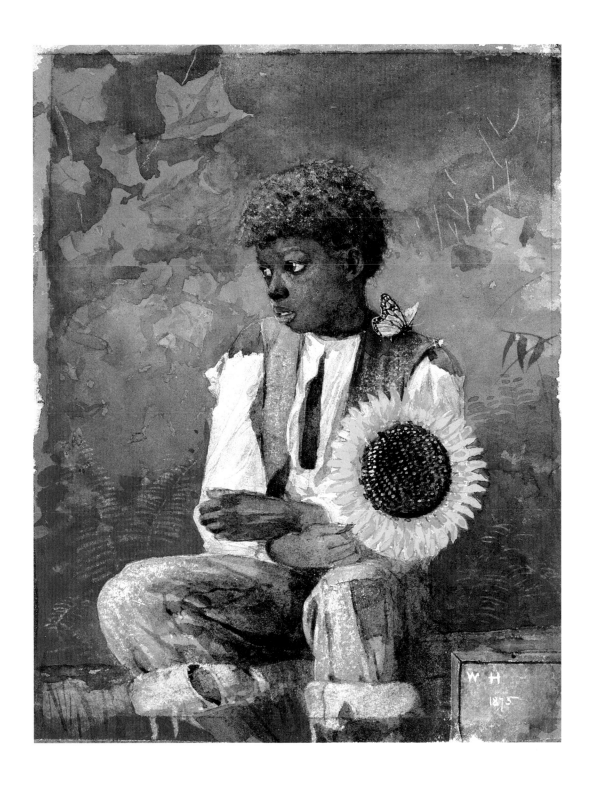

a pleasant illustration of the peculiarly gentle humor, just tinted with pathos, with which this great master of water-color art delighted to treat subjects from lowly life. . . . The little mulatto is not made to look more ridiculous or less intelligent as he bends over the sum written down on his slate than if he were a white boy. We hardly need call attention to the artistic treatment of the subject—the felicitous expression of the little fellow's face, as unconsciously biting his pencil, he rolls up his eyes in a brown study, quite forgetful of his task. The picture might have been studied in one of our own schools for freedmen's children in the South.[186]

Homer's young black is one of those children. He appears to be waiting to enter the schoolhouse, perhaps for his first day of school. Clearly he is preoccupied, an expression of concern or shy apprehension covering his face as he gazes off into the distance, his lips slightly parted. What the future holds for this beginner would seem to be indicated by the emblematic presence of the butterfly, the slate, and the sunflower.

In Christian iconography the butterfly signifies the resurrected human soul, while the life cycle of the caterpillar, chrysalis, and butterfly symbolizes life, death, and resurrection.[187] The insect resting on his shoulder calls to mind the recent metamorphosis of Afro-Americans from slaves into freedmen, and, as a symbol of rebirth and regeneration, points to education as the hope for the future of emancipated blacks. Like the slate, blank but for the artist's name and the date 1875, the pupil is ready to receive the knowledge his forebears had been denied. The youth's trust in the panacea of education is also expressed by the brilliant flower he grasps. In minstrelsy the seed-filled sunflower was the lowly substitute for the rose and, with its bright petals and brown black center, was a visual pun on the dark faces and white teeth of black people.[188] The face of a smiling black next to an enormous sunflower was calculated to ridicule and entertain. Eschewing this attitude, Homer uses the sunflower as the traditional symbol of devotion and patience: just as the flower turns its head to follow the sun, this nascent scholar will direct his attention toward his teacher and enlightenment. Literacy will provide the seeds for full-fledged independence. By thus refusing to belittle the youth's seriousness and the difficulty of the task before him, the artist would appear to express confidence in the boy's ability to succeed.

As in *Contraband*, Homer distills into a small image of a black youth the anticipation and hesitation naturally felt at the moment of a fresh beginning. Northern whites and Southern blacks were equally convinced that one of the great promises of Reconstruction was education, that

profound differences could be obliterated by literacy. Certainly no Gideonite could have expressed that optimism more completely.

Another of Homer's Virginia works, *The Watermelon Boys* (fig. 45) of 1876, merges the themes of education and barefoot boys and alludes to a popular minstrel act. Clustered around a cut watermelon, three boys, two of whom are black, form a tight pyramid in the foreground of this oil painting. They are the sole occupants of a vast, uncultivated field. The bundle of books near the white youth indicates that he at least attended school before stopping on his way home to raid a watermelon patch. Stretched out on his belly, bare feet in the air, he opens his mouth to take another bite of the pinkish red fruit. One of his companions, who is also propped up on his elbows, has just finished eating his crescent-shaped slice. The third and principal figure sits up on his knees and stares away from his portion of watermelon toward a plank fence that bounds the field on the right.

As with *Weaning the Calf*, echoes of a rural, New England scene resound in *The Watermelon Boys*. Specifically, it is reminiscent of Homer's *Boys in a Pasture* of 1874 in which two white youths, grouped closely into a right triangle, are loafing in a broad field.[189] They too cast their gazes beyond the boundaries of the canvas—the seated boy in front toward the birds floating above the horizon in the background, his half-reclined companion toward an unseen point at the right. *Boys in a Pasture* is an image of childhood ease and repose, of openness limited only by the rail fence that parallels the distant horizon.

It is this very serene quality that is missing from *The Watermelon Boys*. All the ingredients needed to make this a bucolic scene of mildly mischievous kids enjoying the fruits of a harmless prank are present. It could even have been an expression of an idealistic vision of race relations after the Civil War. However, two elements disturb the tranquility of this pastoral scene: the black boy's disturbed glance and the fence it encounters. Both could be accounted for if one hypothesized that the fence surrounds the melon patch from which the forbidden fruit was stolen, in which case the young black looks over his shoulder in worry, fearing their exploit will be discovered. A similar explanation was in fact offered when a wood engraving of the painting was used to illustrate an article on Homer and Frederick A. Bridgman. In the print entitled *Water-Melon Eaters* (fig. 44) and initialed "H." on the block, the picture was modified to include an old man threatening the boys from the far side of the fence. However, more than once Homer had altered a composition when transposing it from one medium to another: such changes often had the effect of simplifying the interpretation of a work

by eliminating all but one explanation. This was especially true when he engraved his paintings for the broader market of the illustrated press.[190] Also, Homer was reported to have offered facetious readings of his works to uneasy patrons who failed to understand his figures gazing off toward an unspecified, distant point, or the fate of the black man in *The Gulf Stream*.[191]

Given the frequency with which Homer painted blacks and women absorbed in thought, it seems quite probable that he intended for the viewer to probe their contemplation, respect their concentration. (Certainly for blacks, and in large measure for women as well—whether black or white—popular values deemed them relatively incapable of reflection.) Gainsaying any minstrel caricature the watermelon might bring to mind,[192] Homer gives us the exceptionally sensitive face of a young black who directs his glance toward the one small opening in the fence that angles back into the field, limiting the horizon and blocking his vision. (The fence as barrier will recur in *Dressing for the Carnival*.) Perhaps his expression mirrors his and Homer's growing realization that the hopes of public education, enfranchisement, and equality before the law kindled during the early years of Reconstruction were narrowing in the face of racial hatred and violence.

The books in the foreground of *The Watermelon Boys* allude to the issue of education during Reconstruction, but Homer's full exploration of this important subject is found in his oil painting dated 1877, *Sunday*

44. Winslow Homer. *Water-Melon Eaters*. Illustration for [George W. Sheldon], "American Painters–Winslow Homer and F. A. Bridgman," *Art Journal* (August 1878). Wood engraving. 5⅛ × 7 in. The Mavis P. and Mary Wilson Kelsey Collection of Winslow Homer Graphics, The Museum of Fine Arts, Houston.

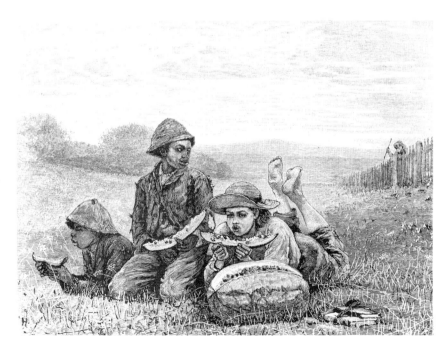

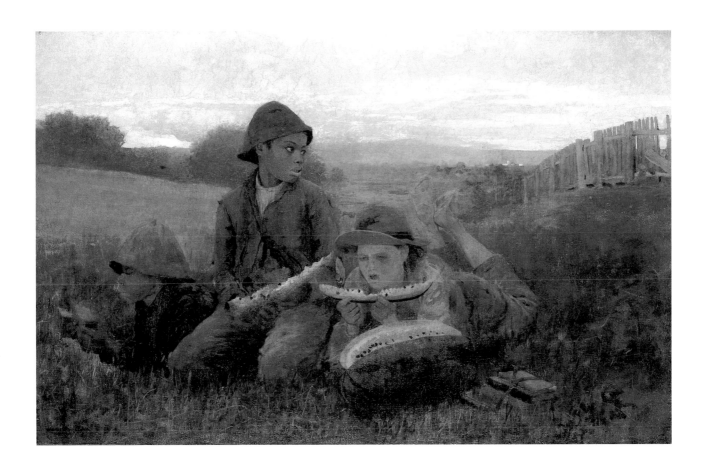

45. Winslow Homer. *The Watermelon Boys*, 1876. Oil on canvas. 24⅛ × 38⅛ in. Cooper-Hewitt Museum, New York.

Morning in Virginia (fig. 47). Viewing literacy as a means of achieving self-sufficiency, freedmen avidly pursued book learning for young and old alike. When describing the Freedmen's School in Vicksburg, Mississippi, for *Harper's Weekly*, A. R. Waud noted and his drawing confirmed: "These scholars, embracing all ages from the grandam down to the infant, are attentive, and master their tasks without any appearance indicating that the labor is irksome." An article published in the same periodical in 1867 included anecdotes about "Uncle Charley," who was attending school in Andersonville, Georgia, on the site of the infamous prison pen, and "Aunt Ellen," a former slave getting her first taste of formal education in Raleigh, North Carolina.[193] According to a Northern teacher in Florida, one sixty-year-old woman, "just beginning to spell, seems as if she could not think of any thing but her book, says she spells her lesson all the evening, then she dreams about it, and wakes up thinking about it."[194]

The book many adults wanted most to read was the Bible, from whose verses were drawn many of the metaphors used to describe

slavery, emancipation, and its aftermath. [195] This desire was voiced in the commentary *Harper's Weekly* attached to the wood engraving *Straightening the Crooked Tree* by the Virginia painter and future president of the Corcoran Gallery, Richard Norris Brooke. Beside the image of a weary matron doing her homework as a light-skinned child peers over her shoulder, the newspaper remarked:

> One of the most remarkable and encouraging features attending the emancipation of the colored race in our Southern States is the eagerness to learn displayed from the earliest moment of freedom. Old and young crowded to the schools opened for the benefit of the freedmen; and it was not uncommon to see men and women who had nearly reached the allotted term of their life poring over the spellingbook with all the eager interest of children. – Slowly and painfully, against every kind of discouragement, they would master the A, B, C, and learn to pick out simple words, until they could read in the book, which thousands of them knew already by heart, the Bible. The younger learned readily, not only to read but to write, and to comprehend the elementary principles of arithmetic.
>
> Our illustration . . . shows a simple-hearted old colored woman poring intently over the alphabet, and trying to master its difficult mysteries, while her young instructor leans on her shoulder ready to assist and explain. The poor old woman may never be able to do more than painfully spell out a few sentences in her Bible, but even this will be a comfort and consolation in her declining years. [196]

Four years after the Brooke engraving, in 1877, T. W. Wood exhibited at the National Academy of Design a painting entitled *Sunday Morning*, a variation on the theme of the younger generation assuming the role of teacher. [197] In this small picture a young girl reads from the Bible as her grandmother sits beside her in prayerful attentiveness.

Not infrequently children attended school and then taught their parents what they had learned during the day. During his southern trip in 1866 Alfred Waud sketched such a scene and inscribed it, "The Young Teacher, S. C." (fig. 46). *Harper's* illustration after this drawing was entitled, *"Uncle Tom" and His Grandchild* and explained as follows:

> A little child, almost white, and very beautiful, is teaching her grandfather—a pure negro—to read. The little girl is just from school, as appears from the satchel hanging on the chair. . . . The picture, as we saw it, seemed to tell at the same time a very sad and a

very hopeful story. The contrast of color, almost violent in those so near of kin, told the history of a great wrong. This little girl, with far more of "Southern chivalry" in her veins than of negro blood, was, or had been, for all that, a slave—a thing to be bought and sold, to be insolently loved or insolently hated; to whose children she must become a curse, as they would be a curse to her. But this sad fate had in her case been averted. She was now free; and her present occupation spoke of a new era for the negro race. So that, on the whole, the picture was a hopeful one. In it seemed to us to be concentrated the great moral of our civil war.[198]

The broad-based quest for literacy in the black community, the specific desire to read the Bible, and the new role of children as teachers—so many themes current in the popular press which Homer assimilated and distilled in *Sunday Morning in Virginia* (fig. 47). Quitting the out-of-doors for the rough interior of a black family's home, he arranged four young people and a grandmother in a corner near the hearth. At first glance the grouping of the figures seems to be structured solely along generational lines as the older woman, dressed in her Sunday clothes, sits slightly removed from the children who are gathered around a large Bible. Her isolation is emphasized by her stiff posture, the straight cane around which her entire being seems to be collected, and her sidelong glance away from the others. On closer examination it becomes evident that Homer has subdivided the chimney corner into four zones which underscore relations among the five figures. From right to left, the old lady occupies the first zone defined by the closed plank door behind her; the girl with her hair in plaits sits alone on a bench in the second area between the doorframe and the corner; beside her, in the third zone delimited by the corner and the fireplace surround, an adolescent girl and a slightly younger boy hold the Bible; in the final space a small boy huddles on a log in front of the brick chimney. The two figures in the third zone are associated not only by their physical proximity and their possession of the Bible but also by their lighter skin color, finer clothing, and their ability to read, all of which separate them from the other three persons. As with the little girl sketched by Waud and engraved by *Harper's*, the presence of "Southern chivalry" in this pair's lineage has not just lightened their skin, it has provided them early exposure to literacy.

The mulattoes' reading of the Holy Word produces complex reactions in the darkskinned children and their elder. The small boy at left leans in eagerly toward the Bible while casting a questioning glance to-

ward what may be his sister, as though seeking her approval. Her arms held close to her sides and hands crossed on her lap, she cuts her eyes sharply in the direction of the other young people, but conceals her response to what is being read and to the act of reading itself. For the grandmother this moment unleashes a flood of emotions and memories that show through in her weary eyes and furrowed brow. Most of her life has been spent in slavery, and she may well be remembering the lashings meted out for reading and for possessing books, or even pencils.[199] She probably recalls her own unspoken desire to read the Lord's Word but fears that it is now too late for such aspirations. It is not unlikely that she also has ambivalent feelings about all these new freedoms, especially about learning from a book rather than from an elder. Will the new order afford her darker grandchildren the same opportunities that the ones with lighter skin will receive? Or will they all be subjected to the intimidation techniques of whites intent on prohibiting blacks from receiving any formal schooling? In the enclosed space of *Sunday Morning in Virginia* Homer offers no solutions, but he expresses some of the complex hopes and anxieties regarding literacy and worship that were felt by the blacks he saw and painted in Virginia in the mid-1870s.

Homer's sojourns in the vicinity of Petersburg, Virginia, brought him to reflect not only on the question of the education of blacks in the Reconstruction South but also on the problem of race relations in the region. His thoughts on this subject found form in *A Visit from the Old Mistress* (fig. 50), an oil dated 1876 that could be viewed as a companion painting to *Sunday Morning in Virginia*.[200] The same size, painted in similar palettes, set in the same interior space, these two works constitute a diptych in which Homer explores many of the issues that preoccupied black and white Americans alike as they were celebrating their nation's Centennial.

Those who lived through the Civil War were familiar with stories of the encounters between freedmen and their former owners following Appomattox. Whites who returned to properties they had abandoned during the war did so with misgivings. They had heard reports of blacks sacking the big house, donning their master's or mistress's finest clothing, and taking possession of the land on the plantations where they had been slaves. Word had it that instead of being welcomed by the "pleasant smile and courtesy or bow to which we were accustomed," the plantation owners were greeted with "angry, sullen black faces" or an "ominous silence." When Captain Thomas Pinckney prepared to make his first postwar visit to his plantation fronting on the Santee River in South Carolina, he reflected, while arming himself:

46. Alfred Rudolph Waud. *The Young Teacher, S. C.* (detail), 1866. Pencil on paper. 8⅝ × 9⅛ in. The Historic New Orleans Collection, Museum / Research Center, Acc. No. 1965.90.326.

47. Winslow Homer. *Sunday Morning in Virginia*, 1877. Oil on canvas. 18 × 24 in. Cincinnati Art Museum.

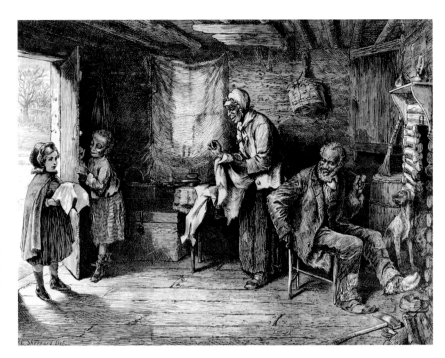

48. William Ludwell Sheppard. *Christmas in Virginia – A Present from the Great House* in *Harper's Weekly* (30 December 1871). Wood engraving. 8⅞ × 11⅝ in. Mary & Mavis Kelsey Collection, Special Collections, Texas A & M University, College Station.

Indeed, I felt no fear or distrust; these were my own servants. . . . They had been carefully and conscientiously trained by my parents. . . . They had been glad to see me from the time that, as a little boy, I accompanied my mother when she made Saturday afternoon rounds of the quarters, carrying a bowl of sugar, and followed by her little handmaidens bearing other things coloured people liked. At every cabin that she found swept and cleaned, she left a present as an encouragement to tidiness.[201]

Blacks lost no time in making clear that the days of unpaid labor were past, that their rights to marry and create stable families would be exercised fully. Most planters were stunned by such assertions and especially by the disappearance of the subservient behavior to which they were so accustomed.

By the 1870s when white apprehensions about the "unfinished revolution" of Reconstruction were widely known, the illustrated press (like the minstrel show) began to reflect nostalgically on the good old days of plantation life, often choosing visiting scenes as a means of conveying the preferred dependent relationship between black and white. In 1870 and 1871 Richmond painter and illustrator William Ludwell Sheppard drew two such scenes for engravings that appeared in *Every Saturday* and *Harper's Weekly*. In the former, *"Merry Christmas and Christmas Gift, Ole Massa"* (see fig. 31) the plantation owner receives

the season's greetings from the Negroes on his land and, by tradition, in turn offers them a gift. *Every Saturday* commented: "This sketch would seem to describe Christmas of years and years before the war shattered the 'domestic' institution of the South; but the change of legal relations has in many instances left undiminished the friendly regard of the former master and the trustful affection of the former slaves, especially the older ones. . . ."[202] The latter, *Christmas in Virginia—A Present from the Great House* (fig. 48), centers on the moment the young heiress to the old plantation enters the former slave quarters to deliver a holiday treat. An old black couple and their granddaughter respond to her arrival with smiles as she stands bathed in the light admitted by the open doorway. Such reassuring scenes of benevolent whites bestowing favors on lowly blacks, especially in a "rustic" setting, induced *Harper's* to remark:

This pleasant picture would have been more generally applicable, we imagine, before the abolition of slavery than at present; though there

49. Sol Eytinge, Jr. *Virginia One Hundred Years Ago* in *Harper's Weekly* (19 August 1876). Wood engraving. 9⅛ × 13⁹⁄₁₆ in. Mary & Mavis Kelsey Collection, Special Collections, Texas A & M University, College Station.

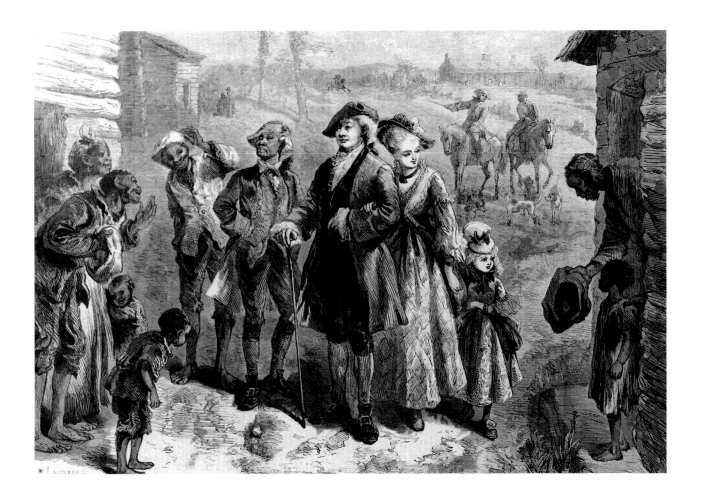

are still large estates where the old servants maintain their dependent relation to their former owners. . . .

Pretty and idyllic, is it not? Yet it represents a condition of society which is rapidly disappearing from a century which has but little sympathy with the idyllic poetry of life. In this practical age such an anomaly as a dependent peasantry could not be tolerated, nor can any sensible person wish that it should be. It must give way to something nobler and more enduring. The serf, the peasant, is every where rising above the level of his old condition, and asserting and winning his rights as a man: and though the world may lose a great deal of poetry and picturesqueness in the process, the substantial gain to humanity will be great and permanent.[203]

Yet another variation on the visiting theme is an exact contemporary of *A Visit from the Old Mistress.* Possibly inspired by the May opening of the Centennial Exhibition in Philadelphia, this fantasy pictures *Virginia One Hundred Years Ago* (fig. 49), in which "the master and mistress and the little daughter, strolling leisurely along by the lowly quarters of 'their people,' are greeted with respectful affection as they pass." Praising the generosity of the Virginia gentry, *Harper's* declares that "the faces of the slaves express content, and tell of kind treatment." It also finds that the author of the engraving, Sol Eytinge, Jr., has a "happy faculty for the delineation of the droll phases of negro character."[204]

Both Sheppard and Eytinge were artists whose illustrations of blacks for *Harper's* and *Frank Leslie's* increased in number at the very moment Homer's declined. Sheppard consistently depicted Afro-Americans in a condescending fashion and with simian features, while Eytinge was the creator of two vehicles for caricaturing blacks, the Smallbreed family and Blackville, the fictional locale inhabited by risible blacks (see fig. 54). Their patronizing stereotypes of Afro-Americans certainly meshed well with the tendency of the illustrated press in the mid-1870s to ignore the deteriorating situation of black Southerners in favor of idealizing preemancipation race relations.

Homer was surely aware of these indirect references to black/white relations in the postwar South and of the visitation as a vehicle for bringing together various classes of people. But he had traveled in Reconstruction Virginia and met former slaves. True to his method of working, his observations took precedence over the patterns of representation used by others. The old mistress in Homer's painting arrives in the home of a black family where she encounters three black women, one of whom holds a toddler, gathered in the chimney corner.

50. Winslow Homer. *A Visit from the Old Mistress*, 1876. Oil on canvas. 18 × 24⅛ in. National Museum of American Art, Washington, D. C.

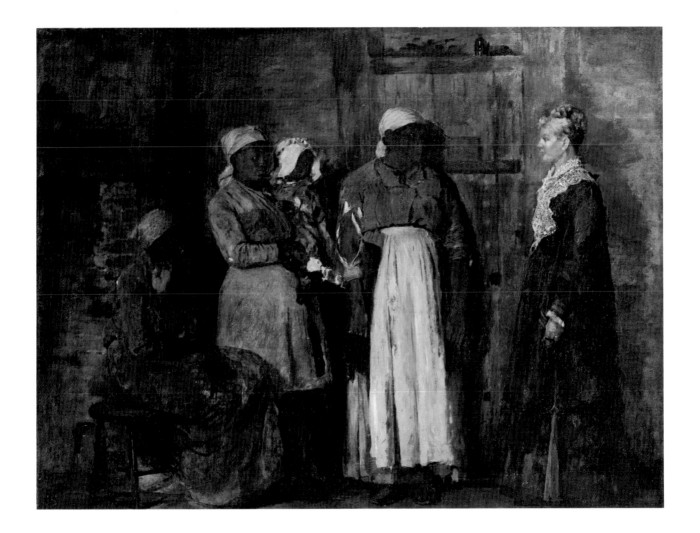

All eyes and heads are turned to acknowledge her arrival, but there is no bowing or scraping, no gesture of welcome. Confronting her former slaves the mistress is elegant but rigid in a black dress which appears lifeless in comparison with the rich, earth tones of the blacks' patched and tattered clothing. Using the four-zone, five-figure structure that he will repeat in *Sunday Morning in Virginia*, on the right side of the room he isolates the older white woman (as he later will the black grandmother). The other three areas are reserved, respectively, for the darkskinned matriarch whose monumental form is uncompromisingly frontal and anchors the center of the painting; for the mother and child, somewhat lighter in complexion, who occupy the corner; and for another darkskinned woman sitting on a taboret, her wrist turned back in a skeptical, considering gesture, her chin resting on a single finger. (The posture and facial shape of this latter figure are strikingly similar to those of the girl wearing her hair in plaits in *Sunday Morning in Virginia*. This observation made, it seems possible that the women in *A Visit from the Old Mistress* are meant to be seen as the mothers of the children in the 1877 oil.)

A Visit from the Old Mistress crystallizes into a single moment the staggering realization faced by all Southerners after the Civil War—both black and white—that things will never again be the same, that American society had been irrevocably changed by the abolition of slavery. In 1868 *Harper's* took satisfaction in the shift, reminding doubtful readers to think twice about "the lovely relations existing between masters and servants in the good old days of the Union-as-it-was with paddles and blood-hounds." The editors observed that in defense of old ways, "We used to hear of that personage" known as a loyal mammy. But the "old Mammy argument," they announced definitively, "is exhausted." [205] In the simplest, but most profound terms, blacks and whites had been declared equal. On a concrete level this meant that blacks were released from a system of slave labor and entered the free market economy. In order to rebuild the warworn South, white landowners were obliged to go to freedmen and negotiate labor agreements. For the first time Afro-Americans had the right to choose what kind of work they would do and for whom they would work. Black women could refuse to work in the fields. Many, still fresh with memories of sexual exploitation at the hands of white masters, were unwilling to do housework for whites, preferring to exercise the privilege of tending their own homes and raising their own children. [206] These and related transformations appeared to render obsolete patterns of behavior that had persisted for generations. No longer could former masters command obeisance from their former

slaves. No longer did a black woman feel obliged to rise from her seat when a white woman entered the room.

Homer's painting expresses the tensions brought on by such potentially revolutionary changes. Repeating the same device used in *Prisoners from the Front* (1866) and later reused in *Sunday Morning in Virginia*, he defines a space between the mistress and those who receive her that is both physical and psychological.[207] It can be bridged by an extended hand or a single step, or it can become a chasm. But so long as the narrow space exists between these Virginia women, facing one another at close quarters on a shared and level footing, the possibility remains for a dialogue between blacks and whites on equal terms.

The monumental quality of the freed women in *A Visit from the Old Mistress* is carried a step further and acquires even greater significance when Homer paints *The Cotton Pickers* (fig. 51) in 1876.[208] Two statuesque young women stand isolated in a vast cotton field, silhouetted against an expanse of white-topped plants and silvery sky. Cropped below the knees and grouped with their loads of cotton as a sculptural mass in the center of the painting, they loom large in the foreground of the picture. Far from being diminished by the acres stretching to the low horizon, they seem to rise out of the land and, through their monumental presence, claim it as their own. One of the women glances downward as she reaches to pick a boll of cotton while the other looks up from her task to gaze off into the distance, as did the woman in *Near Andersonville* and the youth in *The Watermelon Boys, The Busy Bee*, and others.

Michael Quick has traced the iconographic and stylistic sources of this work to the paintings of French peasants by such artists as Jean-François Millet (1814–75) and Jules Breton (1827–1906), whose works Homer would have seen during his 1866–67 sojourn in France.[209] In his use of these sources, Homer identifies American blacks as the equivalent of the peasant class in Europe. (This association had first been made in American art by Eastman Johnson [1824–1906] in *Negro Life at the South* [1859] when, just back from six years of study in Dusseldorf, The Hague, and Paris, he sought American subjects analogous to his *Savoyard Boy* of 1853.[210]) Other contemporaries of Homer also formulated the equation between rural freedmen and European peasantry: Ednah Dow Cheney, for instance, made the connection in her social criticism of Millet's painting published in Boston in 1867; *Harper's Weekly* offered a similar link in its commentary on Sheppard's engraving, *Christmas in Virginia*, of 1871 (see fig. 48).

Similarly, Eugene Benson, the artist/critic who encouraged Homer

to travel to France, wrote an article for *Appleton's Journal* (1872) noting how a viewer's social attitudes could influence his perception of Millet's works.[211] Benson remarked: "The peasant of France, according to the spirit that contemplates him, is a careless and unambitious being, much like the negro of the southern plantations; or, he is heavy and patient, struck with the sadness of the soil, his back rounded, his eyes always upon the earth from which he wrings a scanty subsistence." However, Benson modified the peasant/plantation worker analogy when he defended America's changing agrarian life over Europe's more static ways:

> In France, the peasant is shut off from all the influences that form modern man. He is ignorant of the great fluctuations of the political world, . . . he can hardly be said to think. He neither reads nor writes; the horizon of his field is the only one known to him . . . he seems a primitive man . . . a type which is rarely seen here. . . . The toil, the patient dumb look of men and women who have no part in the great march of improvement and emancipation, the aspect of life so detached from what we understand as life in our century is pathetic and strange.[212]

As fluctuations in the postwar South's political world allowed black workers to look beyond the bounds of their traditional field, reports began to circulate of freedmen's resistance to growing the "slave crop" that had once ruled the region as king. Given an option, black farmers preferred to grow crops they could eat, rather than raising an inedible staple for their employers to ship to some profitable, distant market. An agent informed Northern textile manufacturers that cotton was "associated in the negroes' mind with memories of the overseer, the driver and the lash, in fact with the whole system of slavery." This reluctance notwithstanding, the economic depression of the 1870s forced many black women to return to the fields, particularly during cotton-picking season.[213]

It is within these interwoven contexts of artistic conventions, social criticism, and labor relations in the South during Reconstruction that the true depth of *The Cotton Pickers* can be grasped. While drawing upon the forms and symbols used to depict French peasants, Homer distinguishes his subjects from them. These are not the downtrodden class numbed by endless drudgery that Millet painted in *The Gleaners* (1857) or *Man with a Hoe* (1859–62). Nor do they appear fatigued by the day's labor as does Breton's equally monumental woman in *Le Soir* (1860).[214] Rather, because of the scale of Homer's figures, their

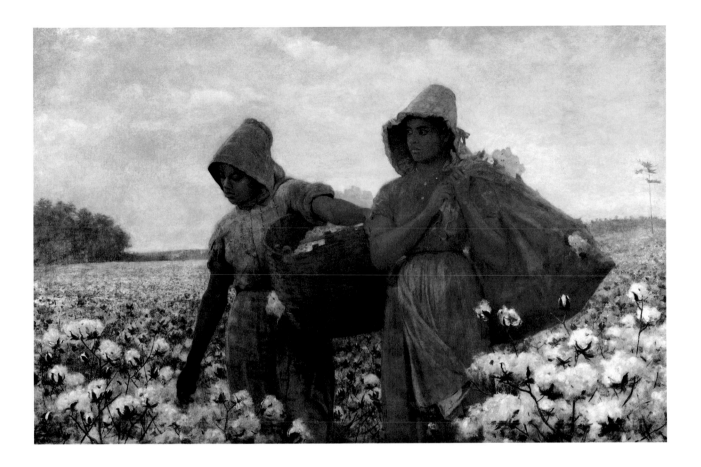

51. Winslow Homer. *The Cotton Pickers*, 1876. Oil on canvas. 24¹⁄₁₆ × 38⅛ in. Los Angeles County Museum of Art, Los Angeles.

relationship to the surrounding land, and their demeanor, these black women seem larger than life and filled with strength and confidence in their ability to chart their own destinies. They are not bowed down by toil, either physically or spiritually; slavery has not left them bereft of their humanity. The woman at left goes about her work, but her face mirrors her indifference, and even resistance, to doing so. Memories of the days before emancipation have not receded that far into the past. Her companion has dropped any pretense of picking cotton and, contrary to the French peasant described by Benson, is absorbed in thought. She looks well beyond the boundaries of the field, contemplating, one suspects, the future. But, like Homer's other blacks from this period whose glance is not contained by the picture, her serious and somber mood suggest that any optimism about the years to come may be dampened by the violence and hardships of the present.

Three years later Homer returned to the theme of black women harvesting cotton in a large painting entitled *Upland Cotton* (fig. 52). A critic who saw it exhibited at the National Academy of Design in 1879 described it as follows:

A picture by Winslow Homer, 'Upland-Cotton' . . . a scene on a Southern plantation, is a remarkable penetration of Japanese thought into American expression. The cotton-plants are straggling across a footpath, in which are two negro women, with their heavy, Oriental figures clad in strong, rich colours. One woman stands upright, with her turbaned head swung back, outlined against a thin, hot sky. The other woman is stooping over and gathering the cotton-pods, and her rounded back seems to bear the burden of all the toil of her race. Down close into the foreground of the canvas . . . each pod is painted as if doing it was all the artist had ever cared for.[215]

Judging from this description, Homer had once again contrasted a working figure and a resting one, an active person and a reflective one. However, in lieu of a broad horizontal with monumental cotton pickers crowding the picture plane, *Upland Cotton* presented a seemingly narrow vertical in which the figures were given less emphasis and distanced from the foreground. Further, the viewer's perspective had been lowered, thus increasing the scale of the cotton plants and making them appear to engulf the working women. This shift in viewpoint had the effect of diminishing the human presence, which may correlate with the declining situation of blacks at the end of Reconstruction. But any speculation along this line is hazardous since the painting we see today was altered substantially by Homer himself sometime after he exhibited it in Atlanta in 1895.[216]

W. E. B. Du Bois wrote succinctly of Reconstruction: "The slave went free; stood a brief moment in the sun; then moved again toward slavery."[217] Homer, having spent time in Virginia in the 1860s and again in the 1870s, glimpsed first-hand this movement of the pendulum. In the extraordinary oil painting entitled *Dressing for the Carnival* (fig. 57), he captured the fleetingness of that moment in the sun and the pathos surrounding the return toward slavery which occurred most dramatically in the Centennial election year of 1876. This enigmatic masterpiece of 1877 has long been venerated for its brilliant use of color and the sheer grace of its unusual friezelike composition. But only recently have some of its deeper topical meanings begun to emerge through the ongoing explorations of current art scholars and social historians. The picture, clearly derived from Homer's Virginia stay, proves to be much more than the resolute elevation of a local anecdote to the realm of enduring art.

In strong midday sunlight a pensive individual is donning a brightly

52. Winslow Homer. *Upland Cotton,* 1879–95. Oil on canvas. 49 × 29¼ in. Weil Brothers, Montgomery.

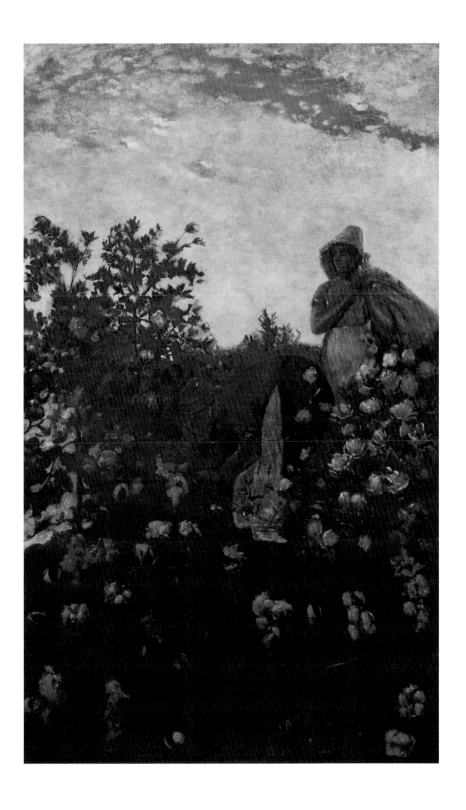

colored costume with assistance from two women who concentrate upon their work while half a dozen earnest youngsters look on with interest. Like Uncle Ned (the only other adult black man in Homer's Reconstruction works) he stands at the center of the picture, body turned and feet set as if ready to move his weight forward or backward. Indeed the somber women—as stoic and deliberate as the Fates of classical mythology who used their thread to shape human destinies—appear to pull him in two directions. They are solemnly sewing him into his regalia almost as if stitching him into his shroud. The discernable thread of the woman before him occupies his attention, stretching from an unseen button as if it were an umbilical cord. The strand of the older and more powerful figure behind him remains invisible, but having drawn it out with her fully extended left arm, she seems prepared to break it off with her uplifted right hand.

Judging from stories about his time in Virginia (and from the design of *A Visit from the Old Mistress*), Homer found himself caught between contending black and white constituencies adjusting to new and uncertain relationships of power. Local white residents were not used to being overlooked by visitors, and they felt antagonized when the artist devoted too much time and attention to their former servants. "While he was at work in Petersburg," related biographer Downes, "it became known to a group of young fire-eaters there that he was consorting with the blacks, and they resolved to drive him out of town," though their effort to intimidate the "d—d nigger painter" eventually failed.[218] "Why don't you paint our lovely girls instead of those dreadful creatures?" one white woman supposedly asked, and Homer is said to have responded that he found the blacks the prettiest.[219]

However, the black Virginians themselves—no longer dependent slaves and contrabands but now full citizens—apparently took issue with Homer's work from the opposite direction, questioning whether it pictured them in a sufficiently positive light. "The negroes had taken offense, it is said, at the studies he made of them, for his models were generally poorly clad," according to one account. "They carried a complaint to the Mayor, and gave him to understand that the sketches in question were of a kind that would reflect little honor on them, and that the artist should be notified that there were plenty of well-dressed negroes if he would but look for them."[220] Another version puts Homer in "Smithville" and reports his black models objected "that such undignified likenesses of themselves should go up to the North. Excitement ran high; they almost mobbed the painter. At length, by way of compromise the latter agreed to paint them in their finery, as

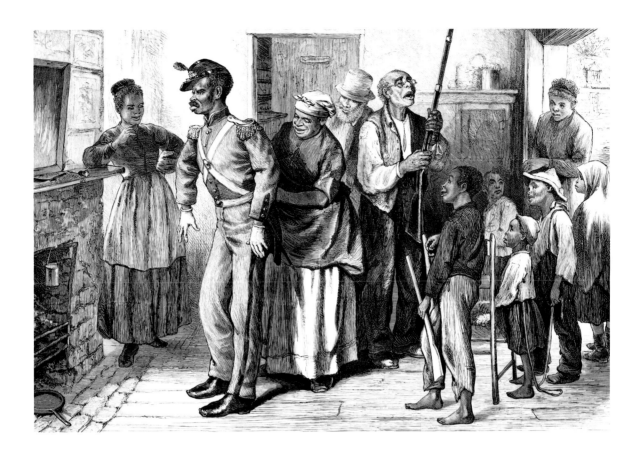

53. Unidentified artist. *Our Colored Militia. – A "Skid" Dressing for the Parade on the Fourth of July* in *Frank Leslie's Illustrated Newspaper* (17 July 1875). Wood engraving. 9¼ × 13¾ in. Library, University of Minnesota, Duluth.

they were accustomed to deck themselves for Christmas festivities."[221]

And what finery Homer creates—a complex blend of local color and national symbolism from head to toe. Like the woman's bandanna in *Near Andersonville*, the man's hat clearly resembles a Phrygian liberty cap.[222] It is red, white, and blue, as are his flaglike pants, making the wearer an embodiment of patriotism and freedom at one level. But at the same time his baggy outfit and oversized shoes present a clownlike aspect, and he appears to hold a red carnation in his teeth (symbol for an aching heart) invoking the blend of light entertainment and poignant reflection associated with a European harlequin. In addition, he represents a slice of Afro-Virginian culture that has since been lost, for the actual Christmas tradition which the Virginia blacks are sharing with the artist would appear to be the revelry and role reversal known as Jonkonnu. Also called John Canoe or John Cooner, the ceremony—still familiar in Jamaica and parts of the Caribbean—has been clearly documented in nineteenth-century North Carolina and southern Virginia. Mounted during the Christmas holidays, it annually provided the one occasion, during slavery times, when blacks could pass through the picket fence separating the quarters from the big house and dance on the front porch,

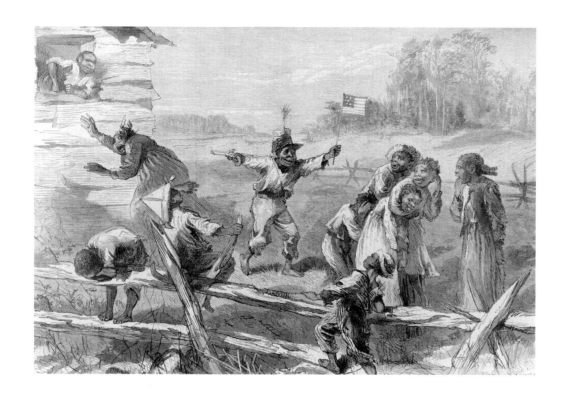

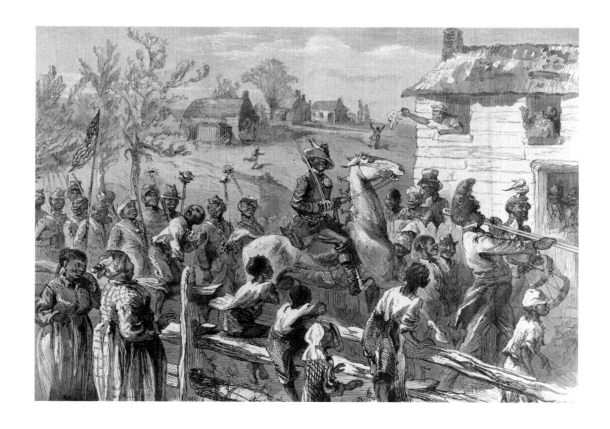

singing mocking songs and demanding coins and gifts from the master.[223]

On 1 January 1863 these year-end rituals took on dramatic new meaning, as New Year's Day replaced West Indian Emancipation Day (1 August) as a date to mark forever the coming of Afro-American freedom. In many black communities annual observances also sprang up to commemorate the actual day on which news of emancipation arrived or actual liberation occurred. Throughout the country during Reconstruction, however, it was the Fourth of July which became a particularly important symbolic occasion for black Americans. If true equality was to reign permanently—as it did each year for only a fleeting moment during the Jonkonnu ritual of slavery times—then one might expect that blacks could now participate fully in the oratory, prayers, and parades of Independence Day, from which they had commonly been excluded even in the North. But the issue remained unsettled, tied to the deepest political and social struggles of Reconstruction. As one historian writes, "Black Emancipation Day and Independence Day celebrations exhibited the ambivalent status of blacks in American life as they glorified the destiny of America while sadly monitoring the past, present and future lack of black participation in that destiny."[224]

Such a combination of sunshine and sadness pervades *Dressing for the Carnival*. Once again Homer reworks a patronizing image from the popular press into a serious painting, for his point of departure seems to have been an 1875 wood engraving from *Frank Leslie's* bearing the title, *Our Colored Militia—A "Skid" Dressing for the Parade on the Fourth of July* (fig. 53).[225] *Skid* refers to the Skidmore Guards, a black social and marching club active in New York during the 1870s, which *Leslie's* described as a clear emblem of "the new order of things."[226] In 1874 Edward Harrigan, the city's leading songsmith of ethnic theater, wrote the words for a rousing piece entitled "The Skidmore Guard,"[227] and by the following year black marching units had become a fresh staple for minstrel shows.[228] The unknown artist of *A "Skid"* makes clear—from the interest of the old man in what may be a loaded rifle and the pride of the little boy with his wooden gun—the view that firearms are a source of ignorant fascination, and therefore danger, in the hands of blacks. Subsequent July illustrations from *Harper's Weekly* by Sol Eytinge, Jr., strike a similar note. In *"De Jubilee am Come"—Fourth of July, 1876* (fig. 55), a motley militia (with flowers in their muskets, a practice of the Skidmore Guards) makes a tumultuous mockery of the Centennial Independence Day. The following summer, in a derogatory engraving entitled *The "Fourth" in Blackville* (fig. 54), a youngster (in the cockade hat of a Skidmore Guard) waves a flag and a pistol, shouting "Hold on

54. Sol Eytinge, Jr. *The "Fourth" in Blackville – "Hold on to Sumfen, She's Goin' off Dis Time"* in *Harper's Weekly* (14 July 1877). Wood engraving. 9¼ × 13⅝ in. Mary & Mavis Kelsey Collection, Special Collections, Texas A & M University, College Station.

55. Sol Eytinge, Jr. *"De Jubilee am Come" – Fourth of July, 1876* in *Harper's Weekly* (15 July 1876). Wood engraving. 9³⁄₁₆ × 13½ in. Library, University of Minnesota, Duluth.

to Sumfen, She's Goin' off Dis Time."

If white illustrators had once depicted slavery itself as the explosive charge, they now reflected the widespread racist notion that a little gunpowder could be a dangerous thing in the hands of the supposedly undisciplined black freedman. Cartoons repeatedly questioned whether blacks were worthy to wear army uniforms, to shoulder weapons, and to march with the flag on the Fourth of July. Such questions were not merely rhetorical but represented part of the bitter struggle over the ending of Reconstruction. And there are clear echoes of that struggle in the imagery of *Carnival*. The plantation complex, represented by the large, two-chimney dwelling and outbuildings in the distance, has again become inaccessible; the gate has been shut. The black man, who may well have worn a federal uniform ten years earlier or served in the militia during Reconstruction, will not carry a gun in this parade. A white butterfly, which might have flitted before his eyes or touched briefly on his shoulder, is squarely behind him now; though it catches the eye of the matriarch with her jaw set and her hand poised, it appears small and elusive—hardly a symbol of hope. The barefoot children share the seriousness of their elders, clinging to small American flags, but now without any school books or Bibles, their future prospects very much in doubt.

Moreover, besides being a general comment on the ending of Reconstruction, the picture may also refer to a more specific occurrence—the Hamburg Massacre in Edgefield County, South Carolina. Little known today, the incident made national headlines in July 1876, marring the observance of the nation's Centennial and presaging the resurgence of the white Democratic party through sanctioned racial violence. By exercising the franchise during Reconstruction, the local black majority had come to dominate the militia and the courts of Hamburg, across the Savannah River from Augusta, Georgia. But when white farmers found themselves obliged to give way to the black militia unit during the July Fourth celebration, animosities boiled over, and four days later a full-scale battle erupted. The town's black marshall and one white died in the face-off; five other blacks were captured and murdered by the white mob which ransacked the town. The atrocities opened a wider campaign of intimidation against black voters in the state. Democratic politicians, waving the "bloody shirt" to arouse wartime memories in white voters, worked so aggressively to keep blacks away from the polls that Confederate general Wade Hampton was elected governor.[229]

It had been twenty years since the Caning of Sumner by Representative Brooks from the Edgefield District. Now once again the symbol for

white rule in South Carolina became the bludgeon. Black Southerners found themselves being systematically terrorized into political and economic submission, and a new term—*to bulldoze*—entered the language for describing the brutal tactics used to root out any prospect for interracial democracy. Thomas Nast published a series of bitter images in *Harper's* decrying the Hamburg Massacre and the bloody shirt campaigns, conducted in the name of "reform," that were overthrowing Reconstruction by any means available. One picture entitled *The "Bloody Shirt" Reformed* depicted the six black victims of the massacre and quoted the excuse given for the murders: "Impudent Niggers Daring to Celebrate the 4th." A more militant and arresting Nast engraving was called *He Wants a Change Too* (fig. 56). On one side it repeated the images of slain citizens amid the ruins of their homes and schools; on the other it spelled out the vituperative public boasts of resurgent white supremacists.[230]

At the center of Nast's engraving, literally between a rock and a

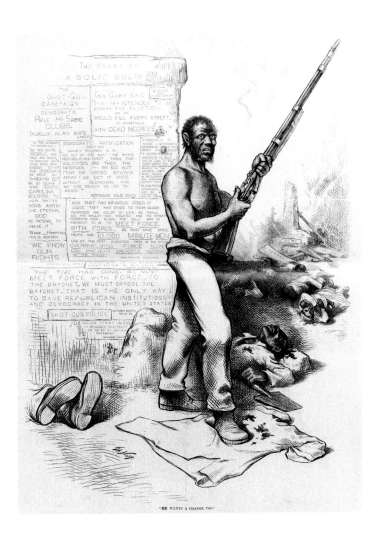

56. Thomas Nast. *He Wants a Change Too* in *Harper's Weekly* (28 October 1876). Wood engraving. 19¹¹/₁₆ × 13³/₈ in. Fondren Library, Rice University, Houston.

hard place, stands a powerful black man, fear and determination in his eyes and a cocked rifle in his hands. At his feet lies a bloody shirt—his own—and he appears committed to fight to the death for his rights. His dire predicament and his look of desperate defiance bring to mind the intrepid worker whose piercing gaze casts bolts of lightning in *A Shell in the Rebel Trenches* (see frontispiece). But Homer had conceived that image in the emancipation year of 1863; if he was to deal with the bloody shirt in *Carnival*, it would be in a far different and more subtle way. His painting, like Nast's polemic, has a black man's shirt at its center, and the red sleeve and shirttail may even contain a veiled reference to Wade Hampton's Red Shirt Campaign and the fate of Hamburg's martyred militiamen who dared "to celebrate the 4th."

Yet this man exudes neither the assimilationist pomp of *Leslie's* Skidmore Guard in uniform nor the short-lived militancy of Nast's stripped-to-the-waist insurgent. He and his close-knit extended family will endure the coming storm because they are bound together by strong historical threads. As the carnival costume suggests, these Southerners have significant ties to both Africa and America and to the broader Christian tradition as well.[231] For had not Joseph, the young dreamer with the coat of many colors (Genesis 37) been brutalized and nearly killed by his own brethren? They had made certain that he was sold into bondage in Egypt and had dipped his brilliant garment in blood, vainly hoping to convince the patriarch Jacob to forsake all care for his respected son.

Once more, as in *Near Andersonville*, Winslow Homer has chosen to locate himself and the viewer on the black side of the fence. Once more, as in *Inviting a Shot*, he seems to have woven into his work a submerged reference to contemporary events that has eluded subsequent generations of commentators. And once more, as in *A Visit from the Old Mistress*, he has given dignity, centrality, and force to black figures. It would not be the last time, for if the world around him was taking a turn for the worse, Homer himself was only just reaching his prime as an artist. *The Gulf Stream* was still more than twenty years away.

57. Winslow Homer. *Dressing for the Carnival*, 1877. Oil on canvas. 20 × 30 in. The Metropolitan Museum of Art, New York.

Neither of us can ever fully thank Dominique de Menil for sharing her insight, enthusiasm, and vision. We cherish her encouragement and friendship more than anyone can know.
PHW & KCCD

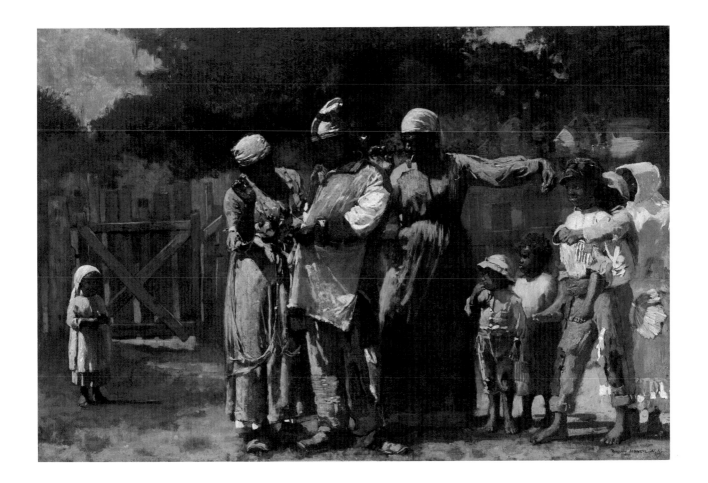

Notes

RICHARD J. POWELL

1. "American Art in Water Colors. The Twelfth Annual Exhibition of the Water Color Society in the National Academy," *New York Evening Post*, 1 March 1879, p. 1.

2. Although the black subjects of the 1870s are generally thought to have been conceived by Homer in Virginia, many scholars would agree that some of these paintings could have been realized in either New York or New England. In an amusing but telling anecdote recounted by William Howe Downes concerning Homer's solicitation of a black woman in New York City to model for him, one gets the impression that a significant amount of the picture-making process for these "Virginia" subjects may have, in fact, taken place in Homer's New York studio. William Howe Downes, *The Life and Works of Winslow Homer* (New York, 1911), pp. 88–89.

3. Lloyd Goodrich explains Homer's lapses into stereotypes in the following manner: "Although his attitude reflected some of the typical Northern idea that the Negro was primarily a humorous object, his sense of colored character and physiognomy was already more realistic than the average artist's minstrel-show conception." Lloyd Goodrich, *Winslow Homer* (New York, 1944), p. 20. In her dissertation on Homer's Civil War subjects, Lucretia Hoover Giese also believes that Homer's appropriation of the "stock" reference to popular taste—i.e., the humorous and mindless entertainer— ultimately has "a positive effect" because "it *clarifies* and *sharpens* their contemporary focus . . ." (my emphasis); Lu- cretia Hoover Giese, "Winslow Homer: Painter of the Civil War" (Ph.D. diss., Harvard University, 1985), pp. 299, 340– 41. What neither writer acknowledges is that the depiction of black people as stock character types *lessens* the overall impact of the work(s) in question and, while it indeed situates these works within an 1860s time frame, it also indicates the artist's inability to transcend, both conceptually and aesthetically, the pre- vailing, racist mindset.

4. Goodrich, *Winslow Homer*, p. 20.

5. "Artists and their Work. Pictures in the Academy. The Negro in American Art—Winslow Homer—Marines by Bunce, Quartley, Edward Moran, and De Haas," *New York Times*, 9 April 1880, p. 5.

6. "American Art in Water Colors," p. 1.

7. Winslow Homer, Scarboro, Maine, writing to Thomas B. Clarke, New York, 23 April 1892, Winslow Homer Papers, Special Collections, Bowdoin College Li- brary, Brunswick, Maine.

8. *The Bright Side* was exhibited not only at the 1867 Universal Exposition in Paris, but also at the National Academy of De- sign in 1865 and, thirteen years later, in Paris again. Both *Sunday Morning in Virginia* and *A Visit from the Old Mistress* were shown in the galleries at the Cen- tury Association, New York (1877); at the Universal Exposition, Paris (1878); and at the National Academy of Design (1880). Other paintings with black sub- ject matter (*Uncle Ned at Homer*, *Wean- ing the Calf*, *The Cotton Pickers*, *The Wa- termelon Boys*, and others) were also pre- miered or prominently displayed by Homer in major exhibitions in New York and Boston. For references to these numerous exhibitions, see Gordon Hen- dricks, *The Life and Work of Winslow Homer* (New York, 1979).

9. One is encouraged to excavate the cultural remnants of the 1860s and 1870s through the example of Christopher Kent Wilson and his excellent article on a rarely discussed painting by Homer, "Winslow Homer's *The Veteran in a New Field*: A Study of the Harvest Metaphor and Popular Culture," *American Art Jour- nal* 17, no. 4 (Autumn 1985): 1–27.

10. Some of the more notable works which have looked at Homer's explo- ration of black subject matter include: Sidney Kaplan, "The Negro in the Art of Homer and Eakins," *The Massachusetts Review* 7 (Winter 1966): 105–20; Ell- wood Parry, *The Image of the Indian and Black Man in American Art: 1590–1900* (New York, 1974); Karen M. Adams, "Black Images in Nineteenth Century American Painting and Literature: An Iconological Study of Mount, Melville, Homer and Mark Twain" (Ph.D. diss., Emory University, 1977); Michael Quick, "Homer in Virginia," *Los Angeles County Museum of Art Bulletin* 24 (1978): 60– 81; Mary Ann Calo, "Winslow Homer's Visit to Virginia During Reconstruction," *American Art Journal* 12, no. 1 (Winter 1980): 4–27; Peter H. Wood, "Waiting in Limbo: A Reconsideration of Winslow Homer's *The Gulf Stream*" in Walter J. Fraser, Jr. and Winfred B. Moore, Jr., eds., *The Southern Enigma: Essays in Race, Class, and Folk Culture* (Westport, CT, 1983), pp. 76–94; Albert Boime, "Fran- cisco Oller and the Image of Black Peo- ple in the 19th Century," *Horizontes* 28 (April 1985): 35–77; and David Park Curry, "Homer's *Dressing for the Carni- val*" (Paper delivered at Winslow Homer: A Symposium, National Gallery of Art/Center for Advanced Study in the Visual Arts, Washington, D. C., 18 April 1986); Marc Simpson, "*The Bright Side*: 'Humorously Conceived and Truthfully Executed'" in Marc Simpson, *Winslow Homer Paintings of the Civil War*, Exhibi- tion catalogue, The Fine Arts Museums of San Francisco, 1988, pp. 46–63.

11. Historian Leon F. Litwack writes convincingly about the consequences of emancipation. Almost across the board, white planters, overseers, managers, and

sympathetic journalists chose to look at the lower levels of productivity on the plantations in terms of the "inherent laziness" and "limited capacity of the African race." Rarely did they ever take into consideration that choosing one's own leisure time was, itself, a much coveted aspect of this new found freedom for former slaves. See Leon F. Litwack, *Been in the Storm So Long: The Aftermath of Slavery* (New York, 1979), pp. 342–46. Homer, as shown, in *The Bright Side*, was aware of this debate, as was the unknown American artist who, in the mid-nineteenth century, painted a black child reclining on a lawn, alongside scattered fruit, embroidered cloth, and elegant dishes. This painting, which was once attributed to Eastman Johnson, carries the provocative title, *Labor Question in the South* (Hartford, Wadsworth Atheneum); see John I. H. Baur, *An American Genre Painter: Eastman Johnson, 1824–1906*, Exhibition catalogue, Brooklyn, Brooklyn Museum and Brooklyn Institute of Arts and Sciences, 1940, p. 44, pl. 16.

12. For a discussion of the special role that mules played in the traditional South, see *Mules & Mississippi*, Exhibition catalogue, Jackson, Mississippi State Historical Museum, 1981. I am indebted to Prof. Peter Wood for introducing me to this fascinating exhibition catalogue. For a discussion of the folklore which surrounds mules and Afro-Americans, see William H. Wiggins, Jr., *O Freedom! Afro-American Emancipation Celebrations* (Knoxville, 1987), pp. 106–7.

13. Homer's usage of childhood themes as metaphors for universal issues is noted in Jules D. Prown, "Winslow Homer in His Art," *Smithsonian Studies in American Art* 1, no. 1 (Spring 1987): 34–37.

14. Even "progressive" whites like Thomas Wentworth Higginson—the celebrated colonel of the First South Carolina Volunteers (an all-black Civil War regiment)—harbored paternalistic attitudes toward blacks. Oddly enough, Higginson could both argue for blacks having leadership roles in the military and then remark on their "childish" nature. Thomas Wentworth Higginson, *Army Life in a Black Regiment* (1870; reprint ed., New York: Norton paperbacks, 1984), pp. 67–71.

15. W. E. B. Du Bois devotes an entire chapter to the founding of public schools for emancipated blacks in his seminal work, *Black Reconstruction: An Essay toward a History of the Part which Black Folk Played in the Attempt to Reconstruct Democracy in America, 1860–1880* (1935; reprint ed., New York, 1983), pp. 637–69.

16. Homer's propensity for undercutting seemingly simplistic, post-Civil War narratives with proto-modern, anachronistic elements was addressed by Professor Roger Stein in his lecture, "Winslow Homer and his Literary Contemporaries: The Structure of Art" (Paper delivered at Winslow Homer: A Symposium, National Gallery of Art/Center for Advanced Study in the Visual Arts, Washington, D. C., 18 April 1986). Homer's relevance for late twentieth-century artists who also subvert artistic conventions is exemplified in an offset lithograph, *Detail of The Bright Side* (1977), by northern California artist William Wiley. In this print, Wiley zooms in on the pipe-smoking, almost detached head which sticks out of the tent in Homer's painting of the same name. This detail, framed by Wiley with personal messages and quotes from Joseph Conrad's *The Nigger of the "Narcissus"*, American Indian testaments, and a Japanese Samurai warrior's oath, complements the abrupt yet forceful image which Homer painted. I thank Jock Reynolds and Suzanne Hellmuth for bringing Wiley's print to my attention.

17. Homer's painting visualizes a post-emancipation fantasy: the reunion of former masters and former slaves, and the resulting exchange of greetings, inquiries, and/or resolutions. Following emancipation countless newspapers and private presses published actual letters between former slaves and their owners which supplied the real-life dialogue for Homer's image. One of the more celebrated of these "confrontational" epistles is the letter from "old servant" Jourdan Anderson to "Old Master" Colonel P. H. Anderson of Big Springs, Tennessee. Jordan Anderson's letter was first published in the *Cincinnati Commercial* in August 1865 and, shortly thereafter, reprinted in the *New York Tribune* and in Lydia Maria Child's *The Freedmen's Book*; see Litwack, *Been in the Storm So Long*, pp. 333–35.

18. For a late nineteenth-century description of "John Coonahs" in North Carolina, see Rebecca Cameron, "Christmas on an Old Plantation," *Ladies' Home Journal* 9 (December 1891): 5. The two definitive texts on Jonkonnu's African, Caribbean, and U. S. manifestations are Judith Bettelheim, "The Afro-Jamaican Jonkonnu Festival: Playing the Forces and Operating the Cloth" (Ph.D. diss., Yale University, 1979), and Elizabeth A. Fenn, "'A Perfect Equality Seemed to Reign': Slave Society and Jonkonnu," *North Carolina Historical Review*, 65, no. 2 (April 1988): 127–153. Also see Wiggins, *O Freedom!*, pp. 25–34.

19. As with many students of American art today, I have benefited greatly from the insights and pioneering work of art historian Jules David Prown. My initial investigations into Winslow Homer's panoply of black images—and specifically, the possible links between his *Dressing for the Carnival* and the *Frank Leslie's* illustration—first took place in a 1980 Yale University graduate seminar on Winslow Homer, conducted by Professor Prown. I thank him and the other participants in that seminar for introducing me to the many issues which surround this important artist's work. Recent conversations with a Homer expert and National Museum of American Art Predoctoral Fellow, Judith Hayward, have also been helpful.

20. Commenting on the desperate situation which blacks and whites found themselves in during this period, one historian wrote: "There was in those Southern states . . . much disorder, and a condition of lawlessness toward the blacks—a disposition, greatest in the more distant and obscure regions—to trample them underfoot, to deny the equal rights, and to injure or kill them on slight or no provocations. The tremendous change in the social arrangements of the Southern whites had suffered a defeat which was sore to bear, and on top of this, they saw their slaves—their most valuable and cherished property—taken away and made free, and not only free, but their political equals. One needs to go into the far South to know what this really meant, and what deep resentment and irritation it inevitably bred." Charles Nordhoff, *The Cotton States in the Spring and Summer of 1875* (New York, 1876), p. 16. Homer's usage of the term "the Carnival" may have had ironic implications. Indeed, blacks prepared themselves for the worst of times during the violent, inflation-ridden decade of the 1870s, as did many other disillusioned Americans. For another sarcastic twist on Homer's terminology, see the editorial, "Crumbs of the Carnival," *Frank Leslie's Illustrated Newspaper* 38, no. 969 (25 April 1874): 98.

PETER WOOD/KAREN DALTON

1. Letter to Colonel George G. Briggs, in Lloyd Goodrich, *Winslow Homer* (New York, 1944), p. 163.

2. For a reconsideration that links the image to the Afro-American experience, see Peter H. Wood, "Waiting in Limbo: A Reconsideration of Winslow Homer's *The Gulf Stream*," in Walter J. Fraser, Jr. and Winfred B. Moore, Jr., eds., *The Southern Enigma: Essays in Race, Class, and Folk Culture* (Westport, CT, 1983), pp. 76–94.

3. *New York Times*, 9 April 1880, p. 5.

4. Ibid. White predecessors such as John Singleton Copley and William Sydney Mount, and contemporaries such as Eastman Johnson and Thomas Hovenden, depicted important black subjects, to name only several of the most familiar. See Sidney Kaplan, *The Portrayal of the Negro in American Painting*, Exhibition catalogue, Brunswick, Maine, Bowdoin College Museum of Art, 1964; Ellwood Parry, *The Image of the Indian and the Black Man in American Art, 1590–1900* (New York, 1974); Karen M. Adams, "Black Images in Nineteenth-Century American Painting and Literature: An Iconological Study of Mount, Melville, Homer and Mark Twain," (Ph.D. diss., Emory University, 1977).

Despite significant pressures not to depict black subjects, the nineteenth century's leading Afro-American artists did so nonetheless, including Joshua Johnson, Robert S. Duncanson, Edward Bannister, Henry O. Tanner, and the sculptress Edmonia Lewis. See Elsa Honig Fine, *The Afro-American Artist: A Search for Identity* (New York, 1973); Carolyn J. Weekley et al., *Joshua Johnson: Freeman and Early American Portrait Painter*, Exhibition catalogue, Williamsburg, The Abby Aldrich Rockefeller Folk Art Center, 1987; Lynda Roscoe Hartigan, *Sharing Traditions: Five Black Artists in Nineteenth-Century America*, Exhibition catalogue, Washington, D. C., National Museum of American Art, 1985.

5. Personal factors undoubtedly help explain this recurrent theme. The artist's own father, for instance, had left home to join the Gold Rush of '49, leaving behind for several years his wife and sons, when Winslow was still at an impressionable age. But this was doubtless only one of many complex factors in determining why Homer later seemed to identify often with those "left behind" or located, with few resources and little power, on the outskirts of the white male adult world. As a bachelor who eventually retreated to the rocky Maine coast, he clearly saw himself as destined to reside one step removed from mainstream, entrepreneurial, urban America.

Blacks, like children and women, may have come to hold a certain fascination and positive attraction for him as persons obliged to live on the fringes of the dominant society. Scholars have noted how often Homer composed outdoor scenes from the perspective of the hunted deer or fish, and seascapes from the vantage point of the mothers and children left behind on shore. The more successful efforts to begin to examine Homer's personal motives as an artist include David Shapiro, "Barbaric Simplicity," *ARTnews* 71, no. 3 (May 1972): 29–31, 60; John Wilmerding, "Winslow Homer's *Right and Left*," *Studies in the History of Art* 9 (1980): 59–85; Henry Adams, "Mortal Themes: Winslow Homer," *Art in America* (February 1983): 112–26; Jules D. Prown, "Winslow Homer in His Art," *Smithsonian Studies in American Art* 1, no. 1 (Spring 1987): 31–45.

6. Goodrich, *Homer*, pp. 3–4.

7. Ibid., p. 5.

8. George W. Sheldon, *American Painters* (New York, 1878), p. 27.

9. David F. Tatham, "Winslow Homer

in Boston: 1854–1859" (Ph.D. diss., Syracuse University, 1970) provides a detailed discussion of Homer's early career. Chapter I, "Painting in Boston, 1820–1850," provides an excellent overview of the artistic environment in which Homer grew up. Also see the fascinating case study of a New England family in Diana Korzenik, *Drawn to Art: A Nineteenth-Century American Dream* (Hanover, NH, 1985), which uses a Homer watercolor, *Blackboard* (1877), as the frontispiece to introduce issues surrounding the widespread interest at this time in learning to draw.

10. On the matter of subtle personal influences between different generations, regions, and races, consider the recollections of another Cambridge resident, abolitionist Thomas Wentworth Higginson, who graduated from Harvard in 1841, at age eighteen, and would later command black troops in South Carolina during the Civil War: "I can truly say that my discovery of the negro's essential manhood first came, long before I heard of the anti-slavery agitation, from a single remark of a slave made to my mother when she was traveling in Virginia in my childhood. After some efforts on her part to convince him that he was well off, he only replied, 'Ah! Missis, free breath is good!' There spoke, even to my childish ear, the instinctive demand of the human being. To this were afterwards added my own observations when visiting in the same state during a college vacation, at the age of seventeen, and observing the actual slaves on a plantation; which experience was afterwards followed by years of intimate acquaintance with fugitive slaves in Massachusetts." Thomas Wentworth Higginson, *Part of a Man's Life* (Boston, 1905), pp. 117.

11. One of Homer's friends, Hubbard Winslow Bryant, was also named for the preacher. Gordon Hendricks, *The Life and Work of Winslow Homer* (New York, 1979), pp. 12–13; Milton Rugoff, *The Beechers: An American Family in the Nineteenth Century* (New York, 1981), pp.

77–78, 100–101. On the close affinity between artistic, middle-class women and their liberal clergymen in New England at this time, see Ann Douglas, *The Feminization of American Culture* (New York, 1977), esp. chap. 3, "Ministers and Mothers."

12. Truman Nelson, ed., *Documents of Upheaval: Selections from William Lloyd Garrison's "The Liberator," 1831–1865* (New York, 1966), pp. 96, 114–16. Wright recalled a meeting of ministers where Hubbard Winslow said that "the abolitionists were utterly beneath any notice; that Garrison was a low-lived, ignorant, insignificant mechanic; that he was connected with no church, and responsible to nobody; that the abolitionists, as a body, were among the poorest, obscurest and most ignorant of people. . . ." Idem, *Documents of Upheaval*, p. xiii.

13. Thomas Wentworth Higginson, *Army Life in a Black Regiment* (1870; Lansing, 1960), p. ix.

14. "Churches still had negro pews, these being sometimes boarded up in front, so that the occupants could only look out through peep-holes, as was once done in the old Baptist meeting-house at Hartford, Connecticut, where a negro had bought a pew and refused to leave it. Or the owner might be ejected by a constable, as happened in Park Street Church, Boston; or the floor be cut from under the negro's pew by the church authorities, as happened in Stoughton, Massachusetts. Even in places like the Quaker town of New Bedford, where pupils of both colors were admitted to the public schools, the black boys were seated by themselves, and white offenders were punished by being obliged to sit with them." For this quote and the one in the text, see Higginson, *Part of a Man's Life*, pp. 118–19.

15. In 1852–53, Charles Homer followed Frémont to London and Paris, finally obtaining a mining lease from the increasingly popular hero of California.

Hendricks, *Life and Work*, p. 29.

16. The following year, after passage of the Fugitive Slave Act, Winslow would have heard about "Freedom's Fight" at Christiana, Pennsylvania, where blacks resisted arrest by a posse from Maryland seeking escaped slaves. This dramatic affair aroused intense interest, and several dozen persons were put on trial in Philadelphia's Independence Hall in the largest treason case in American history. In the nineteenth century this incident came to rank with John Brown's later raid on Harper's Ferry as a key episode in precipitating the Civil War and ending slavery. But later historians allowed it to slip into oblivion, perhaps because black ex-slaves rather than white abolitionists led the action. For a fascinating reconstruction, see Jonathan Katz, *Resistance at Christiana* (New York, 1974).

17. Leon Litwack, *North of Slavery* (Chicago, 1961), pp. 250–51.

18. Mrs. Stowe was about the same age as the Homers, and Charles would undoubtedly have remembered the minister's daughter from the Hanover Street Church two decades earlier. It would be most surprising if her melodramatic story of the noble life and death of a black man did not enter the Homer household.

19. The year 1856 was one of violent upheaval, as national efforts at compromise over the slavery issue gave way to open conflict, particularly in Kansas, where hundreds of proslavery advocates sacked the Free-Soil town of Lawrence, and abolitionist John Brown retaliated by leading a deadly raid at Pottawatomie Creek. Kansas would become the dominant issue in election year politics, and the new Republican party, bent on keeping slavery out of the western territories, would nearly capture the White House when General Frémont—"The Conquerer of California," whom Homer's father had followed admiringly—made a surprisingly strong showing in the 1856 presidential contest. At the same time

that violence erupted in "bleeding Kansas," bloodshed also occurred within the very sanctum of Congress itself. The Caning of Sumner shocked and polarized the entire nation. Harlan Joel Gradin at the University of North Carolina-Chapel Hill has generously shared with us his Master's essay on this subject. His dissertation on the Caning promises to be suggestive.

20. David F. Tatham, "Winslow Homer's *Arguments of the Chivalry*," *American Art Journal* 5, no. 1 (May 1973): 88.

21. David Donald, *Charles Sumner and the Coming of the Civil War* (New York, 1960), p. 307.

22. In Sumner's home state citizens were particularly aroused. Edward Everett commented that when word of the assault reached Boston, "it produced an excitement in the public mind deeper and more dangerous than I have ever witnessed." More than 5,000 people attended an "indignation meeting" at Faneuil Hall to vent their anger. Similar rallies occurred in Cambridge, where Sumner was a familiar figure, and in Concord, home of Sumner's friend, Ralph Waldo Emerson. See ibid., pp. 300–301, 311.

23. *New York Times*, 31 May 1856. The next Sunday, 1 June, Beecher gained further publicity for introducing a fugitive slave from Virginia at his renowned Plymouth Church in Brooklyn and reenacting an auction of the young woman before the huge and emotional congregation. Later, he would raise money in this way to buy the freedom of several other slaves, most notably a little girl named Pinky, for whom he took up a collection in February 1860. "Rose Terry, a famous writer of that day, threw a valuable ring into the basket, and this Mr. Beecher took out and placed on the child's finger, saying: 'With this ring do I wed thee to freedom.'" (This incident became the motivation for Eastman Johnson's 1860 painting, *The Freedom Ring*.) Charles Morris, "How Henry Ward Beecher Sold Slaves in Plymouth Church," in Harriet Beecher Stowe, *Uncle Tom's Cabin* (Art Memorial Edition, Chicago, 1897), pp. 17–23.

24. That same year Homer drew all forty-two members of the Massachusetts senate from photographs—one a day for five dollars a week—in an assemblage that one biographer calls "a tour de force of such work." Hendricks, *Life and Work*, pp. 23, 27. (These same men voted to condemn the Caning, and their resolutions were debated fiercely by the Congress in Washington.)

25. Tatham, "Winslow Homer in Boston," pp. 139–48.

26. *Harper's* ran belittling cartoons about the impact of Brown's action in its issues of 19 and 26 November, but the editors suppressed a negative account of the hanging "after sympathy for Brown swept the North." Daniel Aaron, *The Unwritten War: American Writers and the Civil War* (New York, 1973), p. 248n. Cf. James M. McPherson, *Battle Cry of Freedom: The Civil War Era* (New York, 1988), pp. 206–13.

27. See Charles J. Montgomery, "Survivals from the Congo of the Slave Yacht *Wanderer*," *American Anthropologist* 10 (1908): 611–21, and Gene Gleason, "The *Wanderer*: Racing Yacht to Slave Ship," *Southern Exposure* 12 (March/April 1984): 59–62.

28. W. E. B. Du Bois, *The Suppression of the African Slave Trade in America, 1638–1870* (Cambridge, 1896), p. 191, n. 298. *Harper's Weekly* (2 June 1860): 344, reported the sickly condition of many "passengers" and noted that the "well ones" engaged in "monotonous" songs with "words we did not understand."

29. The somewhat caricatured and detached portrayal of an integrated meeting in *Harper's Weekly* (28 May 1859) probably depicted the gathering of 12 May 1859 at New York City's Shiloh Presbyterian Church in honor of the deceased abolitionist leader, Judge William Jay. See John W. Blassingame, ed., *The Frederick Douglass Papers*, Series One, *Speeches, Debates, and Interviews*, vol. 3 (New Haven, 1985), p. 249 (hereafter cited as *Douglass Papers*).

30. *Douglass Papers* 3: 387–88, 404, 407.

31. *Harper's Weekly* (15 December 1860): 787, 788.

32. *Harper's Weekly* (10 November 1860). (Brady's picture was thought to have aided the Republican Lincoln considerably in his close victory over Stephen Douglas.) A month later the weekly published Homer's dour portrait of Chief Justice Roger B. Taney, author of the Supreme Court's momentous 1857 Dred Scott decision precluding any prospect of full citizenship for slaves and their descendents. *Harper's Weekly* (8 December 1860).

33. Another figure from *Arguments*, Robert Toombs (soon to be the Confederacy's first secretary of state), appeared in a Homer portrayal of Georgia's congressmen for the *Harper's Weekly* of 5 January 1861, and a similar picture of the seceding Mississippi delegation for 2 February featured Senator Jefferson Davis. After the shelling of Fort Sumter Homer initialed a full-length image of General P. G. T. Beauregard for the *Harper's* of 27 April.

34. Sheldon, *American Painters*, p. 28.

35. Open letter of introduction dated 8 October 1861, in the handwriting of editor/publisher Fletcher Harper and signed "Harper & Brothers." Reproduced in Marc Simpson, *Winslow Homer: Paintings of the Civil War*, Exhibition catalogue, San Francisco, The Fine Arts Museums of San Francisco, 1988, p. 18.

36. Letter of 28 October 1861, quoted in Hendricks, *Life and Work*, p. 45.

37. Sally Mills, "A Chronology of Homer's Early Career, 1859–1866" in Simpson, Homer, p. 18. An unusual oil study on canvas entitled The Shackled Slave, now in the collection of Mr. and Mrs. Paul Mellon, may date from this brief trip—if Homer created the work at all. The signed and dated canvas shows a black man seated on the ground, with chains on his ankles and clothed only at the waist. But the final digit of the date is difficult to decipher, and the picture's uncertain provenance and style have prompted some experts to declare it a forgery. The picture could well be the work of a young artist who has recently been taking classes in life drawing and oil painting. Should The Shackled Slave ever be authenticated, this study of a lone figure, his head drawn forward toward his bent knees in a posture of silent despair, would represent an important addition. (See reproduction in Hendricks, Life and Work, p. 56.)

Significantly, not only were shackled slaves still highly visible in the Washington area, but a controversy had recently erupted over the local practice of confining black men and women to prison and then selling them into slavery at a profit. See the illustrated front-page story, "Persecution of Negroes in the Capitol—Astounding Revelations," in Frank Leslie's (28 December 1861).

38. George B. Forgie, Patricide in the House Divided: A Psychological Interpretation of Lincoln and His Age (New York, 1979), pp. 168–73, 181–82, 188; Thomas Nelson Page, Mount Vernon and Its Preservation, 1858–1910 (New York, 1910). In the capital, the intended monument for Washington had risen scarcely a quarter of the projected height since its commencement in 1848, and by the time Homer might have viewed the unfinished base in 1861, its grounds near the Potomac marshes were being used to graze cattle for Union troops. Frank Friedel and Lonnelle Aikman, Washington, Man and Monument (Washington, D. C., 1965), pp. 35–44.

39. Eastman Johnson, Washington's Kitchen at Mount Vernon, Cummer Gallery of Art, Jacksonville, inv.: C.117. See Patricia Hills, The Genre Painting of Eastman Johnson: The Sources and Development of his Style and Themes (New York, 1977), pp. 54–55. In the late 1840s Johnson had been in Cambridge painting portraits of Sumner, Longfellow, and others. Patricia Hills, Eastman Johnson, Exhibition catalogue, New York, Whitney Museum of American Art, 1972, pp. 8–10. If Homer did not meet Johnson as a youth in Cambridge, he certainly knew him later, since both rented studio space in the University Building in New York during the 1860s.

40. The technique was one which Homer would use repeatedly in later years. Describing a picture from Burmuda at the end of the century, Helen Cooper writes, "we are drawn back to this tiny note of red and black in the center of the composition." Helen A. Cooper, Winslow Homer Watercolors, Exhibition catalogue, Washington, D. C., National Gallery of Art, 1986, p. 220.

41. The Songs of War in Harper's Weekly (23 November 1861):744–45. For a "Check List of Lithographs Put on Stone by Winslow Homer" involving sheet music title pages made during his apprenticeship, see Tatham, "Winslow Homer in Boston," pp. 77–97.

42. In a Dickensian illustration of the previous year entitled Thanksgiving Day, 1860—The Two Great Classes of Society, Homer divided the picture down the middle, as suited a two-page spread, and put the darker and more ambiguous scenes on the right—an approach he would often repeat in later years. Harper's Weekly (1 December 1860):760–61. For a fine discussion of Homer's compositional balancing, see John Wilmerding, "Winslow Homer's Right and Left," Studies in the History of Art 9 (1980):59–85.

43. Massachusetts troops had helped to spread the song, "John Brown's Body

lies a-mouldering in the grave," through the Union army. "We had Col. Leonard's regiment on their way to the war also, and the 'John Brown War song' was sounding through the streets all the evening," Thomas Higginson recorded in Worcester during August. "I never heard anything more impressive and it seemed a wonderful piece of popular justice to make his name the War song." Mary Thatcher Higginson, Thomas Wentworth Higginson: The Story of His Life (1914; reprint ed., Port Washington, NY, 1971), pp. 208–9.

44. The Atlantic Monthly published Howe's verses, and the new National Hymn Commission immediately gave official sanction to the title. See Page Smith, Trial by Fire: A People's History of the Civil War and Reconstruction (New York, 1982), pp. 141–42.

45. A cartoon in Frank Leslie's from the same time (21 December 1861, p. 80) depicts the Confederacy as a huge circus float, with "Davis's Vagrant Acrobats" being pulled along by pairs of Negro workers.

46. Hans Nathan, Dan Emmett and the Rise of Early Negro Minstrelsy (Norman, 1962), chap. 16.

47. Letter of September 1831 from "Nero" in Ira Berlin, "After Nat Turner: A Letter from the North," Journal of Negro History 55 (April 1970):144–51.

48. Letter of Higginson to James Shepherd Pike, Washington correspondent for the New York Tribune, 9 February 1857, quoted in Robert F. Durden, "Ambiguities in the Antislavery Crusade of the Republican Party" in Martin Duberman, ed., The Antislavery Vanguard (Princeton, 1965), p. 371.

49. Langston Hughes, Milton Meltzer, and C. Eric Lincoln, A Pictorial History of Blackamericans (New York, 1973), p. 84. During the fall of 1861, drawings frequently suggested that the Confeder-

acy was playing with dynamite in its effort to prove that cotton was still king. Specifically, as Union ships sailed toward South Carolina during the fall, speculation hinged upon whether Sea Island planters could compel their slaves to pick the current cotton crop and could then ship it to Europe through a blockade, or whether slaves and cotton alike might fall to the Yankees. No doubt Homer had seen drawings such as the one which shows a central black man shouldering a live bomb instead of a bale of cotton, and these may have influenced his sketch for the final engraving.

50. Benjamin Quarles, *The Negro in the Civil War*, new ed. (Boston; paperback edition, 1969), pp. 58–61. See Theodore R. Davis, *The Arrival of the Original Contraband at Fortress Monroe*, after a sketch by the artist, 1861, in Stephen W. Sears, ed., *The American Heritage Century Collection of Civil War Art* (New York, 1974), pl. 13.

51. In Missouri on 30 August, General John C. Frémont brought jubilation to local blacks and fellow abolition sympathizers by issuing an order that freed all the slaves in the state belonging to rebel masters. "The hour had come, and the man!" exulted Harriet Beecher Stowe, writing for her brother's newspaper. "The hero of the golden gate who opened the doors of that splendid new California world has long been predestined in the traditions of the slave as their coming Liberator." But Lincoln, who would later accept the title of Liberator for himself, remained more cautious than his Republican rival. Anxious not to offend the border states, the president reprimanded his new Commander of the Western Department and modified the proclamation to conform with the recent Confiscation Act.

52. Quarles, *The Negro in the Civil War*, p. 69.

53. *New York Tribune*, 7 December 1861.

54. In a patronizing cliché that would be repeated throughout the war, the correspondent called the exodus "the most laughable and at the same time pitiable sight I ever witnessed." *Harper's Weekly* (17 August 1861): 524, 527. Significantly, this same issue contained long excerpts from General Butler's letter justifying his contraband policy (p. 515). Robert F. Engs, *Freedom's First Generation: Black Hampton, Virginia, 1861–1890* (Philadelphia, 1979).

55. Word of the contrabands aroused great curiosity on the home front, where slave culture had long been known only through secondhand reports and crude minstrelsy imitations and parodies. During a fall that had few battles, thousands of soldiers and sailors with time on their hands passed along their varied first impressions of escaping slaves to the folks back home. Young Arthur Homer, for instance, may well have written home from Florida coastal waters after his ship, the *Kingfisher*, took aboard half a dozen starving contrabands who had been surviving on roots and using a tattered blanket as the sail for their flimsy boat. Quarles, *The Negro in the Civil War*, p. 62.

56. Dena J. Epstein, *Sinful Tunes and Spirituals: Black Folk Music to the Civil War* (Urbana, 1977), pp. 242–48, 363–73. Hendricks, *Life and Work*, p. 26, shows that several early Homer sheet-music covers "were manufactured by Bufford for the famous music house of Oliver Ditson & Company; this same Ditson was depicted by the artist in a *Harper's Weekly* drawing of April 2, 1859."

57. *Harper's Weekly* (21 December 1861): 808–9. Also on 21 December, the *Anti-Slavery Standard* reprinted "The Contrabands' Freedom Hymn," reporting that it had "been sung for at least fifteen or twenty years in Virginia and Maryland, and perhaps all the slave states, though stealthily, for fear of the lash; and is now sung openly by the fugitives who are living under the protection of our

government and in the enjoyment of Mr. Lockwood's ministry." See also Joe M. Richardson, *Christian Reconstruction: The American Missionary Association and Southern Blacks, 1861–1890* (Athens, 1986).

58. Homer frequently repeated individual figures in his work. This one, for example, reappeared a year later at the far left of *Thanksgiving in Camp* in *Harper's Weekly* (29 November 1862): 764.

59. The actual motion Homer depicts may resemble the Negro jigs and reels that black dancers such as William Henry Low ("Master Juba") had performed in minstrel shows before the war. This would have been more identifiable to his Northern audience than a depiction of some less familiar "buck dance." See Lynne Fauley Emery, *Black Dance in the United States from 1619 to 1970* (New York, 1980).

60. In November, for example, the *Atlantic Monthly* had carried a full discussion of "The Contrabands at Fort Monroe." Homer's picture struck a responsive chord even in Europe. Assuming the picture applied to the Sea Islands, a French artist made it over into a print entitled *Guerre d'Amérique—Bivouac des fédéraux dans la Caroline du Sud.* The Schomburg Center for Research in Black Culture, New York, owns a copy of this engraving.

61. Cf. e.g., *Frank Leslie's* (31 January 1863): 292; *Frank Leslie's* (10 September 1864): 385; *Harper's Weekly* (6 July 1867): 420.

62. *Frank Leslie's* (22 February 1862): 212.

63. See Peter H. Wood, " 'Gimme de Kneebone Bent': African Body Language and the Evolution of American Dance Forms," plus other essays and bibliography in the 1988 booklet entitled *The Black Tradition in American Modern Dance*, distributed by the American Dance Festival, Durham, NC.

64. *Frank Leslie's* (7 June 1862): 160.

65. *Harper's Weekly* (11 January 1862): 18, reported that refugees at Fort Monroe were being paid small cash wages for their services, but that donations were needed to augment inadequate shelter and winter clothing. "There are about fifteen hundred contrabands, of whom six hundred are women. The Government partly supplies the men whom it employs with coat, trowsers, shoes, and hat; but furnishes none for women and children, and no under-clothing for any. The quarters are still insufficient, and these people are painfully crowded. . . . And it is not only at Fort Monroe that the aid will be needed. . . . Deserted by their masters, or flying to a flag which they believe to be the the flag of liberty, the responsibility of caring for them is thrown upon us. We neither can nor ought to avoid it. We must direct their industry, and we must see that they do not suffer. *Our duty is not done when circumstances have freed them. The long arrears of injury to a race are not settled quite so easily.* But the question is manageable now, and it will be our fault if it becomes unmanageable. It is not the fault of the poor contrabands that they are cold and hungry." (Italics added.)

66. Losses for the Ninth Louisiana Regiment, USCT, amounted to "45 per cent of its strength, the highest per cent in killed and wounded suffered by any unit in a single engagement during the course of the war. Milliken's Bend was thus one of the hardest fought encounters in the annals of American military history. Its lesson was not lost on the Union high brass: 'The bravery of the blacks at Milliken's Bend,' observed Assistant Secretary of War Charles A. Dana, "completely revolutionized the sentiment of the army with regard to the employment of Negro troops.'" Quarles, *The Negro in the Civil War*, p. 224.

67. *Frank Leslie's* (16 January 1864): 264–65, 267.

68. Letter of 17 December 1861 from Homer's mother to his brother Arthur, quoted in Hendricks, *Life and Work*, p. 45.

69. Pass signed by Homer and dated 1 April 1862, granting the bearer "permission to pass to and from VIRGINIA." Homer Collection, Bowdoin College Museum of Art, Brunswick, Maine. The sketch is reproduced in Lucretia Hoover Giese, "Winslow Homer: Painter of the Civil War" (Ph.D. diss., Harvard University, 1985), vol. 2, fig. 29.

70. *Harper's Weekly* (7 March 1863): 150.

71. For an excellent overview of the black teamsters and their work, see Simpson, *Homer*, pp. 201–6. For illustrations by other artists, see *Gen. Robert M'Cook Waylaid by Rebel Guerillas while Sick and Wounded in His Ambulance, on His Way from Salem, Alabama, to Join His Brigade* in *Frank Leslie's* (30 August 1862), and *The Negro Drivers of the Baggage Train, Attached to Gen. Pleasanton's Cavalry Brigade, Watering Their Mules in the Rappahannock* in ibid. (30 August 1862): 201.

72. This time the figure holds a pipe, which puts him one step closer to the figure who will pop his head through the opening of the canvas tent in *The Bright Side*. *Smoke* was one of many derogatory terms used to describe a black person.

73. In a useful discussion of Northern racism, Geise ("Winslow Homer," p. 75) quotes a pro-Southern New York newspaper called *The Caucasian* (15 March 1862) which protested: "All persons of a 'loyal color' are now liberally provided for by Uncle Sam, not only with bread and dinner, but even clothes." Also see Basil Leo Lee, *Discontent in New York City* (Washington, 1943), chap. 4; Forrest G. Wood, *Black Scare: The Racist Response to Emancipation and Reconstruction* (Berkeley, 1968), chap. 1; George M. Fredrickson, *The Black Image in the White Mind: The Debate on Afro-American Character and Destiny, 1817–1914* (New York, 1972).

74. Hendricks, *Life and Work*, pp. 50–51. All the lithographs are reprinted in Lloyd Goodrich, *The Graphic Art of Winslow Homer*, Exhibition catalogue, New York, Museum of Graphic Art, 1968, pls. 13–24.

75. For black men preparing food, see *Scenes of Camp and Army Life in General Williams's Brigade* in *Harper's Weekly* (6 July 1861): 422, and *Camp in the Confederate Army—Mississippians Practicing with the Bowie-Knife* in ibid. (31 August 1861): 556.

76. David H. Wallace, *John Rogers: The People's Sculptor* (Middletown, CT, 1967), p. 202, no. 88 (illus.).

77. *Harper's Weekly* (11 January 1862): 21. Black cooks, such as Fleece in Herman Melville's *Moby Dick*, had long been familiar figures in American literature.

78. Quarles, *The Negro in the Civil War*, p. 222.

79. "Jim Williams," *Harper's Weekly* (28 March 1863): 196.

80. McPherson, *Battle Cry*, p. 564. "Once let the black man get upon his person the brass letters, U. S.," wrote Frederick Douglass the following year; "let him get an eagle on his button, and a musket on his shoulder and bullets in his pocket, and there is no power on earth which can deny he has earned the right to citizenship."

81. Simpson, *Homer*, p. 123.

82. Quarles, *The Negro in the Civil War*, pp. 161–62.

83. Ibid., pp. 174–76. For an 1870 engraving of blacks visiting their former master at year's end, see *infra*, fig. 31.

84. Hugh Honour, *The Image of the Black in Western Art*, vol. 4, *From the American Revolution to World War I*, part 1, pp. 196–98 (hereafter cited as Honour, *Im-*

age). We are grateful to the author for allowing us to consult page proofs of these books prior to their publication in 1989. Carlton made two versions of the picture, which may have been commissioned by his friend William Lloyd Garrison. Honour reports, "It was bought by a group of subscribers and sent in the summer of 1864 to Lincoln as 'the most fitting person in the world to receive it.'"

85. Willie Lee Rose, *Rehearsal for Reconstruction: The Port Royal Experiment* (New York, 1964), pp. 195–198.

86. *The Journal of Charlotte L. Forten*, ed. Ray Allen Billington (New York, 1961) p. 171.

87. Quarles, *The Negro in the Civil War*, pp. 171–73. *Douglass Papers*, 3 : 546–48.

88. *Harper's Weekly* (24 January 1863): 55. "At the top of the picture the Goddess of Liberty appropriately figures. The slaves have often heard of her before, but have rather regarded her as a myth."

89. The image of Lincoln minding the store was not uncommon. For a cartoon in which Dr. Lincoln, the druggist, prescribes heavy doses of medicine for "our Southern patient," see *Drawing Things to a Head* in *Harper's Weekly* (28 November 1863): 768.

90. Stefan Lorant, *Lincoln: A Picture Story of His Life*, rev. enl. ed. (New York, 1969), pp. 170–71,

91. The connection between blacks (long regarded as property to be sold) and scales (traditionally associated with justice) was an obvious one for preachers, politicians, and artists alike. In January *Harper's* had published, on the front of the issue containing Nast's *Emancipation*, a scene entitled *The New Orleans Market*, by Boston-born artist Theodore Russell Davis. It showed Union soldiers exchanging their rations for tastier local foods, and two black figures are closely associated with the victualer's hanging scales.

92. McPherson, *Battle Cry*, pp. 566, 559–60. The Democrats made substantial gains in the fall's off-year election but failed in their December attempt to push a resolution through the House calling emancipation "a high crime against the Constitution." Idem, *Battle Cry*, p. 562.

93. *Frank Leslie's* (5 April 1862): 352.

94. *Harper's Weekly* (7 March 1863): 150.

95. *Harper's Weekly* (10 January 1863): 17. "So much has been said about the wickedness of using the negroes on our side in the present war," the paper's lead story began. The New York editors regretted "there are still people here at the North who affect to be horrified at the enrollment of negroes into regiments. Let us hope that the President will not be deterred by any squeamish scruples of the kind from garrisoning the Southern forts with fighting men of any color that can be obtained."

96. *Harper's Weekly* (10 May 1862): 289, 299. The journal explained that Mr. Mead's sketch "represents a struggle between two negroes and a rebel captain, who insisted upon their loading a cannon within range of Berdan's Sharp-shooters. . . . The rebel captain succeeded in forcing the negroes to expose themselves, and they were shot, one after the other." On Berdan's Sharpshooters as observed by Homer and others in 1862, see the excellent essay of Christopher Kent Wilson in Simpson, *Homer*, pp. 25–45.

97. *Harper's Weekly* (17 January 1863): 34, 36. For an earlier discussion of "Negroes in the Rebel Army," see *Frank Leslie's* (1 March 1862): 230.

98. The same week that Homer's engraving appeared, a Massachusetts infantryman, standing picket duty at the front in eastern North Carolina, sketched, and *Harper's* promptly published *The Effects of the Proclamation—Freed Negroes Coming into Our Lines at Newbern, North Carolina* to illustrate the point that Lincoln's explosive message had been heard. The soldier reported that his company "was out on picket duty the night before our return to Newbern, when an old slave came in to us in a drenching rain; and on being informed that he and his friends could come to Newbern with us, he left, and soon the contrabands began to come in, with mule teams, oxen, and in every imaginable style. When morning came we had 120 slaves ready to start with their little all, happy in the thought that their days of bondage were over. They said that it was known far and wide that the President has declared the slaves free." *Harper's Weekly* (21 February 1863): 116, 119.

99. "We will rest the men and use the spade," Grant commented, having lost 65,000 soldiers killed, wounded, or missing in less than two months. McPherson, *Battle Cry*, pp. 741–43.

100. At the left side of *Prisoners*, both the landscape and the youngest Southern captive bear a close resemblance to *Inviting a Shot*. Barlow, the Union officer in *Prisoners*, was apparently present at Petersburg throughout the siege, though on 27 July his wife died of typhus in Washington. Simpson, *Homer*, pp. 247–59.

101. Ibid., pp. 181–87. In the 1909 painting of two ducks at the instant of death, both barrels of a shotgun have been discharged in the distance, and there, as with *Inviting a Shot*, we are literally caught in the line of fire, frozen helplessly to watch the roulette of the hunt from the perspective of the victim.

102. McPherson, *Battle Cry*, p. 758. Henry Pleasants, Jr., *The Tragedy of the Crater* (Washington, 1938), is by a cousin of the engineer who executed the unprecedented mining project, as is Henry Pleasants, Jr. and George H. Straley, *Inferno at Petersburg* (Philadelphia, 1961).

For a fine fictionalized account, see Richard Slotkin, *The Crater* (New York, 1981). Logically, Slotkin's dustjacket has a close-up from *Inviting a Shot*.

103. The emblematic significance of the Crater after the war can be sensed in the image, *The Lost Found, Harper's Weekly* (3 February 1866): 76. In 1876 the Virginia artist John A. Elder, who had been in New York in the late fifties and must have met Homer before or after the war, sent the Northern painter an inscribed photograph of his most celebrated work, *The Battle of the Crater*. Hendricks, *Life and Work*, p. 104.

104. The powder keg image had been driven home again a few months earlier in a *Harper's* cartoon, undoubtedly familiar to Homer and his audience, showing Jefferson Davis working at his desk, while an entire arsenal of explosives smolders dangerously in a vault beneath his feet. *Condition of the "Mining Bureau" Over Which Jeff Davis is Sitting* in *Harper's Weekly* (26 December 1863): 832.

105. Alfred R. Waud, *The Battle of the Crater* in *Battles and Leaders of the Civil War*, 4 vols. (New York, 1888) 4: 522. In this volume, see the articles of William H. Powell, "The Battle of the Petersburg Crater" and Henry Goddard Thomas, "The Colored Troops at Petersburg."

106. Geoffrey Regan, *Great Military Disasters* (New York, 1987), chap. 5. The Negro unit sustained losses approaching fifty percent in part because here at the Crater, as in other encounters, the presence of black freedmen angered Southern soldiers so much that they gave no quarter. Though 1,700 Northerners were taken captive, most of them were white.

107. The immediate official inquiry into reasons behind the "unsuccessful assault" was conducted by Major General W. S. Hancock, using his Second Corps headquarters as a courtroom. Since Homer's friend Barlow was an officer under Hancock, he was in an excellent position to observe the depressing proceedings, in which Grant and Meade both disguised their costly doubts about committing black troops in the vanguard.

108. For example, *Harper's Weekly* for 4 July 1863 showed black soldiers defending the American flag at Milliken's Bend (cf. fig. 11) and depicted the story of Gordon, a Mississippi slave who escaped to Union lines in Louisiana, served as a scout, was captured and badly beaten by rebel soldiers, but survived to return and join a Negro regiment. On the same page a single picture showed the entire evolution, as slaves on South Carolina's Combahee River leave the rice fields to join a gunboat manned by the black soldiers of the Second South Carolina Volunteers. Also see *Harper's Weekly* (2 July 1864): 422, 428, for pictures of an Alabama escaped slave who enrolls in the Union Army. Like Gordon, he is pictured first sitting in tatters, then standing in uniform, since the metaphor of "standing up" was crucial to the transition from slavery.

109. Sidney Kaplan, "The Black Soldier of the Civil War in Literature and Art," *The Chancellor's Lecture Series, 1979-1980* (Amherst, 1981): 16–17.

110. Goodrich, *Homer*, p. 17. On 12 December 1887 Homer wrote to James J. Higginson regarding his sketch of two of Sheridan's scouts, disguised in Confederate uniforms: "Interesting from the fact that they were drawn from life, when in advance of the Army on its last campaign March 28th 1865." Copy in the Lloyd Goodrich Papers, file on "Homer Letters 1860s, 1870s, 1880s," courtesy of the CUNY/Goodrich/Whitney Record of the Works of Winslow Homer.

111. The former, as Mark Simpson notes, offers an early depiction of the kind of carefree youths for which Homer would later become famous. Simpson, *Homer*, pp. 223-25. The latter depicts seasoned veterans of numerous campaigns whom Homer had sketched before. Idem,

Homer, pp. 47–63, 199–207.

112. Homer would return to this controversial theme—the balance between labor and rest for newly-freed black workers—in several Reconstruction paintings.

113. For blacks resting against Union tents, see *The Camp of the Contrabands* in *Frank Leslie's* (22 November 1862): 140. For a related Confederate scene by C. W. Chapman, see Mark E. Neely, Jr., Harold Holzer, Gabor S. Boritt, *The Confederate Image: Prints of the Lost Cause* (Chapel Hill, 1987), pl. 20.

114. Homer regularly chooses emblems that can be read on different levels. The cards in *Army Boots* can suggest shirking and gambling, or they can ask, like the cards in *Bivouac Fire*, who is really gambling with these young boys' lives? One can read the canteen beneath them as a stolen drink, or as the staff of life. Similarly in *The Bright Side* (called *Army Teamsters* in another version) viewers can see the foreground keg as containing liquor, thus implying a drunken stupor to the morning snooze, or filled with powder, underscoring that blacks occupy a precarious position, whether working or resting. Do the mules in the background suggest dumb and balky animals, or a vital military task well done?

115. The terms *bright* and *shine* associated with these pictures had racial connotations as well in the white vernacular of the day.

116. Honour, *Image*, vol. 4, pt. 1, p. 227.

117. A Boston-based children's magazine, *Our Young Folks* (July 1866): 393-98, carried a piece on Homer called "Among the Studios" (alongside a story by Thomas Wentworth Higginson). The artist provided an engraving of *The Bright Side*, cropped to omit the assertive pipe-smoker and the loaded barrel—one of many examples of his willingness to alter images and meanings for the illustrated press. T. B. Aldrich gave a revealing and

supposedly humorous account of how Homer completed the picture in New York, hiring off the street as the model for all the figures a former slave from Virginia who "was engaged in the lucrative profession of bootblack,—a profession of which he is still a shining ornament." The author tells, with all the exaggeration and stereotypes of a minstrel show, how the black man panicked when Homer supposedly got him up to the studio and locked the door. The demeaning anecdote seems designed to obliterate the hints of openness and meaningful confrontation that infuse the actual painting. (It is revealing that Aldrich could see only "Three picturesque-looking Contrabands, loving the sunshine as bees love honey." He chose to overlook the fourth reclining man, who wears an army cap and may dream of becoming, or already be, a Union soldier.)

118. Simpson, *Homer*, p. 241. Cf. Honour, *Image*, vol. 4, pt. 1, p. 229: "She is the first of the sturdy, statuesque black women in Homer's oeuvre, still a slave but depicted in a way that makes a better claim for blacks to be regarded as equals than all the pathetic images that ostensibly protested against slavery."

119. One Thomas Nast picture depicting *A Group of Union Prisoners Escorted Through a Rebel Town* contrasted the reactions of whites and blacks to the federal captives. *Harper's Weekly* (13 June 1863): 373. According to the editor (p. 375): "The mingled curiosity and hatred with which they are regarded by some of the spectators, and the half-disguised sympathy shown them by others, especially the negroes, are well portrayed in the picture."

120. *Harper's Weekly* (14 June 1862): 373. Fence rails, like door sills, often served to denote issues of social hierarchy and status inversion when invoked in a racial context. "Hello, massa," said a black soldier who found himself guarding his former master as a Confederate prisoner in 1865; "bottom rail on top dis

time!" McPherson, *Battle Cry*, p. 862.

121. This same issue contains related material. One picture shows Robert Smalls, a black man who piloted the rebel gun-boat *Planter* past the Charleston Battery and delivered it to Union forces. Another shows a black woman in a kerchief outside a row of slave cabins, *Feeding the Negro Children Under Charge of the Military Authorities at Hilton Head, South Carolina*. A third, by Winslow Homer, summarizes aspects of *News From the War*. It contains a vignette regarding news "From Richmond" in which a handsome black woman with her basket of vegetables glances at two Confederate veterans on her right, in a scene that seems to prefigure *Near Andersonville*.

122. *Harper's Weekly* (7 January 1865): 10. The preceding page contained an *Interior View of the Prison-Pen at Millen, Georgia*, one of the first depictions to reach the North of the devastating conditions in the South's POW camps.

123. See, for example, the 1864 sculpture by John Rogers, *The Wounded Scout/A Friend in the Swamp*, in Honour, *Image*, vol. 4, pt. 1, p. 227; or the poem, "Prayer of the Contraband" in *Frank Leslie's* (14 October 1865): 53: . . . He lead our men for weary miles/Through tangles swamps and drear;/He found them pathways through the maze,/And made the doubtful clear;/He served us well for many months,/And now the end drew near. . . ."

124. Hence, in a *Harper's Weekly* cover picture called *Arrival of Union Refugees at Kingston, Georgia* (10 December 1864), a white family at the center is bracketed by a sympathetic Union soldier on the right and a supportive black woman, cradling a white or mulatto baby, on the left.

125. *Harper's Weekly* (5 November 1864): 708, 717. The same issue (p. 720) contained a cartoon mocking reports that the embattled Confederacy expected to arm blacks as soldiers without

fear of defection. *The Impetuous Charge of the First Colored Rebel Regiment [by our Prophetic Artist]* showed an entire unit rushing over to the enemy as soon as a black Union soldier called out, "Come in Boys, Dinner's Ready."

126. The closing line from John Milton's well-known sonnet, "On His Blindness," suits Homer's black woman (and many of his later stoic female figures as well).

127. *Harper's Weekly* (30 September 1865): 613.

128. "To Georgia's slaves the arrival of this avenging host seemed, as one federal officer put it, 'the fulfillment of the millennial prophecies.'" Eric Foner, *Reconstruction: America's Unfinished Revolution, 1863–1877* (New York, 1988), p. 70. Cf. Paul D. Escott, "The Context of Freedom: Georgia's Slaves During the Civil War," *Georgia Historical Quarterly* 58 (Spring 1974): 92–93.

129. Southern blacks commonly used such gourds as dippers for drinking. In the night sky, they referred to the Big Dipper (in the constellation of Ursa Major)—which points to the Pole Star and therefore indicates the direction of the North and freedom—as the "Drinking Gourd," and a slave song about escaping north to freedom was entitled "Follow the Drinking Gourd." See the discussion of the gourd dipper in Thomas Waterman Wood's *A Southern Cornfield, Nashville, Tenn.* (1861) in Honour, *Image*, vol. 4, pt. 1, pp. 220–22.

130. McPherson, *Battle Cry*, pp. 755, 796–98.

131. Honour, *Image*, vol. 4, pt. 1, pp. 222–24.

132. McPherson, *Battle Cry*, pp. 792–95. The quotations are from the Confederacy's exchange commissioner and its Secretary of War.

133. It is no coincidence that while the artist was putting the final touches on the picture in early 1866, the contrasting image of *Prisoners from the Front* was also in his studio, with its implied assurance that Homer's prominent friend, General Francis Channing Barlow, would deal fairly with the Confederate prisoners before him. See Lucretia H. Giese, "Prisoners from the Front: An American History Painting?" in Simpson, *Homer*, p. 65.

134. Foner, *Reconstruction*, p. 67.

135. See, e.g., Frederick Douglass, *Life and Times of Frederick Douglass Written Himself. His Early Life as a Slave, His Escape from Bondage, and His Complete History* (Hartford, CT, 1882), pp. 85–95.

136. See William Stanton, *The Leopard's Spots: Scientific Attitudes toward Race in America, 1815–59* (1960; Chicago, Midway reprint, 1982).

137. "Education in the Southern States," *Harper's Weekly* (9 November 1867): 706–7.

138. Quarles, *The Negro in the Civil War*, pp. 121–26. Robert C. Morris, *Reading, 'Riting, and Reconstruction: The Education of Freedmen in the South, 1861–1870* (Chicago, 1981).

139. Ronald E. Butchart, *Northern Schools, Southern Blacks, and Reconstruction: Freedmen's Education, 1862–1876,* (Westport, CT, 1980), pp. 170–71. Thomas Wentworth Higginson, commander of the First South Carolina Volunteers, noted in his camp diary on 7 January 1863: "We also have a great circular school-tent. . . ." Thomas Wentworth Higginson, *Army Life in a Black Regiment* (1870; reprint ed., Williamstown, MA, 1984), p. 45.

140. This statement of mission, made by Edward L. Pierce, is quoted in Quarles, *The Negro in the Civil War*, p. 124. Pierce was a friend of Senator Charles Sumner. Eric Foner notes that "when the Gideonites arrived in the Sea Islands in 1862, they found two schools already in operation, one of them taught by a black cabinetmaker who for years had conducted secret night classes for slaves." Foner, *Reconstruction*, p. 97. Jacqueline Jones, *Soldiers of Light and Love: Northern Teachers and Georgia Blacks, 1865–1873* (Chapel Hill, 1980).

141. Quarles, *The Negro in the Civil War*, pp. 292–94; Butchart, *Northern Schools, Southern Blacks*, pp. 171–72. For a succinct summary of the Northern liberal view, see "The Freedmen's Schools," *Harper's Weekly* (3 October 1868): 637.

142. Foner, *Reconstruction*, pp. 189, 155.

143. Hendricks, *Life and Work*, pp. 65, 68, 72–76.

144. See Philip C. Beam, *Winslow Homer's Magazine Engravings* (New York, 1979), p. 149, no. 122.

145. "1860–1870," *Harper's Weekly* (8 January 1870): 26.

146. John W. DeForest, "The Duchesne Estate," *Galaxy* 7, no. 6 (June 1869): 822–35. A native of Connecticut, DeForest spent some time in the South before the war and later commanded a company of Union volunteers in Louisiana and the Shenandoah Valley. After the war he worked with the Freedmen's Bureau in South Carolina and wrote one of the best-known novels about the Civil War, *Miss Ravenel's Conversion from Secession to Loyalty* (1867).

147. DeForest, "The Duchesne Estate," p. 823.

148. William Howe Downes, *The Life and Works of Winslow Homer* (New York, 1911), p. 85; Goodrich, *Homer*, pp. 58–59.

149. Hendricks, *Life and Work*, p. 104. On Homer's trips to Virginia, see also Michael Quick, "Homer in Virginia," *Los Angeles County Museum of Art Bulletin* 24 (1978): 60–81, and Mary Ann Calo, "Winslow Homer's Visits to Virginia During Reconstruction," *American Art Journal* 12, no. 1 (Winter 1980): 4–27.

150. Cooper, *Winslow Homer Watercolors*, p. 34. Amongst the other watercolors shown along with *Contraband* were *Taking a Sunflower to the Teacher* and *The Busy Bee*.

151. The same model appears in *The Busy Bee, Taking a Sunflower to the Teacher, The Watermelon Boys, Study for "The Unruly Calf"*, and perhaps also in *Two Boys in a Cart*.

152. This opinion is well articulated in a *Harper's* editorial, "For the Contrabands," *Harper's Weekly* (11 January 1862): 18.

153. In 1864 Homer did a charcoal and white chalk drawing of a soldier giving a drink from his canteen to a wounded comrade (New York, Cooper-Hewitt Museum, 1912-12-100). Sharing one's canteen was understood as a gesture of generosity and even sacrifice. See Simpson, *Homer*, pp. 236, 238, n. 5 and cat. no. 18c.

154. See "The Arts," *Appleton's Journal* 14, no. 346 (6 November 1875): 603; Calo, "Winslow Homer's Visits to Virginia," pp. 18–19.

155. We have benefited from discussions with David Findley and Susan Barnes, respectively associate conservator and chief curator of the North Carolina Museum of Art, about Homer's modifications of the composition of *Weaning the Calf*. Recent examination of the painting using x-ray and infrared reflectography brought these changes to light. In addition to enlarging the white boys, Homer painted out a horse standing just right of the haystacks as well as two groups of trees on either end of the picture, the latter alteration leveling and lowering the horizon. He also reduced the size

of the cow and changed her color from red brown to white, shrank proportionately the tree and dog near the cow, altered the calf's tail to hang down rather than wave in the air, and deleted some chickens. Homer's original bold signature, "Winslow Homer NA/1875," was overpainted and replaced with a more modest "Winslow Homer 1875."

156. Proslavery Southerners were convinced that blacks would never work unless coerced. See Leon F. Litwack, *Been in the Storm So Long: The Aftermath of Slavery* (New York, 1981), p. 363.

157. In minstrelsy this trend was manifested in an increased use of "plantation material" that often included emotional scenes, usually played by the "Old Darky" (Uncle Ned, Old Black Joe, etc.), regretting the vanished happy times; see Robert C. Toll, *Black Up: The Minstrel Show in Nineteenth-Century America* (New York, 1974), pp. 243–45.

158. See the excellent analysis of this phenomenon by Sarah Burns, "Barefoot Boys and Other Country Children: Sentiment and Ideology in Nineteenth-Century American Art," *American Art Journal* 20, no. 1 (1988): 24–50.

159. Ibid., p. 33. Homer contributed illustrations to *Our Young Folks* between 1866 and 1869. His scenes of rural childhood were also published in *Harper's Weekly*, *Appleton's Journal*, and *Every Saturday*. All are reproduced in Beam, *Magazine Engravings*.

160. For the rich associations that nineteenth-century viewers brought to this painting, see Christopher Kent Wilson, "Winslow Homer's *The Veteran in a New Field*: A Study of the Harvest Metaphor and Popular Culture," *American Art Journal* 17, no. 4 (Autumn 1985): 2–27. See also Nicolai Cikovsky, Jr., "A Harvest of Death: *The Veteran in a New Field*" in Simpson, *Homer*, pp. 82–101.

161. Cooper, *Winslow Homer Watercol-*

ors, pp. 32–33, figs. 19, 20.

162. Burns, "Barefoot Boys," pp. 37–40 and illus.

163. This work has been known under several titles. It may have first been shown in an unfinished state at the Century Association opening of 10 January 1874, entitled simply *The Dove Cote*; see Hendricks, *Life and Work*, p. 104, although Mary Ann Calo ("Winslow Homer's Visits to Virginia," p. 16, n. 19) questions Hendricks's hypothesis. After being exhibited as *Uncle Ned at Home* at the National Academy of Design, it was purchased by Thomas B. Clarke, perhaps at the Kurtz Gallery in New York in April 1879, under the title *Happy Family*. While in Clarke's collection, the picture was titled *Uncle Ned's Happy Family*. The information regarding title changes was gleaned from the manuscript catalogue raisonné of the works of Winslow Homer by Lloyd Goodrich.

164. For the verses of "Uncle Ned," see John Tasker Howard, *A Program of Stephen Foster Songs* (New York, 1934), pp. ix, 23–25. Several variations in the lyrics may be found in Newman I. White, *American Negro Folk-Songs* (1928; reprint ed., Hatboro, PA, 1965), pp. 164–67.

165. On Rogers's life and work, especially the commercial failure of *The Slave Auction*, see Wallace, *John Rogers*, pp. 79–84, 182–83, no. 58 (illus.).

166. Ibid., p. 112.

167. On *Uncle Ned's School*, see ibid., p. 216, no. 109. Rogers gave a copy of this group to Henry Ward Beecher.

168. On the theme of young blacks teaching their elders to read, see *infra*, pp. 85–87.

169. *Admiring the Kitty*, signed and dated 1870 and measuring 10 × 8 inches, belonged to the Raydon Gallery, New York

in 1980.

170. On the "Old Darky" type and its increased frequency in post-Civil War minstrel shows, see Toll, *Black Up*, pp. 78–79, 187, 244–45.

171. *New York Evening Post*, 7 April 1875, quoted in Hendricks, *Life and Work*, p. 104.

172. A dovecote figures prominently in Eastman Johnson's painting *Mating*. Exhibited at the National Academy of Design in 1860 (no. 465), a young mulatto couple court beneath the structure's roof as birds coo above. The connection between *Uncle Ned at Home* and *Mating* is suggested by Hills, *The Genre Painting of Eastman Johnson*, pp. 61–62 and p. 208, fig. 37.

173. When *Uncle Ned at Home* was exhibited in *Winslow Homer: A Retrospective Exhibition* (no. 36) at the National Gallery of Art, Washington, D. C. and The Metropolitan Museum of Art, New York, in 1958–59, it belonged to Mr. Edward A. Hauss in Century, Florida. Since the painting's present location is unknown and the work is known only from a black-and-white reproduction, details regarding its colors are taken from the manuscript catalogue raisonné of the works of Winslow Homer by Lloyd Goodrich.

174. Toll, *Blacking Up*, p. 240.

175. Dorothy W. Phillips, " *Sketch of a Cottage Yard* by Winslow Homer (1836–1910)," *Corcoran Bulletin* 13, no. 3 (October 1863): 20–22. Calo ("Winslow Homer's Visits to Virginia," p. 24, fig. 22) dates this sketch to ca. 1876, while Hendricks (*Life and Work*, p. 281, CL-46) favors 1875. The presence of sunflowers may offer a clue to its date as they also occur in Homer's watercolor *Rustic Courtship* (Collection of Mr. and Mrs. Paul Mellon, Upperville, VA) and most prominently in *Taking a Sunflower to the Teacher*, dated respectively 1874 and

1875.

176. See John Michael Vlach, *The Afro-American Tradition in Decorative Arts*, Exhibition catalogue, Cleveland, The Cleveland Museum of Art, 1978, pp. 25–26.

177. "Education in the Southern States," pp. 706, 707.

178. For the announcement of this series, see "Our Artists in the South," *Harper's Weekly* (28 April 1866): 259. Waud's tour lasted through October 1866. For his itinerary see Frederic E. Ray, *Alfred R. Waud, Civil War Artist* (New York, 1974), pp. 53–57.

179. Alfred R. Waud, "Zion School, Charleston, S. C.," *Harper's Weekly* (15 December 1866): 790, 797. A pencil sketch of this scene is inscribed "Singing in the Primary School–Colored–Calhoun St., Charleston S. C."; it belongs to the Historic New Orleans Collection (1977. 137.6.14). In addition to his engraving of the freedmen's school in Memphis (see *infra*, n. 180), Waud also illustrated *Noon at the Primary School for Freedmen, Vicksburg, Mississippi* and *Primary School for Freedmen, in Charge of Mrs. Green, at Vicksburg, Mississippi*, both in *Harper's Weekly* (23 June 1866): 392. Theodore R. Davis drew the *School-House and Chapel at Trent River Settlement* (*Harper's Weekly* [9 June 1866]: 361). Sketches of black schools or students by unidentified artists appear not infrequently in *Harper's* issues of this period; see, e.g., *Freedmen's School-House at Atlanta, Georgia* and *Freedmen's Farm-School, Near Washington, D. C.* (30 March 1867, p. 193); *Colored Scholars Learning Their Lessons on the Street* and *Colored Scholars on Their Way to School* (25 May 1867, p. 321); engravings of six teaching institutions for blacks, including Fisk University (3 October 1868, p. 637); *Colored School–Object Teaching* (26 February 1870, p. 141).

180. Alfred R. Waud, "The Memphis Riots," *Harper's Weekly* (26 May 1866): 321–22.

181. Foner, *Reconstruction*, p. 428.

182. The burning school first occurs in Nast's *Reconstruction and How It Works* in *Harper's Weekly* (1 September 1866): 552–53. The image is repeated in his work for *Harper's* during the late 1860s and '70s.

183. In addition to exhibiting this work at the American Society of Painters in Water Color in February 1876, Homer also sent it, along with *The Busy Bee*, to the Centennial Exhibition in Philadelphia; *Official Catalogue of the International Exhibition of 1876*, 2d rev. ed. (Philadelphia, 1876), part II, *Art Gallery, Annexes, and Out-Door Works of Art. Department IV: Art*, p. 28, no. 388.

184. *Harper's Weekly* (22 August 1868): 540.

185. *Harper's Weekly* (5 March 1870): 152. At least two watercolors of this scene are known, one entitled *A Negro Boy* in Yale Center for British Art, New Haven (inv. B1975.4.583) and a second, whose present location is unknown, sold by Phillips, Son & Neale, London, 29 June 1981, no. 139. On the artist see John Witt, *William Henry Hunt (1790–1864): Life and Work, with a Catalogue* (London, 1982).

186. "*A Brown Study*," *Harper's Weekly* (5 March 1870): 155.

187. James Hall, *Dictionary of Subjects & Symbols in Art*, rev. ed. (New York; Icon Editions, 1979), p. 54, s.v. "Butterfly."

188. The first association we have found between the sunflower and minstrelsy dates from 1867 when Billy Emerson, the famous tenor and end-man, composed "The Big Sun-Flower"; Carl Wittke, *Tambo and Bones: A History of the American Minstrel Stage* (1930; reprint ed., Westport, CT, 1968), pp. 78–79. (We are grateful to Linda Wood of The Free Library of Philadelphia for providing a copy of the sheet music.) The following year *The Big Sun-Flower Song-*

ster was published, its cover decorated with an illustration of Emerson's head poking through the center of the sunflower. The Harry T. Peters "America on Stone" Collection (Washington, D. C., Smithsonian Institution, National Museum of American History, cat. no. 60.2863) possesses a piece of music dated 1875 and entitled "I'm as Happy as a Big Sunflower." The lithograph on its cover shows a fashionable black woman holding a sunflower to her bosom and looking over her shoulder toward her caricatured beau. A minstrel group called the Jackson Wagon Sun Flower Band wore bib overalls appliquéed with sunflowers when they performed at the "Great Fairs of 1884"; see a colored lithograph in the Michigan Historical collections (acc. no. 3094) at the University of Michigan, Ann Arbor.

189. Reproduced in Hendricks, *Life and Work*, p. 114, no. 170.

190. See, e.g., *The Army of the Potomac—A Sharpshooter on Picket Duty* and *The Bright Side*, reproduced in Beam, *Magazine Engravings*, p. 117, no. 99 and p. 146, no. 120. *The Watermelon Boys* was examined under x-ray and infrared light for any change of composition in the area where the old man appears in the engraving. The upper right-hand corner of the painting had not been modified at all. Our thanks to Elizabeth Broun and Andrew Connors of the National Museum of American Art, Washington, D. C., for providing this information.

191. In a letter dated 3 March 1880 and addressed to Mr. Smith apparently concerning *Promenade on the Beach*, Homer replied: "My picture represents the eastern shore at sunset. The long line from the girls is the shadow from the sun. [sketch] The girls are 'somebody in particular' and I can vouch for their good moral chracter they are looking at anything that you wish to have them look at, but it must be something at sea and a very proper and appropriate object for girls to be interested in. The schooner

is a Gloucester Fisherman." This letter is in a file of "Homer Letters 1860s, 1870s, 1880s," the Lloyd Goodrich Papers. Similarly, for the painter's acid response to a request to explain *The Gulf Stream*, see Hendricks, *Life and Work*, p. 250.

192. Apparently the denigrating association between blacks and watermelons made its debut on the minstrel stage in 1856 with J. W. McAndrews's routine and song, "The Watermelon Man"; see Toll, *Blacking Up*, p. 45; Wittke, *Tambo and Bones*, p. 225.

As difficult as it may be for us to realize today, the grotesque images of glossy black faces with cavernous mouths stretched into toothy smiles large enough to accommodate a watermelon slice do not appear until the 1880s, reaching their peak in the 1890s and early 1900s. J. Stanley Lemons rightly observes, "Certainly, the black comic figure had existed a half century before the 1880s, but often the treatment of blacks in illustrations presented them as humans. Then in the 1880s coarse, grotesque caricatures began to dominate. . . . This transition from human to grotesque in the 1880s suggests that whites had wearied of the whole Reconstruction question that had wracked the country from 1865 to 1877." J. Stanley Lemons, "Black Stereotypes as Reflected in Popular Culture, 1880–1920," *American Quarterly* 19, no. 1 (Spring 1977): 104–6. Our researches and those of Brooke Baldwin in the nineteenth-century illustrated press and humor magazines have uncovered only two images linking blacks and watermelons before 1880; see *Yankee Notions* (January 1853): 24, and *Anticipation—Return from a Melon Scout* in *Harper's Weekly* (25 August 1877): 665.

193. Alfred R. Waud, "Pictures of the South: Freedmen's School at Vicksburg," *Harper's Weekly* (23 June 1866): 398. "Educating the Freedmen," ibid. (25 May 1867): 321–22.

194. Foner, *Reconstruction*, p. 96. For a

gently humorous account of a seventy-one-year-old cook attending school, see *An Old Scholar* in *Harper's Weekly* (21 May 1870): 336.

195. For the use of biblical metaphors in the discourse of black politicians after emancipation, see Foner, *Reconstruction*, pp. 93–95.

196. "Straightening the Crooked Tree," *Harper's Weekly* (3 May 1873): 368. On R. N. Brooke, who is known particularly for his Negro genre paintings from the 1880s, see Jessie J. Poesch, "Growth and Development of the Old South: 1830–1900" in *Painting in the South: 1564–1980*, Exhibition catalogue, Richmond, Virginia Museum of Fine Arts, 1983, pp. 91–93.

197. The painting (oil on paperboard mounted on canvas; 14 × 10 in.) now belongs to the National Museum of American Art, Washington, D. C. (inv. 1979.5.8). Wood's drawing of the same subject dated 1877, with differences in the composition, is in The T. W. Wood Art Gallery, Vermont College Art Center, Montpelier.

198. "'Uncle Tom' and Grandchild," *Harper's Weekly* (3 November 1866): 689, 690.

199. Quarles, *The Negro in the Civil War*, p. 290.

200. Both paintings were exhibited at the Universal Exposition, Paris in 1878, and at the National Academy of Design, New York in 1880.

201. See Litwack, *Been in the Storm So Long*, pp. 157, 205–12.

202. "Christmas Pictures," *Every Saturday* (31 December 1870): 873, 862.

203. *Harper's Weekly* (30 December 1871): 1220.

204. Ibid., (19 August 1876): 677–78.

205. "The Old Mammy," *Harper's Weekly* (3 October 1868): 627.

206. Foner, *Reconstruction*, pp. 85–86.

207. The corollaries between *A Visit from the Old Mistress* and *Prisoners from the Front* were first noted by Sidney Kaplan (*Portrayal of the Negro*, n. p.) and later developed by Ellwood Parry, *The Image of the Indian and the Black Man*, pp. 140, 143.

208. Exhibited at the Century Association, New York, in March 1877, *The Cotton Pickers* was purchased by an English collector who took it to London where it was shown at the Royal Academy in 1878 (no. 60) under the title of *Cotton Pickers—North Carolina*; see Quick, "Homer in Virginia," p. 80, n. 1.

209. Ibid., pp. 60–81. Homer would have known Millet's paintings before his trip to France since William Morris Hunt and several of his artist and collector friends purchased and exhibited them in Boston in the 1850s and 1860s.

210. Hills, *Eastman Johnson*, pp. 10–20.

211. On Ednah Dow Cheney and Eugene Benson, see Laura L. Meixner, "Popular Criticism of Jean-François Millet in Nineteenth-Century America," *Art Bulletin* 65, no. 1 (March 1983): 95–98. For the quotation from *Harper's Weekly*, see *supra*, p. 92. On the connection between Homer and Benson, see Hendricks, *Life and Work*, pp. 65, 72–73.

212. Eugene Benson, "The Peasant-Painter: Jean-François Millet," *Appleton's Journal* 4 (1872): 404, quoted in Meixner, "Popular Criticism," p. 97.

213. Foner, *Reconstruction*, p. 108. See also Foner's discussion of black women's labor, p. 86.

214. Quick, "Homer in Virginia," figs. 16, 20.

215. "The Academy Exhibition," *Art Journal*, New York ed., n.s. 5 (1879) : 158.

216. According to Lloyd Goodrich's records, *Upland Cotton* was shown in the Cotton States and International Exposition, Atlanta, 18 September–31 December 1895, no. 311. The same documentation should be consulted for information regarding modifications of the painting by Homer and others. See also Calo, "Winslow Homer's Visits to Virginia," pp. 24–25.

217. W. E. B. Du Bois, *Black Reconstruction: An Essay toward a History of the Part which Black Folk Played in the Attempt to Reconstruct Democracy in America, 1860–1880* (New York, 1935), p. 30.

218. Downes, *The Life and Works of Winslow Homer*, pp. 85–86.

219. *Art Amateur* (May 1880) : 112.

220. "In short, there was a very strong feeling of animosity toward him so, by way of re-establishing himself in their favor, he painted this canvas, in which he represented a group of negroes in tawdry costumes of many colors, to their entire satisfaction." *New York Sun*, 12 March 1898.

221. C. W. Knauff, "Winslow Homer," *Churchman* (23 July 1898). This and the previous quote are cited in Calo, "Winslow Homer's Visits to Virginia," p. 20. Smithville appears to be a conflation of Smithfield, an actual town in the vicinity, and Blackville, a fictional setting made famous in stereotypes (see fig. 54).

222. The image of the French liberty cap had often been associated with freedom for blacks in both positive and negative ways. See, for example, the 1792 stipple engraving called *Moi Libre Aussi*, showing a black in a Phrygian cap, or the American painting from the same year by Samuel Jennings, *Liberty Displaying the Arts and Sciences*. Honour, *Image*, vol. 4, pt. 1, pp. 83, 49. Giese, "Winslow

Homer," p. 77, notes that "as late as 1864 a caricature entitled *The Northern Coat of Arms* published by J. E. Cutler of Boston depicted the enlarged feet of a black surmounted by a liberty cap."

223. David Park Curry, "Homer's *Dressing for the Carnival*" (Paper delivered at Winslow Homer: A Symposium, National Gallery of Art/Center for Advanced Study in the Visual Arts, Washington, D.C., 18 April 1986). See Judith Bettelheim, "The Afro-Jamaican Jonkonnu Festival: Playing the Forces and Operating the Cloth" (Ph.D. diss., Yale University, 1979); Elizabeth A. Fenn, " 'A Perfect Equality Seemed to Reign': Slave Society and Jonkonnu," *North Carolina Historical Review* 65, no. 2 (April 1988) : 127–53. At Somerset Place, a plantation site in eastern North Carolina where slaves performed an annual Jonkonnu dance, Dorothy Redford started to revive this ceremony in 1988, with the assistance of Chuck Davis's African-American Dance Company.

224. Leonard I. Sweet, "The Fourth of July and Black Americans in the Nineteenth Century: Northern Leadership Opinion Within the Context of the Black Experience," *Journal of Negro History* 61, no. 3 (July 1976) : 273. See also William H. Wiggins, Jr., *O Freedom: Afro-American Emancipation Celebrations* (Knoxville, 1987).

225. *Frank Leslie's* (17 July 1875) : 333. Art historian Richard J. Powell first associated this wood engraving with *Dressing for the Carnival* in "An Examination of Winslow Homer's *The Carnival*," an unpublished graduate essay for Professor Jules D. Prown at Yale in 1980. We are grateful to Dr. Powell for sharing a copy of this work. (See Introduction.)

226. *Frank Leslie's* (17 July 1875) : 338. The members, sixty young men who worked mostly as barbers and servants, took great pride in their handsome uniforms (French imperial army dress which included pants with a side stripe, epaulets

for the officers, and blue trimmed helmets topped with a cockade), fine parties, and precision marching. They competed against other ethnic drill teams in the city, including the all-black Ginger Blues, and the Irish Mulligan Guards. Toll, *Blacking Up*, p. 249.

227. "The Skidmore Guard" followed Harrigan's "immensely popular 'Mulligan Guard' song" and dealt kindly, in ethnic dialect, with specific members of the group, including the impressive flag bearer, who "took de prize for marching out on 'Mancipation day." We are indebted to Betty Gubert at the Schomburg Center of the New York Public Library for locating this sheet music.

228. "In 1875–76 Callender's Minstrels closed the first part of their show with a 'ludicrous military burlesque.' Such lampoons of black soldiers had been occasional minstrel features since the Civil War, but this skit proved so popular that it became the standard finale for the first part of the black minstrel show." Toll, *Blacking Up*, pp. 248–49; cf. pp. 120–25.

229. Foner, *Reconstruction*, pp. 570–75. Thomas Holt, *Black Over White: Negro Political Leadership in South Carolina during Reconstruction* (Urbana, 1977), chap. 8; George C. Rable, *But There Was No Peace: The Role of Violence in the Politics of Reconstruction* (Athens, 1984), chap. 10; Richard Nelson Current, *Those Terrible Carpetbaggers: A Reinterpretation* (New York, 1988), chap. 17.

230. *Harper's Weekly* (12 August 1876) : 712; ibid. (2 September 1876) : 652; ibid., (28 October 1876) : 872–73.

231. See Mechal Sobel, *The World They Made Together: Black and White Values in Eighteenth-Century Virginia* (Princeton, 1987).

Exhibition Checklist

Unless otherwise noted, all works
are by Winslow Homer.
Dimensions are in inches, height
preceding width.

1 *Expulsion of Negroes and Abolitionists from Tremont Temple, Boston, Massachusetts,*
 on December 3, 1860 in *Harper's Weekly* 4, no. 207 (15 December 1860) : 788
 Monogrammed
 Wood engraving. 6¹⁵/₁₆ × 9⅛
 The Museum of Fine Arts, Houston. The Mavis P. and Mary Wilson
 Kelsey Collection of Winslow Homer Graphics. Inv.: 75.670

2 *View of Mount Vernon and North Colonnade*
 Signed and dated 1861
 Ink, watercolor, and pencil on paper. 5⁷/₁₆ × 8⁹/₁₆
 Collection of the Mount Vernon Ladies' Association of the Union

3 *Dixie* (sketch for *The Songs of War*), 1861
 Pencil, gray watercolor on paper. 10 × 7
 Cooper-Hewitt Museum, New York. The Smithsonian Institution's
 National Museum of Design. Inv.: 1912–12–120

4 *The Songs of War* in *Harper's Weekly* 5, no. 256 (23 November 1861) : 744–45
 Signed
 Wood engraving. 14 × 20
 The Museum of Fine Arts, Houston. The Mavis P. and Mary Wilson
 Kelsey Collection of Winslow Homer Graphics. Inv.: 75.689

5 Unidentified artist
 Stampede of Slaves from Hampton to Fortress Monroe in *Harper's Weekly*
 5, no. 242 (17 August 1861) : 524
 Wood engraving. 9³/₁₆ × 13⅞
 Texas A & M University, College Station. Special Collections
 Mary & Mavis Kelsey Collection. No inventory number

6 *Soldier Dancing* (sketch for *A Bivouac Fire on the Potomac*), 1861
 Pencil on paper. 9½ × 6¼
 Cooper-Hewitt Museum, New York. The Smithsonian Institution's
 National Museum of Design. Inv.: 1912–12–134

7 *A Bivouac Fire on the Potomac* in *Harper's Weekly* 5, no. 260 (21 December
 1861) : 808–9
 Signed
 Wood engraving. 13¹³/₁₆ × 20³/₁₆
 The Museum of Fine Arts, Houston. The Mavis P. and Mary Wilson Kelsey
 Collection of Winslow Homer Graphics. Inv.: 75.690

8 C. E. F. Hillen
 *The Negro in the War—Sketches of the Various Employments of the Colored Men
 in the United States Armies* in *Frank Leslie's Illustrated Newspaper* 17, no. 433
 (16 January 1864): 264–65
 Signed
 Wood engraving. 14³/₁₆ × 19¹/₂
 Franklin and Marshall College, Lancaster. Shadek-Fackenthal Library.
 Archives and Special Collections Dept. Call no.: L45

9 *Army Wagon* (sketch for *Campaign Sketches: The Baggage Train*), 1862
 Pencil, watercolor washes on paper. 9¹/₂ × 6³/₁₆
 Cooper-Hewitt Museum, New York. The Smithsonian Institution's
 National Museum of Design. Inv.: 1912–12–119

10 *Campaign Sketches: The Baggage Train*
 One of six plates lithographed and published by Louis Prang (1823–1909)
 Signed. 1863
 Lithograph. 14 × 10⁷/₈
 Museum of Fine Arts, Boston. Inv.: M13833

11 *Campaign Sketches: Foraging*
 One of six plates lithographed and published by Louis Prang (1823–1909)
 Signed. 1863
 Lithograph. 14 × 10⁷/₈
 Museum of Fine Arts, Boston. Gift of Charles G. Loring. Inv.: 13835G

12 *Campaign Sketches: Our Jolly Cook*
 One of six plates lithographed and published by Louis Prang (1823–1909)
 Signed. 1863
 Lithograph. 14 × 10⁷/₈
 American Antiquarian Society, Worcester. No inventory number

13 *Study of a Negro Teamster*, 1862 (?)
 Graphite, gray watercolor on paper. 8⁷/₈ × 6³/₁₆
 Cooper-Hewitt Museum, New York. The Smithsonian Institution's
 National Museum of Design. Inv.: 1912-12-201

14 *A Shell in the Rebel Trenches* in *Harper's Weekly* 7, no. 316 (17 January 1863): 36
 Signed
 Wood engraving. 9¹/₈ × 13¹³/₁₆
 The Museum of Fine Arts, Houston. The Mavis P. and Mary Wilson
 Kelsey Collection of Winslow Homer Graphics. Inv.: 75.706

15 *Life in Camp. Part 2: In the Trenches*
 One of twenty-four souvenir cards lithographed and published by
 Louis Prang (1823–1909), 1864
 Chromolithograph. 4¹/₈ × 2¹/₂
 Museum of Fine Arts, Boston. Gift of Charles G. Loring. Inv.: K3383 12/8

16 *Pay-Day in the Army of the Potomac* in *Harper's Weekly* 7, no. 322 (28 February
 1863): 136–37
 Wood engraving. 13⁹/₁₆ × 20¹/₂
 The Museum of Fine Arts, Houston. The Mavis P. and Mary Wilson
 Kelsey Collection of Winslow Homer Graphics. Inv.: 75.708

17 Thomas Nast (1840–1902)
 The Emancipation of the Negroes, January 1863—The Past and the Future
 in *Harper's Weekly* 7, no. 317 (24 January 1863) : 56–57
 Wood engraving. 13⅜ × 20½
 Texas A & M University, College Station. Special Collections
 Mary & Mavis Kelsey Collection. No inventory number

18 *The Bright Side* in *Our Young Folks* 2, no. 6 (July 1866) : 396
 Wood engraving. 2¾ × 3⅝
 The Museum of Fine Arts, Houston. The Mavis P. and Mary Wilson
 Kelsey Collection of Winslow Homer Graphics. Inv.: 75.725

19 *1860–1870* in *Harper's Weekly* 14, no. 680 (8 January 1870) : 24–25
 Signed
 Wood engraving. 13⁷⁄₁₆ × 20½
 The Museum of Fine Arts, Houston. The Mavis P. and Mary Wilson
 Kelsey Collection of Winslow Homer Graphics. Inv.: 75.774

20 *Contraband*
 Signed and dated 1875
 Watercolor on paper. 8 × 7
 Canajoharie Library and Art Gallery, Canajoharie. Inv.: 317101

21 *Two Boys in a Cart*
 Signed. Ca. 1875
 Watercolor and graphite on paper. 8¾ × 6¼
 Philadelphia Museum of Art, Philadelphia. Given by Dr. and Mrs. George
 Woodward. Inv.: 39-7-10

22 Study for *The Unruly Calf*
 Monogrammed. Ca. 1875
 Pencil with chinese white on paper. 4¾ × 8½
 The Brooklyn Museum, Brooklyn. Museum Collection Fund. Inv.: 24.241

23 *Weaning the Calf*
 Signed and dated 1875
 Oil on canvas. 24 × 38
 North Carolina Museum of Art, Raleigh. Purchased with funds from the
 State of North Carolina. Inv.: 52.9.16

24 *Sketch of a Cottage Yard*, Ca. 1876
 Oil on academy board. 10¼ × 14½
 The Corcoran Gallery of Art, Washington, D. C. Purchased through the Gift
 of the Honorable Orme Wilson and from the W. A. Clark Fund. Inv.: 61.18

25 *The Busy Bee*
 Signed and dated 1875
 Watercolor on paper. 9¾ × 8⅞
 Private Collection, New York

26 *Taking a Sunflower to the Teacher*
 Monogrammed and dated 1875
 Watercolor on paper. 7 × 5⅞
 Georgia Museum of Art, University of Georgia, Athens
 Eva Underhill Holbrook Memorial Collection of American Art
 Gift of Alfred H. Holbrook. Inv.: GMOA 45.50

27 *The Watermelon Boys*
 Signed and dated 1876
 Oil on canvas. 24⅛ × 38⅛
 Cooper-Hewitt Museum, New York. The Smithsonian Institution's
 National Museum of Design. Inv.: 1917–14–6

28 *Water-melon Eaters* in [George W. Sheldon], "American Painters–Winslow
 Homer and F. A. Bridgman," *Art Journal* n.s. 4 (August 1878): 225
 Monogrammed
 Wood engraving. 5⅛ × 7
 The Museum of Fine Arts, Houston. The Mavis P. and Mary Wilson
 Kelsey Collection of Winslow Homer Graphics. Inv.: 75.821

29 William Ludwell Sheppard (1833–1912)
 Christmas in Virginia—A Present from the Great House in *Harper's Weekly*
 15, no. 783 (30 December 1871): 1220
 Wood engraving. 8⅞ × 11⅝
 Texas A & M University, College Station. Special Collections
 Mary & Mavis Kelsey Collection. No inventory number

30 Solomon Eytinge, Jr. (1833–1905)
 Virginia One Hundred Years Ago in *Harper's Weekly* 20, no. 1025
 (19 August 1876): 677
 Signed
 Wood engraving. 9⅛ × 13⁹⁄₁₆
 Texas A & M University, College Station. Special Collections
 Mary & Mavis Kelsey Collection. No inventory number

31 *A Visit from the Old Mistress*
 Signed and dated 1876
 Oil on canvas. 18 × 24⅛
 National Museum of American Art, Washington, D. C. Smithsonian
 Institution. Gift of William T. Evans. Inv.: 1909.7.28

32 *Upland Cotton*
 Signed and dated 1879–95
 Oil on canvas. 49 × 29¼
 Weil Brothers, Montgomery

33 Unidentified artist
 Our Colored Militia.—A "Skid" Dressing for the Parade on the Fourth of July
 in *Frank Leslie's Illustrated Newpaper* 40, no. 1033 (17 July 1875): 333
 Wood engraving. 9¼ × 13¾
 University of Minnesota, Duluth. Library. No call number

34 *Dressing for the Carnival*
 Signed and dated 1877
 Oil on canvas. 20 × 30
 The Metropolitan Museum of Art, New York. Amelia B. Lazarus Fund, 1922
 Inv.: 22.220

Winslow Homer Chronology, 1850–79

NATIONAL EVENTS	EARLY CAREER AND WORKS INCLUDING BLACKS
1850 Compromise of 1850.	
1851 Serialization of Harriet Beecher Stowe's *Uncle Tom's Cabin* (1851–52).	
1852 Publication of Harriet Beecher Stowe's *Uncle Tom's Cabin*.	
1854 The Kansas-Nebraska Act.	Homer's first professional work, done for John Bufford & Sons, Boston.
1855	First year of two-year apprenticeship at Bufford's.
1856 John Brown's raid at Pottawatomie Creek, Kansas. Caning of Charles Sumner.	*Arch near Baptist Church Danvers Port* in *Proceedings at the Reception and Dinner in Honor of George Peabody, Esq. of London, by the Citizens of the Old Town of Danvers, October 9, 1856*, facing p. 89. Lithograph. 4½ × 8¹/₁₆.
1857 *Dred Scott* decision by Supreme Court ruling that blacks were not citizens.	Completion of apprenticeship at Bufford's (24 Feb.). – First wood engraving for *Ballou's Pictorial Drawing-Room Companion* (June).
1858	Homer family moves to Belmont, Massachusetts.
1859 Harper's Ferry Insurrection (Oct.). Hanging of John Brown (2 Dec.).	Visits West Point (summer). – Moves to New York City. – Registers in the Life School of the National Academy of Design (Oct.). – Works for *Harper's Weekly* on a freelance basis.
1860 South Carolina secedes from the Union (20 Dec.).	Exhibits one work at the National Academy of Design. – Takes a studio (no. 8) in the University Building on Washington Square. – Draws from Mathew Brady's photographs for *Harper's* Abraham Lincoln (10 Nov.), Roger B. Taney (8 Dec.), and the seven members of the seceding South Carolina delegation (22 Dec.). *Expulsion of Negroes and Abolitionists from Tremont Temple, Boston, Massachusetts, on December 3, 1860* in *Harper's Weekly* 4 (15 Dec. 1860): 788.
1861 Remaining states secede (Mississippi, Florida, Alabama, Georgia, Louisiana,	Draws from photographs for *Harper's* the ten seceding Georgia members (5 Jan.). – Draws from photographs by Mathew Brady for *Harper's, The Seceding Mississippi*

1861 *(continued)*

Texas, Virginia, North Carolina, Tennessee, Arkansas).

Bombardment of Fort Sumter (12 April).

Runaway slaves start moving into Union camps (late May).

Three runaways enter Union lines at Fortress Monroe, are declared "Contraband of War" by General Benjamin F. Butler (23 May).

John C. Frémont, then commanding the Department of the West, declares martial law in Missouri, specifying that all slaves are freed. Frémont repudiated by Lincoln (30 Aug.).

Delegation in Congress, topped by Jefferson Davis (2 Feb.). – Sketches Abraham Lincoln on the balcony of the Astor House; published by *Harper's* on the cover of its 2 March issue. – *Harper's* sends WH to Washington, D. C. to record Lincoln's inauguration; publishes sketches 16 March. – Spends summer in and around his brother's house in Belmont, Mass. – WH sketches the steamship *Colorado* in Boston harbor (June) for *Harper's* of 13 July. – Visits Lake George: sketches fellow artist Benjamin Bellows Grant Stone (1827–1906) (July). – WH's brother, Arthur Benson Homer, enlists in U. S. Navy (13 Sept.) and boards the *Kingfisher* (ca. 1 Oct.). – Letter dated 8 Oct. from Fletcher Harper identifying WH as an "artist-correspondent" for *Harper's Weekly* and requesting the cooperation of "commanding Generals and other persons in authority." – One-week pass dated 15 Oct. issued to WH by an adjutant to General George B. McClellan, Army of the Potomac. – Spends Thanksgiving Day with his family in Belmont, before leaving for Washington (21 Oct.). – Letter dated 28 Oct. from his mother to his brother Arthur places Winslow Homer back in Washington, D. C. – Visits Mount Vernon. – WH definitely back in New York (letter of 17 Dec. from his mother to Arthur).

Sketch for *A Bivouac Fire on the Potomac: Soldier Dancing*. Pencil on paper. 9½ × 6¼. Cooper-Hewitt Museum, New York.

War Songs: sketch for *The Songs of War*. Pencil and gray wash, with iron gall ink on paper. 14⅛ × 20. Library of Congress, Washington, D. C.

Dixie: sketch for *The Songs of War*. Pencil, watercolor washes on paper. 10 ×7. Cooper-Hewitt Museum, New York.

View of Mount Vernon and North Colonnade. Ink, watercolor, and pencil on paper. 5⁷/₁₆ ×/ 8⁹/₁₆. The Mount Vernon Ladies' Association, Mount Vernon.

The Inaugural Procession at Washington Passing the Gate of the Capitol Grounds in *Harper's Weekly* 5 (16 March 1861): 161. Wood engraving. 10⁷/₈ × 9⅛.

The Inauguration of Abraham Lincoln as President of the United States, the Capitol, Washington, March 4, 1861 in *Harper's Weekly* 5 (16 March 1861): 168–69. Wood engraving. 13¾ × 20⅛.

The Songs of War in *Harper's Weekly* 5 (23 Nov. 1861): 744–45. Wood engraving. 14 × 20.

A Bivouac Fire on the Potomac in *Harper's Weekly* 5 (21 Dec. 1861): 808–9. Wood engraving. 13¹³/₁₆ × 20³/₁₆.

1862

Vincent Colyer, the Superintendent of the Poor, set up schools for blacks and poor whites in the New Bern region of North Carolina (Feb.).

Major General David Hunter recruited the first regiment of Negroes in the Civil War, the First South Carolina Volunteer Regiment (April–May). Disbanded 10 August due to lack of pay and failure to be mustered in.

Confiscation Act passed by Congress—declares free the slaves of all who are in rebellion (17 July).

General Benjamin F. Butler, ranking officer in the Department of the Gulf, authorizes the enlistment of free Negroes (22 Aug.).

Letter dated March from WH to his father says he is preparing to return to the front and to Washington, D. C. – Pass dated 1 April grants WH "permission to pass to and from Virginia for the purpose of Business." WH remains with troops in this theater until late May or early June. – Leaves the Army of the Potomac and returns to New York (letter dated 7 June from WH's mother to Arthur). – During the next six months seven of his wood engravings, all related to the war, are published in *Harper's Weekly*, and he works on his first known oil painting, *Sharpshooter*.

Army Wagon: Sketch for *Campaign Sketches: The Baggage Train*. Pencil, watercolor washes on paper. 9½ × 6⁷/₈. Cooper-Hewitt Museum, New York.

Study of a Negro Teamster. Pencil, watercolor washes on paper. 8¹⁵/₁₆ × 6⁷/₈. Cooper-Hewitt Museum, New York.

Winslow Homer and Alfred Rudolph Waud. *Our Army Before Yorktown, Virginia* in *Harper's Weekly* 6 (3 May 1862): 280–81. Wood engraving. 13¾ × 20¾.

News from the War in *Harper's Weekly* 6 (14 June 1862): 376–77. Wood engraving. 13¼ × 20¼.

1862 *(continued)*
Lincoln issues preliminary Emancipation Proclamation (22 Sept.).
First South Carolina Volunteers mustered in (7 Nov.).

1863

Emancipation Proclamation goes into effect (1 Jan.).
Congress passes first comprehensive conscription law in the country (3 March).
First battle in which black soldiers are engaged, Port Hudson (27 May).
New York antidraft riots (12–16 July).
Fifty-Fourth Massachusetts Volunteer Infantry, under the command of Robert Gould Shaw, leads the assault on Fort Wagner, SC (18 July).

Exhibits two paintings at the National Academy of Design (April). From this date to the end of the year *Harper's Weekly* publishes five more wood engravings by WH. – Presumably spends the summer in Belmont. – Exhibits two paintings at the Artists' Fund Society's Fourth Annual Exhibition, New York (Nov.). – Louis Prang, Boston lithographer, publishes Homer's *Campaign Sketches*, six plates plus cover, illustrating serious and humorous incidents of Civil War life, three including blacks. Prang proposes (Dec.) another series, *Life in Camp,* to include twenty-four souvenir cards.

Campaign Sketches, 3 including blacks: *The Baggage Train, Our Jolly Cook, Foraging.* Lithographs. Each: 14 × 10⅞.
A Shell in the Rebel Trenches in *Harper's Weekly* 7 (17 Jan. 1863): 36. Wood engraving. 9⅛ × 13¾.
Pay-Day in the Army of the Potomac in *Harper's Weekly* 7 (28 Feb. 1863): 136–37. Wood engraving. 13⅝ × 20½.

1864

Massacre of black troops at Fort Pillow (12 April).
Fighting at Petersburg and beginning of siege of that city (14–15 June until 1 April 1865).
Congress passes an act saying that blacks will receive equal pay, uniforms, medical treatment, etc., retroactive to 1 January 1864 (15 June).
Mine exploded, starting the Battle of the Crater, Petersburg (30 July).
William T. Sherman's invasion of and march through Georgia.

Between Jan. and April exhibits paintings at several places in New York. In May is elected Associate Academician of the National Academy of Design. During May and June returns to the Army of the Potomac in Virginia, sketches the terrain around Petersburg. – Exhibits five works at the Artists' Fund Society Fifth Annual Exhibition (Nov.).

Life in Camp. Part 2: In the Trenches. Chromolithograph. 4⅛ × 2½.
Study for "The Bright Side." Oil on paper. 6½ × 8¼. Private Collection.
Sketch for "The Bright Side.", ca. 1864. Pencil and wash on brown paper. 6⅝ × 9¾ . The Harold T. Pulsifer Memorial Collection on loan to Colby College, Waterville, Maine.
Inviting a Shot Before Petersburg, Virginia. Oil on wood. 12 × 18. The Detroit Institute of Arts.

1865

Thirteenth Amendment ratified, outlawing slavery and involuntary servitude (Feb.).
Fifty-Fifth Massachusetts Colored Regiment enters Charleston in triumph (21 Feb.).
Bureau of Refugees, Freedmen and Abandoned Lands—known as Freedmen's Bureau—established by an act of Congress. Lasted seven years under the leadership of Commissioner O. O. Howard (March).
Robert E. Lee surrenders to Ulysses S. Grant at Appomatox (9 April).

WH apparently returns briefly to the front in late March.
Exhibits *The Bright Side* at the Brooklyn Art Association (22–25 March). – Exhibits three works at the National Academy of Design, New York, including *The Bright Side.* – Is elected Academician of the National Academy of Design (May). – Seven of WH's wood engravings appear in the illustrated press between July and Dec. – Exhibits two painting at the Artists' Fund Society Sixth Annual Exhibition, New York, including *Army Boots* (Nov.). – Is elected a member of the Century Club, New York (30 Nov.).

The Bright Side. o/c. 13 × 17½. The Fine Arts Museums of San Francisco.
Army Boots. o/c. 14 × 18. Hirshhorn Museum and Sculpture Garden, Washington, D. C.

1865 *(continued)*

Lincoln endorses black suffrage publicly (11 April).

Assassination of Abraham Lincoln (14 April).

President Andrew Johnson's plan of Reconstruction announced: rebels must take oath of loyalty to the Union and of support for emancipation (29 May).

Johnson overruled Freedmen's Bureau Commissioner Howard and ordered the return of confiscated and abandoned lands to pardoned Southerns (August).

Johnson announced that black units would be removed from the South; all mustered out within two years (August).

1866

Ku Klux Klan organized in Pulaski, Tennessee.

Passage of Civil Rights Bill (April).

Race riots in Memphis and New Orleans (May and Sept.).

Opening of the National Academy of Design's 41st Annual Exhibition, New York, with two of Homer's paintings (16–17 April). – Exhibits six paintings at Miner and Somerville, New York, including *Near Andersonville*. – WH back in Belmont (July), may have remained there through October. Forms association with Eugene Benson, critic and artist. – Exhibits three paintings at Avery's, New York. – WH and Eugene Benson have joint sale at Henry H. Leeds and Miner Gallery, 12th and Broadway, New York (ostensibly to help with travel finances). WH offers nineteen works (17 Nov.). – Sails for Europe from Boston on the *Africa* (5 Dec.). According to Albert Kelsey, Belmont friend and fellow artist in Paris, WH shares a Montmartre studio with him. Homer stays in Europe one year.

Sketch of two little girls for *Near Andersonville*. Pencil on paper. 4¾ × 3½. Cooper-Hewitt Museum, New York.
Near Andersonville (formerly known as *At the Cabin Door* and *Captured Liberators*). o/c. 22 × 17¼. The Newark Museum.
Engraving of *The Bright Side* in *Our Young Folks* (July 1866):396.
Army Teamsters. o/c. 16¾ × 27. Colby College Art Museum, Waterville, Maine.

1867

Congress passes the Military Reconstruction Act (22 March).

Freedmen's Bureau's courts and medical system dismantled.

Opening of the Universal Exposition, Paris, France, where Homer's *Prisoner from the Front* and *The Bright Side* are exhibited (1 April). – During his stay in Paris WH's wood engravings continue to appear in the American illustrated press. – WH travels to Picardy and area around Cernay-la-Ville; paints hay-making scenes (late summer). – WH arrives back in New York on the *Ville de Paris* (17 Dec.).

A Parisian Ball—Dancing at the Casino in *Harper's Weekly* 11 (23 Nov. 1867):745. Wood engraving. 9³⁄₁₆ × 13¾.

1868

All former states of Confederacy, except four, readmitted to Union (June).

Fourteenth Amendment ratified, making blacks citizens (28 July).

President Andrew Johnson impeached.

Ulysses S. Grant elected president,

WH back to the University Building (11 Jan.). Throughout 1868 publishes twenty-one wood engravings in *Harper's Weekly*, *The Galaxy*, *Harper's Bazar*, *Our Young Folks*. – Exhibits two French pictures at the National Academy of Design (April). – Summer in Manchester, Massachusetts, north of Boston. – WH to Belmont and Lawrence, where he visits his brother Charles and his new wife Martha ("Mattie") who had married while WH was in Paris. – WH in the White Mountains of New

1868 *(continued)*
Schuyler Colfax vice president.
Former Confederate states hold constitutional conventions and adopt new constitutions guaranteeing universal suffrage. Former slaves are allowed to vote.

Hampshire—passes through Vermont, visits Saratoga probably.

1869

During 1869 WH creates 23 wood engravings that are published in *Harper's Weekly, Appleton's Journal, The Galaxy, Harper's Bazar, Hearth and Home, Our Young Folks.* – Returns to the White Mountains; also visits Sawkill River and Delaware River in Pennsylvania; also Salem and perhaps Gloucester; Long Branch, New Jersey (Aug.). – Exhibits one painting at the Brooklyn Art Association (7 Dec.).

Hi! H-o-o-o! He done come. Jumboloro tell you fust. in *The Galaxy* 7, no. 6 (June 1869), facing p. 823. Wood engraving. 6⅞ × 4⅞.

1870
Hiram Rhoades Revels sworn into the U. S. Senate as senator from Mississippi (25 Feb.).
Adoption of the Fifteenth Amendment, forbidding the denial of the right to vote "on account of race, color, or previous condition of servitude" (30 March).
First Ku Klux Klan (or Enforcement) Act gives Grant power to act against white terrorists in South.

During 1870 WH publishes seventeen wood engravings in *Harper's Weekly, Appleton's Journal, Every Saturday, The Galaxy, Harper's Bazar.* – Exhibits one painting at the Century Association (3 March). – Exhibits ten works at the National Academy of Design (April). – WH back at Long Branch (6 Aug.). – First of WH's trips to the Adirondack Mountains (Sept.).

1860–1870 in *Harper's Weekly* 14 (8 Jan. 1870): 24–25. Wood engraving. 13⅜ × 20½.

1871
Last of Confederate States, Georgia, readmitted to Union.

Publishes seven wood engravings in *Every Saturday* during the year. – Moves to new studio at 41 West Tenth Street, Tenth Street Studio Building, New York. – Opening of the National Academy of Design, with WH exhibiting two paintings (12 April). – Begins regular visits to a house in Walden, New York, which the Lawson Valentines started renting the previous year; also to Hurley, New York (near Walden) (summer).

1872
Ulysses S. Grant reelected over Democratic candidate Horace Greeley.

Exhibitions at the Century Association (13 Jan. and 12 Feb.). – Exhibits five oils at the National Academy of Design (April). – During 1872 WH publishes three wood engravings, all in *Harper's Weekly.* – WH's family moves to Brooklyn to live in the house belonging to Mrs. Homer's wealthy brother, Arthur Benson, president of the Brooklyn Gas Light Company.

1873

Mrs. Homer exhibits watercolors at the Brooklyn Art Association (March). – WH exhibits no works at the National Academy of Design (April). – *Harper's Weekly* publishes eleven wood engravings by WH between April and Dec. – At Gloucester, Massachusetts WH begins producing watercolors (summer). – WH *may* have made first trip to Virginia since the war (late 1873).

1874

Death of Charles Sumner (11 March).

Exhibits at Century Association two pictures, one called *The Dove Cote*, which may be *Uncle Ned at Home* (10 Jan.). – Exhibits five "Leaves from a Sketch Book" (previous summer's watercolors) at the American Society of painters in Water Color (29 Jan.). – Exhibits one painting at the Palette Club, New York (9 March). – Exhibits four paintings at the National Academy of Design (April). – In the following months WH shows more Gloucester pictures at the Century, which brings forth a condemnation by the National Academy of Design and the warning that works shown elsewhere first would not be exhibited at the National Academy of Design. – WH in the Adirondacks again, at the Bakers'; arrives there 15 May. – Leaves Adirondacks (10 June). – Working in East Hampton (sketch of David Pharaoh, "the last of the Montauks," dated 21 July). – During 1874 eleven of WH's wood engravings are published by *Harper's Weekly*. – Traditional dating of WH's first trip to Virginia since the Civil War (fall or winter 1874–75).

1875

Publishes final wood engravings for *Harper's Weekly*. – Homer present at Century Association meeting (March). – Homer present at Century Association meeting (April). – Exhibits four paintings at the National Academy of Design, including *Uncle Ned at Home* (April). – WH may have made a trip to Virginia (late spring/early summer). Note: Arthur Homer married on 22 June in Lowell, Mass. – WH's first visit to Prout's Neck, Maine, to visit his brother Arthur and his new bride (Alice Patch) on their honeymoon (July). – Publication in *The Galaxy* of Henry James's well-known critique of Homer's work (July). – In a letter dated 7 August from Prout's Neck addressed to Philip Henry Brown WH indicates that his parents are with him and want to return to New York the following Tuesday. – Article in *Appleton's* of 6 Nov. written by critic who had visited artist's studio and seen "twenty important studies as the result of his summer vacation." Describes *The Unruly Calf*.

Study for *The Unruly Calf*. Pencil with chinese white on paper. 4¾ × 8½. The Brooklyn Museum.
The Unruly Calf (originally exhibited as *Cattle Piece*). o/c. 28¼ × 38½. Private Collection.
Weaning the Calf. o/c. 24 × 38. North Carolina Museum of Art, Raleigh.
The Busy Bee. w/c. 9¾ × 8⅞. Private Collection, New York.
Contraband. w/c. 8 × 7. Canajoharie Library and Art Gallery, Canajoharie.
Uncle Ned at Home (also known as *A Happy Family in Virginia*; *The Dove Cote*). o/c. 14¼ × 22. Present location unknown. Formerly (1959) in the collection of Edward A. Hauss, Century, FL.
Blossom Time in Virginia. w/c. 14 × 20. The Detroit Institute of Arts.
Two Boys in a Cart. w/c. 8¾ × 6¼. Philadelphia Museum of Art.
Taking a Sunflower to the Teacher. w/c. 7 × 5⅞. Georgia Museum of Art, University of Georgia, Athens.

1876

Massacre of black militiamen in Hamburg, SC (8 July).
Democratic nominee for president, Samuel J. Tilden, wins the popular vote over Republican Rutherford B. Hayes, but the electoral vote is disputed because of returns from three Southern states.

Article in the New York *Evening Post* of 5 Jan. that describes *Weaning the Calf*. – John A. Elder, Virginia painter, inscribed a photograph of his most celebrated painting, *The Battle of the Crater*, to Homer: "Richmond Va/Jany 7th 1876/Mr. Elder's/compliments to/W. Homer." Not known if Elder gave WH the photo or mailed it to him. – WH at Century Association meeting, where *Weaning the Calf* is exhibited (8 Jan.). – Exhibits fourteen works at the American Watercolor Society including *The Busy Bee*, *A Flower for the Teacher*, and *Contraband* (Feb.). – Exhibits five works at the National Academy of Design, including *Cattle Piece*, the

1876 *(continued)*

original title for *The Unruly Calf* (April). – Exhibits at the Centennial Exhibition in Philadelphia *The Busy Bee* and *Flower for the Teacher* (2 April). – WH probably in Virginia (July). Substantiated by a "sketch" entitled "4th July in Virginia" WH exhibits at the Century Association on 2 June 1877. – WH may have been in Virginia and done studies for *Cotton Pickers* and *Upland Cotton*—during the cotton harvest (Sept.-early Dec.). – WH's first documented visit to Lawrence Valentine's Houghton Farm (24 Sept.). Appearance of female model who recurs in Homer's work in 1876 and 1877.

The Cotton Pickers. o/c. 24¹/₁₆ × 38¹/₈. Los Angeles County Museum of Art.
The Watermelon Boys. o/c. 14¹/₈ × 38¹/₈. Cooper-Hewitt Museum, New York.
Sketch of a Cottage Yard. Oil on academy board. 10¹/₄ × 14¹/₂. The Corcoran Gallery of Art, Washington, D. C.
A Visit from the Old Mistress. o/c. 18 × 24¹/₈. National Museum of American Art, Washington, D. C.

1877

Electoral commission created by Congress rules that all disputed ballots belong to Hayes, who is elected president. Final withdrawal of federal troops from the South.

Exhibits one painting at the Century Association (Feb.). – Exhibits three watercolors at the Water Color Society, New York (Feb.). – Exhibits *The Cotton Pickers* at the Century Association (10 March). – Opening of National Academy of Design annual exhibition with two paintings by WH (2 April). – Letter for WH to Lawson Valentine re payment on a painting. WH must have been in New York at this time (24 April). – Founding of *The New York Tile Club*, group of twelve artists who did 8 x 8 in. ceramic tiles together (fall).

Sunday Morning in Virginia. o/c. 18 × 24. Cincinnati Art Museum.
Dressing for the Carnival. o/c. 20 × 30. The Metropolitan Museum of Art, New York.

1878

Exhibits six works at the National Academy of Design, including *The Watermelon Boys* (April). – Exhibits five paintings at the Paris Exposition, including *The Bright Side, A Visit from the Old Mistress,*and *Sunday Morning in Virginia* (2 May). – Exhibits *Cotton Pickers—North Carolina* at the Royal Academy, London. – Travels to West Townsend (at Mattie's house, 5 July); in Ipswich, New Hampshire the following day to visit Mattie's aunt, Elizabeth Preston (summer). – WH back at Houghton Farm in Mountainville making studies of sheep, shepherds, and shepherdesses. (Drawing of sheep dated 5 Oct. 1878 at Cooper-Hewitt Museum, New York.) (fall). – Shows twenty "studies," probably of Houghton Farm subjects, at the Century Association (2 Nov.).

Water-melon Eaters in *Art Journal*, (August 1878): 225. Wood engraving. 5¹/₈ × 7.

1879

Exhibits several works at the Century Club (11 Jan.). – Exhibits twenty-nine works at the American Water Color Society (1 Feb.). – Sale of 75 drawings and watercolors at Matthew's Gallery, New York (4 March). – Exhibits *Upland Cotton* at the Union League Club, New York (11 March). – Exhibits three paintings at the National Academy of Design including *Upland Cotton* (April). – Visits his old artist-friend Joseph Foxcroft Cole in Winchester, Mass. (spring).

Upland Cotton. o/c. 49 × 29¹/₄. Weil Brothers, Montgomery.

Images of Black Americans in Art, 1850–79

The following list includes works depicting Afro-Americans by American and foreign artists. Compiled from the archives of the Menil Foundation's Image of the Black in Western Art project, it is limited to dated or easily datable paintings and sculptures.

NATIONAL EVENTS	WORKS OF ART

1850

Compromise of 1850.

John Blanchard, *Portrait of Thomas Howland*, ca. 1850–57. Oil on wood. 29⅝ × 23⅜. The Rhode Island Historical Society, Providence.

James Goodwyn Clonney. *The Trappers.* 17¼ × 14. Private Collection.

James Goodwyn Clonney. *Which Way Shall We Go?* Exhibited at the American Art-Union, New York. Present whereabouts unknown.

William Sidney Mount. *California News* (also known as *News from the Gold Diggings*; *Reading the Tribune*). o/c. 21⅛ × 20¼. The Museums at Stony Brook.

William Sidney Mount. *The Lucky Throw.* o/c. Approx. 30 × 25. Presents whereabouts unknown.

William Sidney Mount. *Right and Left.* o/c. 30 × 25. The Museums at Stony Brook.

1851

Serialization of Harriet Beecher Stowe's *Uncle Tom's Cabin*, 1851–52.

George Caleb Bingham. *The County Election* (1851–52). o/c. 35⁷⁄₁₆ × 48¾. St. Louis Art Museum.

James Goodwyn Clonney. *Waking Up.* o/c. 27 × 22. Museum of Fine Arts, Boston.

Johann Mongles Culverhouse. *Tavern Dance.* o/c. 18⅜ × 23½. Present whereabouts unknown.

Robert Scott Duncanson. *Cincinnati from Covington, Ky.,* ca. 1851. o/c. 25 × 30. Cincinnati Historical Society.

Emanuel Gottlieb Leutze. *Washington Crossing the Delaware.* o/c. 149 × 255. The Metropolitan Museum of Art, New York.

Junius Brutus Stearns. *Washington as a Farmer at Mount Vernon.* o/c. 37½ × 54. Virginia Museum of Fine Arts, Richmond.

J. Taylor. *The Peter Francisco Incident.* o/c. 25⅛ × 30⅛. Abby Aldrich Rockefeller Folk Art Collection, Williamsburg.

1852

Publication of Harriet Beecher Stowe's *Uncle Tom's Cabin*.

George Henry Durrie. *Settling the Bill* (previously entitled *Selling Corn*). Oil on wood. 19½ × 24. Shelburne Museum.

Emanuel Gottlieb Leutze. *Mrs. Schuyler Burning Her Wheat Fields on the Approach of the British.* o/c. 32 × 40. Los Angeles County Museum of Art, Los Angeles.

Taylor after Charles Howland Hammatt Billings. *American Slave Market.* o/c. 28⅛ × 33³⁄₁₆. Chicago Historical Society.

Richard Caton Woodville. *The Sailor's Wedding.* o/c. 18⅛ × 22. Walters Art Gallery, Baltimore.

1853

Frederick E. Cohen. *Meeting of the Michigan State Agricultural Society: Reading the List of Premiums.* o/c. 29½ × 24½. The Burton Historical Collection, Detroit Public Library, Detroit.

1853 (continued)

Felix Octavius Carr Darley. *Entry of Washington into New York.* o/c. 60 × 90. Chrysler Museum at Norfolk.

Robert Scott Duncanson. *Uncle Tom and Little Eva.* o/c. 27¼ × 38¼. The Detroit Institute of Arts.

George Henry Hall. *Boys Pilfering Molasses.* o/c. 27³/16 × 22. Georgia Museum of Art, The University of Georgia, Athens.

John Adam Houston. *The Fugitive Slave.* o/c. 33 × 60. Jay P. Altmayer Collection.

Eastman Johnson. *Uncle Tom and Little Eva.* Exhibited at The Hague in 1853. Present whereabouts unknown.

William Allen Wall. *Birth of the Whaling Industry.* o/c. 44 × 57. New Bedford Free Public Library.

1854

George Caleb Bingham. *The Verdict of the People (The Election Announcement),* 1854–55. o/c. 46 × 65. Boatman's National Bank of St. Louis.

Alonzo Chappel. *Militia Cavalrymen.* o/c. 25½ × 30½. West Point Museum, West Point, NY.

William Sanford Mason. *Sledding.* o/c. 24⅞ × 30⅛. Philadelphia Museum of Art.

William Matthew Prior. *Three Sisters of the Coplan Family.* o/c. 26¾ × 36¼. Museum of Fine Arts, Boston.

Caleb Peirce Purrington. *Man, Cat, and Mackerel.* o/c. 17¼ × 21½. Old Dartmouth Historical Society, The Whaling Museum, New Bedford.

Charles Wimar. *Flatboatmen on the Mississippi.* o/c. 19¼ × 23⅝. Amon Carter Museum, Fort Worth.

1855

James Goodwyn Clonney. *What a Catch!.* o/c. 24 × 34. Museum of Fine Arts, Boston.

Charles F. Blauvelt. *The German Immigrant Inquiring His Way.* o/c. 36 × 29. North Carolina Museum of Art, Raleigh.

Francis William Edmonds. *All Talk and No Work,* 1855–56. o/c. 24 × 20¹/16. The Brooklyn Museum.

1856

John Brown's raid on Pottawatomie.

Francis William Edmonds. *The Scythe Grinder.* o/c. 24 × 20. New-York Historical Society, New York.

Walter Gould. *Islamic Scene.* o/c. 36 × 30¼. Hirschl & Adler Galleries, New York.

William Sidney Mount. *The Banjo Player.* o/c. 36 × 29. The Museums at Stony Brook.

William Sidney Mount. *The Bone Player.* o/c. 36 × 29. Museum of Fine Arts, Boston.

1857

Dred Scott decision ruling that blacks were not citizens.

George Caleb Bingham. *Jolly Flatboatmen in Port.* o/c. 47¹/16 × 69 10/16. St. Louis Art Museum.

J. A. Bingham. *Topsy and Eva.* o/c. 16¾ × 13¾. Stowe-Day Foundation, Hartford.

J. A. Bingham. *Eliza and Child.* o/c. 18 × 14¾. Stowe-Day Foundation, Hartford.

Constantino Brumidi. *Cornwallis Sues for Cessation of Hostilities Under the Flag of Truce.* Mural painting. United States Capitol, Washington, D. C.

John Carlin. *After a Long Cruise.* o/c. 19⅞ × 30. The Metropolitan Museum of Art, New York.

George Catlin. *Shooting Flamingoes.* o/c. 19 × 26½. Memorial Art Gallery of the University of Rochester.

1857 *(continued)*

Francis William Edmonds. *Devotion.* o/c. 24¼ × 24. Collection of Mr. & Mrs. E. G. Nicholson.

George Fuller. Drawings of blacks in and around Montgomery, Alabama (1857–58). Private Collection.

Eastman Johnson *Washington's Kitchen at Mount Vernon.* Oil on wood. 12½ × 20½. Cummer Gallery, Jacksonville.

Eastman Johnson. *Washington's Kitchen at Mount Vernon.* o/c. 14 × 21. Sotheby, New York, 25/X/73, no. 33.

Tompkins Harrison Matteson. *The Turkey Shoot.* o/c. 36⅛× 48. New York State Historical Association, Cooperstown.

1858

James Cameron. *Col. and Mrs. James A. Whiteside, Son Charles and Servants*, ca. 1858–59. o/c. 53 × 75. Hunter Museum of Art, Chattanooga.

George Fuller. *Negro Nurse and Child.* Oil on wood. 9 × 7. Private Collection.

Randolph Rogers. Doors with relief figures representing the four continents including a black woman depicting Africa. Bronze. United States Capitol, Washington, D. C.

William Wetmore Story. *Cleopatra*, 1858–60. H: 55. Marble. Los Angeles County Museum of Art, Los Angeles.

Thomas Waterman Wood. *Flower Vendor.* o/c. 24 × 15. The Fine Arts Museums of San Francisco.

Thomas Waterman Wood. *Moses, the Baltimore News Vendor.* o/c. 24 × 15. The Fine Arts Museums of San Francisco.

1859

Harper's Ferry Insurrection (Oct.).
Hanging of John Brown (2 Dec.).

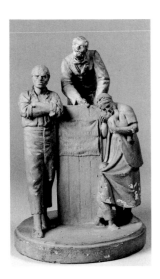

John Antrobus. *Cotton Picking* (first of a series of twelve pictures of "Southern life and nature" announced in the New Orleans *Daily Crescent* of 26 January 1859). Present whereabouts unknown.

David Gilmour Blythe. *Justice*, ca. 1859–62. o/c. 20¼ × 24½. The Fine Arts Museums of San Francisco.

Alonzo Chappel. *Battle of Bunker Hill, June 17th, 1775.* o/c. 15⅝ × 11¾. Chicago Historical Society.

Francis William Edmonds. *The Flute.* o/c. 13¼ × 17¼. Amon Carter Museum, Fort Worth.

John J. Egan. *The Panorama of the Monumental Grandeur of the Mississippi Valley.* Tempera on muslin. 400 x 4,176. St. Louis Art Museum.

Eastman Johnson. *Confidence and Admiration.* o/c. 14 × 12. Private Collection.

Eastman Johnson. *My Old Kentucky Home.* 19 × 11. Amherst College, Mead Art Gallery, Amherst.

Eastman Johnson. *Negro Life at the South* (also called *Old Kentucky Home—Life in the South*). o/c. 36 × 45¼. New-York Historical Society, New York (on loan from The New York Public Library.

Eastman Johnson. *Portrait of a Mulatto Girl.* Oil on academy board. 13½ × 10½ (sight). Georgetown University, Washington, D. C.

Eastman Johnson. *Southern Courtship.* o/c. 20 × 16. Private Collection, Washington, D. C.

◄ John Rogers. *The Slave Auction.* Plaster. H: 13¼. New-York Historical Society, New York.

1860

South Carolina secedes from the Union (20 Dec.).

John Antrobus. *Plantation Burial.* o/c. 53 × 81½. Historic New Orleans Collection, New Orleans.

1860 *(continued)*

David Gilmour Blythe. *Abraham Lincoln, Railsplitter.* o/c. 30 × 40. The Carnegie Museum of Art, Pittsburgh.

François Fleischbein (attributed to). *Portrait of Marie Laveau's Daughter,* after 1860. o/c. 26 × 21. New Orleans Museum of Art.

Eastman Johnson. *Negro Boy.* o/c. 14 × 17. National Academy of Design, New York.

Eastman Johnson. *The Freedom Ring.* Oil on wood. 18 × 22. Hallmark Cards, Kansas City.

Eastman Johnson. *Preparing Breakfast.* Oil on academy board. 12⅝ × 9½. Private Collection, New York.

Eastman Johnson. *Mating.* o/c. 17 × 21. Private Collection.

Eastman Johnson. *Head of a Black Woman,* 1860s. Oil on academy board. 19½ × 13¾. Private Collection.

D. Morrill. *Minstrel Banjo Player.* o/c. 23½ × 19. Wadsworth Atheneum, Hartford.

Louis Liscolm Ransom. *John Brown on his Way to Execution.* o/c. 120 × 84. Oberlin College, Allen Memorial Art Museum, Oberlin.

Unidentified artist. *Slave Market.* o/c. 29¾ × 39½. The Carnegie Museum of Art, Pittsburgh.

1861

Bombardment of Fort Sumter (12 April).

Richard Ansdell, *Hunted Slaves.* o/c. 72⁷⁄₁₆ × 121¼. Walker Art Gallery, Liverpool.

David Gilmour Blythe. *The Blair Family.* o/c. 20½ × 24. Private Collection.

David Gilmour Blythe. *The Higher Law.* o/c. 20¼ × 24½. The Carnegie Museum of Art, Pittsburgh.

Eyre Crowe. *Slaves Waiting for Sale—Richmond, Virginia.* Exhibited at the Royal Academy, London, 1861. o/c. 21⅞ × 32⅛. Private Collection.

Eyre Crowe. *After the Sale: Slaves Going South from Richmond,* ca. 1861? o/c. 27⅛ × 36⅛. Chicago Historical Society.

David Claypool Johnston. *Early Development of Southern Chivalry,* ca. 1861. Watercolor on paper. 9⅞ × 14. Menil Foundation Collection, Houston.

William Wetmore Story. *The Libyan Sibyl.* Marble. H: 53. The Metropolitan Museum of Art, New York.

Adalbert Johann Volck, pseudonym V. Blada. *Confederate War Etchings* (29 plates) and drawings (1861–63).

Edwin White. *Thoughts of Liberia, Emancipation.* o/c. 17 × 21. New York Public Library.

Thomas Waterman Wood. *A Southern Cornfield, Nashville.* o/c. 28 × 40. The T. W. Wood Art Gallery, Vermont College Art Center, Montpelier.

1862

Confiscation Act passed by Congress—declares free the slaves of all who are in rebellion (17 July).

Lincoln issues preliminary Emancipation Proclamation (22 Sept.).

Eastman Johnson. Study for *Babe with Maid,* o/c. 12 × 9½. Private Collection.

Eastman Johnson. *Babe with Maid.* o/c. 14¾ × 12¼. Present whereabouts unknown.

Eastman Johnson. *A Ride for Liberty—The Fugitive Slaves.* Oil on paperboard. 22 × 26¼. The Brooklyn Museum. [2 other versions are known.]

Thomas Moran. *The Slave Hunt* or *Slaves Escaping through the Swamp.* o/c. 34 × 44. Philbrook Art Center, Tulsa.

John Rogers. *The Camp Fire: Making Friends with the Cook.* Painted plaster. H: 12. New-York Historical Society, New York.

1863

Emancipation Proclamation goes into effect (1 Jan.).

Congress passes first comprehensive conscription law in the country (3 March).

William Tolman Carlton. *Watch Meeting, Dec. 31st 1862. Waiting for the Hour.* 29 × 36¼. The White House, Washington, D. C.

William Tolman Carlton. *The Hour of Emancipation.* o/c. 29 × 36¼. Private Collection.

1863 *(continued)*

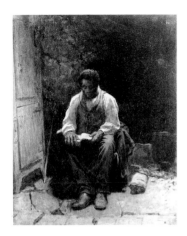

Conrad Wise Chapman. *Battery Bee, Sullivan's Island (December 3, 1863).* Oil on academy board. 11¾ × 15¾. The Museum of the Confederacy, Richmond.

Conrad Wise Chapman. *Battery Bee, Sullivan's Island (December 3, 1863).* Oil on academy board. 11 × 14. Valentine Museum, Richmond.

Victor Dubreuil, after Alfred R. Waud. *The Teamsters' Duel.* o/c. 16 × 20. The Coggins Collection of American Art, Marietta.

John Whetten Ehninger. *Old Kentucky Home.* o/c. 15¼ × 9. Shelburne Museum.

John O'Brien Inman. *Uncle Dick.* o/c. 17 × 13⅞. Munson-Williams-Proctor Institute, Utica.

◄ Eastman Johnson. *The Lord Is My Shepherd.* Oil on wood. 16⅝ × 13⅛. National Museum of American Art, Washington, D. C.

Eastman Johnson. *The Chimney Corner.* Oil on academy board. 15½ × 13. Munson-Williams-Proctor Institute, Utica.

Elihu Vedder. *The Questioner of the Sphinx.* o/c. 36 × 41¾. Museum of Fine Arts, Boston.

John Quincy Adams Ward. *The Freedman.* Plaster. H: 25. Pennsylvania Academy of the Fine Arts, Philadelphia.

John Quincy Adams Ward. *The Freedman.* Bronze. H: 19⅝. Cincinnati Art Museum.

Anne Whitney. *The Liberator* (statuette), ca. 1863. Present whereabouts unknown.

Anne Whitney. *Toussaint L'Ouverture in Prison,* ca. 1863. Present whereabouts unknown.

Thomas Worthington Whittredge. *A Window, House on Hudson River.* o/c. 27 × 19½. New-York Historical Society, New York.

Unidentified artist. *Ellen Caroline Porter and Slave Celeste,* ca. 1863. o/c. 29¾ × 24⅜. Present whereabouts unknown.

1864

Congress passes act giving blacks equal pay, uniforms, medical treatment, etc., retroactive to 1 January 1864 (15 June).

Eliphalet Frazer Andrews. *Sporting Party Breaking Camp.* o/c. 26 × 44. Present whereabouts unknown.

David Gilmour Blythe. *Old Virginia Home.* o/c. 20¾ × 28¾. The Art Institute of Chicago.

Edward Lamson Henry. *Presentation of Colors to the First Colored Regiment of New York City by the Ladies of the City, in Front of Old Union League Club, Union Square, N. Y. C., in 1864.* o/c. 17 × 26. The Union League Club, New York.

Thomas Hovenden. *Negro Boy.* o/c. 20 × 15⅞. Philbrook Art Institute, Tulsa.

Thomas Hovenden. *Ain't That Ripe.* o/c. 21¹⁵⁄₁₆ × 15¹⁵⁄₁₆. The Brooklyn Museum.

Eastman Johnson. *Mount Vernon Kitchen.* Oil on academy board. 12½ × 20½. The Mount Vernon Ladies' Association of the Union, Mount Vernon.

Edmonia Lewis. *Wounded Black Civil War Soldier,* ca. 1864–65. Present whereabouts unknown.

John Rogers. *The Wounded Scout/A Friend in the Swamp.* Painted plaster. H: 23. New-York Historical Society, New York.

Thomas Sully. *Portrait of Edward James Roye.* o/c. 24 × 20. The Historical Society of Pennsylvania, Philadelphia.

Thomas Sully. *Portrait of Daniel Dashiel Warner.* o/c. 24 × 20. The Historical Society of Pennsylvania, Philadelphia.

James E. Taylor, *General Philip Henry Sheridan at Dinwiddie (Va.) Court House on 31 March 1865.* Watercolor on paper. 12⅜ × 20½. Kennedy Galleries, Inc., New York.

Edward Troye, *The Undefeated Asteroid, Dec. 11, 1864.* o/c. 28¼ × 38⅜. Private Collection.

William D. Washington. *Burial of Latane.* o/c. 36⅛ × 46⅛. Private Collection, Virginia.

1865

Thirteenth Amendment ratified, outlawing slavery and involuntary servitude (Feb.).

Bureau of Refugees, Freedmen and Abandoned Lands—known as Freedmen's Bureau—established by an act of Congress (March). Lasted seven years under the leadership of Commissioner O. O. Howard.

Robert E. Lee surrenders to Ulysses S. Grant at Appomatox (9 April).

Assassination of Abraham Lincoln (14 April).

President Andrew Johnson's plan of Reconstruction announced (29 May).

Thomas Ball. *Emancipation Group*, ca. 1865. Bronze. H: 34½. The Montclair Museum.

George Caleb Bingham. *Order No. 11*, 1865–70. o/c. 55½ × 78½. Cincinnati Art Museum.

Aaron E. Darling. *Portrait of John Jones (1817–1879)*, ca. 1865. o/c. 42 ×¾ 31¾. Chicago Historical Society.

Aaron E. Darling. *Portrait of Mrs. John (Mary Richardson) Jones (1819–1910)*, ca. 1865. o/c. 28 × 22½. Chicago Historical Society.

Henry W. Herrick. *Reading the Emancipation Proclamation in the Slaves' Cabin*. Exhibited at the National Academy of Design, New York, 1865, no. 22. Present whereabouts unknown. [Known from an engraving dated 1864.]

Thomas Satterwhite Noble. *The American Slave Market*. o/c. Destroyed by fire in Chicago after 1875.

David Norslup. *Negro Boys on the Quayside*. Oil on wood. 15⅞ × 19½. The Corcoran Gallery of Art, Washington, D. C.

Elihu Vedder. *Jane Jackson*. o/c. 18 × 18. National Academy of Design, New York.

Elihu Vedder. *The African Sentinel*. o/c. 14¼ × 8½. The Metropolitan Museum of Art, New York.

Thomas Waterman Wood. *Portrait of a Black Man*, ca. 1865–70. Oil on paper. 6 × 7¼. The T. W. Wood Art Gallery, Vermont College Art Center, Montpelier.

Unidentified artist, formerly attributed to Eastman Johnson. *Labor Question in the South*, ca. 1865. Oil on wood. 10½ × 17. Wadsworth Atheneum, Hartford.

Unidentified artist. *Lincoln and an Emancipated Slave*, 1865–75? Plaster. H: 42. Wadsworth Atheneum, Simpson Collection, Hartford.

1866

Ku Klux Klan organized in Pulaski, Tennessee.

Passage of Civil Rights Bill (April).

Race riots in Memphis and New Orleans (May and Sept.).

Dennis Malone Carter. *Lincoln's Drive through Richmond*. o/c. 45 × 68. Chicago Historical Society.

Thomas Eakins. *Portrait of a Negress*, ca. 1866–68. o/c. 23 × 19¾. The Fine Arts Museums of San Francisco.

Edwin Forbes. *Contrabands*. Collection of Hermann Warner Williams, Jr.

Eastman Johnson. *Portrait of a Black Woman*. Oil on academy board. 10½ × 8½. Private Collection.

Eastman Johnson. *Fiddling His Way*. o/c. 24¼ × 36¼. Chrysler Museum, Norfolk.

Thomas Hicks. *The Musicale, Barber Shop, Trenton Falls, N. Y.* o/c. 25 × 30. North Carolina Museum of Art, Raleigh.

Edmonia Lewis. *The Freed Woman and Her Child*. Present whereabouts unknown.

John Rogers. *Uncle Ned's School*. Bronze master model. H: 20. New-York Historical Society, New York.

John Rogers. *Taking the Oath and Drawing Rations*. Plaster. H: 22½. Delaware Art Museum, Wilmington.

Randolph Rogers. *Lincoln and the Emancipated Slave*, ca. 1866–68. Plaster. H: 22½. University of Michigan Museum of Art, Ann Arbor.

◄ Thomas Waterman Wood. *A Bit of War History: The Contraband, The Recruit, The Veteran*. o/c. Each: 28¼ × 20¼. The Metropolitan Museum of Art, New York.

1867

Congress passes the Military Reconstruction Act (22 March).

Freedmen's Bureau's courts and medical system dismantled.

Frank Buchser. *The Volunteer's Return*. o/c. 38³⁄₁₆ × 30⁵⁄₁₆. Öffentliche Kunstsammlung, Kunstmuseum Basel.

Frank Buchser. *Guitar Player*. o/c. 24 × 18. Kennedy Galleries, Inc., New York.

Frank Buchser. *Portrait of a Black Man*, ca. 1867. o/c. 25½ × 21⅞. Private Collection.

Frank Buchser. *Negermädchen in Bach*. o/c. 30⅛ × 25³⁄₁₆. Museum der Stadt Solothurn.

1867 *(continued)*

William M. Davis. *Sharpening the Saw*. o/c. 14 × 15¼. The Museums at Stony Brook.

John Whetten Ehninger. *Fife and Drum*. o/c. 14½ × 12. Kenneth Lux Gallery, New York.

Edwin Forbes. *Mess Boy Asleep*. Oil on canvas. 14 × 20¼. Wadsworth Atheneum, Hartford.

Harriet Goodhue Hosmer. Design for the Freedmen's Monument to Abraham Lincoln (reproduced in *Art-Journal*, n.s. 7 [1 January 1868]:8).

Theodor Kaufmann. *On to Liberty*. o/c. 36 x 56¼. The Metropolitan Museum of Art, New York.

Daniel Ridgway Knight. *The Burning of Chambersburg, Pa.* o/c. 49 × 62½. Washington County Museum of Fine Arts, Hagerstown.

Edmonia Lewis. *Forever Free*. Marble. H: 41¼. Howard University, Gallery of Art, Washington, D. C.

Edmonia Lewis. *Hagar*. Present whereabouts unknown.

William Sidney Mount. *The Dawn of Day (Politically Dead. The Break of Day)*. Oil on academy board. 7¾ × 12. The Museums at Stony Brook.

Thomas Nast. Five remaining paintings from the panoramic series of thirty-three works entitled *Grand Caricaturama*. Tempera on cotton. Each approx. 84 × 132. Library of Congress, Washington, D. C.

Thomas Satterwhite Noble. *John Brown's Blessing*. o/c. 84¼ × 60¼. New-York Historical Society, New York.

Thomas Satterwhite Noble. *Margaret Garner* (large version). o/c. Exhibited at the National Academy of Design, New York, 1867, no. 234. Present whereabouts unknown.

Thomas Satterwhite Noble. *Margaret Garner* (small version). Oil on wood. 10¾ × 14¼. Private Collection.

Ferdinand Willem Pauwels. *Glorification of the American Union* (study for or reduced copy of a lost painting). o/c. 28 × 44½. Calvert Gallery, Washington, D. C.

Louis Schultze. *And the Negro Troops Fought Nobly*. Probably o/c. Exhibited at the National Academy of Design, New York, 1867. Present whereabouts unknown.

Louis Schultze. *Negro Serenade*. Probably o/c. Exhibited at the National Academy of Design, New York, 1867. Present whereabouts unknown.

Thomas Waterman Wood. *American Citizens (To the Polls)*. w/c. 18 × 36 (sight). The T. W. Wood Art Gallery, Vermont College Art Center, Montpelier.

1868

All former states of Confederacy, except four, readmitted to Union (June).

Fourteenth Amendment ratified, making blacks citizens (28 July).

Former Confederate states hold constitutional conventions and adopt new constitutions guaranteeing universal suffrage. Former slaves are allowed to vote.

President Andrew Johnson impeached.

Ulysses S. Grant elected president, Schuyler Colfax vice president.

Eastman Johnson. *Head of a Negro Man (Uncle Remus)*, ca. 1868. Oil on academy board. 18½ × 14¼. Private Collection.

Thomas Nast. *Lincoln Entering Richmond*. Gouache. 23¾ × 17¾ (sight). The Union League Club, New York.

Thomas Satterwhite Noble. *The Price of Blood: A Planter Selling His Son*. o/c. 39¼ × 49½. Private Collection, Spartanburg, S. C.

Edward Virginius Valentine. *Knowledge Is Power*. Plaster. H: 18½. Valentine Museum, Richmond.

Edward Virginius Valentine. *The Nation's Ward*, H: 25⅝. Valentine Museum, Richmond.

1869

Frank Buchser. *Negro-Home in Virginia*. o/c. 39⅜ × 29⅛. Öffentliche Kunstsammlung, Kunstmuseum Basel.

1869 *(continued)*

William M. Davis. *Waiting for a Bit.* o/c. 10 × 8½. The Museums at Stony Brook.

◄Thomas Satterwhite Noble. *Study of a Black Man from Behind*, late 1860s. o/c. 10 × 10. Yale University Art Gallery, New Haven. Gift of William V. Garretson.

John Rogers. *The Fugitive's Story.* Plaster. H: 22. New-York Historical Society, New York.

William Aiken Walker. *Negro Youth with Basket on Head (Cuba).* o/c. 10 × 6. Jay P. Altmayer Collection.

1870

Hiram Rhoades Revels sworn into the U. S. Senate as senator from Mississippi (25 Feb.).

Adoption of the Fifteenth Amendment, forbidding the denial of the right to vote "on account of race, color, or previous condition of servitude" (30 March).

First Ku Klux Klan (or Enforcement) Act gives Grant power to act against white terrorists in South.

Frank Buchser. *Negro Cabin in Charlottesville.* o/c. 12⅝ × 19¹⁵⁄₁₆. Öffentliche Kunstsammlung, Kunstmuseum Basel.

Frank Buchser. *Negeridyll.* o/c. 21⅞ × 27. Museum der Stadt Solothurn.

Frank Buchser. *The Song of Mary Blane.* o/c. 40¾ × 60⅝. On loan from Museum der Stadt Solothurn to Gottfried-Keller-Stiftung, Bern.

John Donaghy. *Just Picked Peaches.* o/c. 14⅛ × 12⅛. Present whereabouts unknown.

John Adams Elder, *The Battle of the Crater*, ca. 1870. o/c. 37 ×59½ . Commonwealth Club, Richmond.

Theodor Kaufmann. *Portrait of Hiram Rhoades Revels* (March). Oil on academy board. 12 × 10. Herbert F. Johnson Museum of Art, Cornell University, Ithaca.

Thomas Satterwhite Noble. *Last Sale of the Slaves* (second version of 1865 painting), after 1870. o/c. 60 × 84. Missouri Historical Society, St. Louis.

William Aiken Walker. *Vegetable Vendor at Charleston Market*, ca. 1870. Oil on academy board. 8½ × 4½. Jay P. Altmayer Collection.

Thomas Waterman Wood. *Admiring the Kitty.* o/c. 10 × 8. Private Collection.

Unidentified artist. *Hiram*, ca. 1870. Wood. H: 71. D. & J. de Menil Collection, Houston.

1871

Last of Confederate States, Georgia, readmitted to Union.

Charles Calverley. *Little Ida*, ca. 1871. Marble. 17 × 13¼. The Metropolitan Museum of Art, New York.

E. B. D. Fabrino Julio. *Haw-Yar.* o/c. 29½ × 44. Private Collection.

1872

Ulysses S. Grant reelected over Democratic candidate Horace Greeley.

James Henry Beard. *Goodbye, Ole Virginia.* o/c. 25 × 35½. J. N. Bartfield Galleries, New York (1973).

Charles J. Hamilton. *Charleston Square.* o/c. 36⅝ × 35⅝. Abby Aldrich Rockefeller Folk Art Collection, Williamsburg.

1873

Julian Scott. *Confederate Prisoners Buying Food.* o/c. 26¼ × 20½. West Point Museum.

Edward Virginius Valentine. *Uncle Henry. Ancien Regime*, 1873–74. Plaster. H: 25³⁄₁₆. Valentine Museum, Richmond.

1874

Death of Charles Sumner (11 March).

Thomas Eakins. *Pushing for Rail.* o/c. 13 × 30¹⁄₁₆. The Metropolitan Museum of Art, New York.

Thomas Eakins. *Whistling for Plover.* w/c. 11 × 16½. The Brooklyn Museum.

George Fuller. *Negro Boy with Goat.* o/c. Private Collection.

Edward Lamson Henry. *The Morning Call.* Oil on wood. 8⅞ × 7⅞. Private Collection.

1875

John George Brown. *Card Tricks*, ca. 1875. o/c. 24½ × 30½. Joslyn Art Museum, Omaha.

Thomas Eakins. *Negro Boy Dancing* (study for *Study of Negroes*). o/c. 21 × 9. Collection of Mr. and Mrs. Paul Mellon.

Thomas Eakins. *The Banjo Player* (study for *Study of Negroes*). o/c. 19 × 14⅜. Collection of Mr. and Mrs. Paul Mellon.

Charles Giroux. *Louisiana Road Scene*, ca. 1875. o/c. 14 × 24. New Orleans Museum of Art.

Edmonia Lewis. *Hagar*. Marble. H: 52⅝. National Museum of American Art, Washington, D. C.

B. J. Such. *Down South*. o/c. 14 × 20⅛. Museum of Fine Arts, Boston.

1876

Massacre of black militiamen in Hamburg, SC (4 July).

Democratic nominee for president, Samuel J. Tilden, wins the popular vote over Republican Rutherford B. Hayes, but the electoral vote is disputed because of returns from three Southern states.

Thomas Ball. *Emancipation* (Freedmen's monument). Bronze. H: ca. 108. Lincoln Square, Washington, D. C.

Thomas Eakins. *Will Schuster and Blackman Going Shooting*. o/c. 22⅛ × 30¼. Yale University Art Gallery, New Haven.

George Fuller. *The Banjo Player*. o/c. 17 × 21. Private Collection.

George Inness. *Montclair Landscape (An Old Roadway)*, ca. 1876–80. o/c. 48 × 72. Present whereabouts unknown.

Francesco Pezzicar. *L'emancipazione dei negri*. Bronze. H: 92½. Civico Museo Revoltella, Galleria d'arte Moderna, Trieste.

Elihu Vedder. *The Cumaean Sibyl*. o/c. 38 × 59. The Detroit Institute of Arts.

1877

Electoral commission created by Congress rules that all disputed ballots belong to Hayes, who is elected president.

John Adams Elder. *A Virginny Breakdown*, ca. 1877. o/c. 18½ × 22¼. Virginia Museum of Fine Arts, Richmond.

George Fuller. *Interior of Negro Quarters*, ca. 1877–78. Oil on wood. 17½ × 21½. Vose Galleries, Boston.

Thomas Waterman Wood. *Sunday Morning*. Oil on paperboard/canvas. 14 × 10. National Museum of American Art, Washington, D. C.

1878

Horace Bonham. *Nearing the Issue at the Cockpit*. 20¼ × 27⅛. The Corcoran Gallery of Art, Washington, D. C.

Thomas Eakins. *Study of Negroes—Negro Boy Dancing*. w/c. 18¼ × 22⅝. The Metropolitan Museum of Art, New York.

Thomas Waterman Wood. *"Not a Drop Too Much"*. o/c. 20½ × 14½. Alexander Gallery, New York.

George Fuller. *Turkey Pasture in Kentucky*. o/c. 27⅜ × 40¾. Chrysler Museum, Norfolk.

◄ William Michael Harnett. *Attention Company!* o/c. 36 × 28. Amon-Carter Museum, Fort Worth.

Edward Lamson Henry. *Making the Dog's Collar*. o/c. 7¼ × 9¼. The Coggins Collection of American Art, Marietta, GA.

William Aiken Walker. *Louisiana Cabin Scene with Stretched Hide on Weatherboard and Stick Chimney Covered with Clay*, ca. 1878. Oil on academy board. 9 × 12. Private Collection.

Thomas Waterman Wood. *Crossing the Ferry*. o/c. 19 × 27. The T. W. Wood Art Gallery, Vermont College Art Center, Montpelier.

1879

Thomas Pollock Anshutz. *The Cabbage Patch.* o/c. 24 × 17. The Metropolitan Museum of Art, New York.

Thomas Ball. *Emancipation* (replica of the Freedmen's Monument in Washington, D. C.). Bronze. Park Square, Boston.

John George Brown. *The Longshoremen's Noon.* o/c. 33¼ × 50¼. The Corcoran Gallery of Art, Washington, D. C.

William M. Davis. *On the Way to the Dance (Be Careful O'Dar Jug Honey)*, ca. 1879. Oil on canvas board. 12 × 14. The Museums at Stony Brook.

John Whetten Ehninger. *Turkey Shoot.* o/c. 25 × 43½. Museum of Fine Arts, Boston.